EIGHTEENTH-CENTURY WOMEN ARTISTS

Their trials, tribulations & triumphs

Caroline Chapman

EIGHTEENTH-CENTURY WOMEN ARTISTS

Their trials, tribulations & triumphs

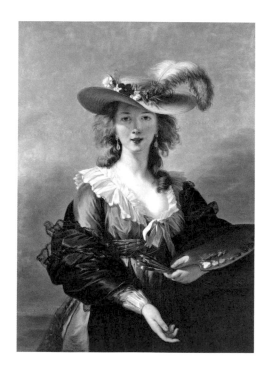

Caroline Chapman

UNICORN

Published in 2017 by

Unicorn, an imprint of Unicorn Publishing Group LLP

101 Wardour Street

London

W1F 0UG

www.unicornpublishing.org

ISBN 978-1-910787-50-2

10 9 8 7 6 5 4 3 2 1

Designed by Nicola Liddiard
Printed in China

Contents

֍

Biographies of the principal
eighteenth-century women artists ... 7

Introduction ... 14

I. A woman's place ... 24

2. Training ... 41

3. The artist's studio ... 59

4. Portraiture ... 75

5. The genres ... 92

6. The marketplace ... 109

7. The patrons ... 129

8. Private lives ... 151

9. A polite recreation ... 171

10. Looking ahead ... 189

Notes ... 210

Bibliography ... 214

List of illustrations ... 217

Index ... 220

Acknowledgements ... 224

Biographies of the principal eighteenth-century women artists

Pauline Auzou (1775–1835)

Born in Paris, she was trained by Jean-Baptiste Regnault. By 1793 she was exhibiting at the Salon. She married Charles-Marie Auzou and gave birth to four children, but continued to paint. She maintained a school for women artists for twenty years. She executed portraits, genre scenes and history paintings.

Lady Diana Beauclerk (1734–1808)

Daughter of the 2nd Duke of Marlborough, she grew up at Blenheim Palace and made pastel studies of the family paintings. She married Topham Beauclerk in 1768 following her divorce from the 2nd Lord Bolingbroke. She is known for her images of cupids and children. Although an amateur, she may have sold some of her designs to Wedgwood later in life when she was short of money.

Marie-Guillemine Benoist (1768–1826)

Born in Paris, she studied first under Elisabeth Vigée Le Brun and then Jacques-Louis David, whose work she emulated throughout her career. Her marriage to the royalist Pierre-Vincent Benoist in 1793 jeopardised her career during the Terror, which followed the Revolution, but she was later commissioned by Napoleon to paint portraits of himself and his family. She is best known for her sentimental genre scenes of women and children. She was awarded a gold medal in the Salon of 1804.

Marie-Geneviève Bouliar (1762–1825)

Born in Paris, the only daughter of a tailor, Greuze is thought to have been one of her several teachers. Little is known about her career, but she exhibited at the Salon from 1791 to 1817. In 1795 she won a Prix d'Encouragement. The few portraits known to be by her exhibit a warm sympathy for her subject, as demonstrated by her portrait of her friend Adélaïde Binart on the front cover.

Marie-Gabrielle Capet (1761–1817)

Born in Lyon into humble circumstances, she somehow escaped the provinces and went to Paris where she entered the studio of Adélaïde Labille-Guiard who not only taught her but promoted her and in every way changed her life. She began by painting portraits in pastel but converted to painting miniatures. She became one of the best and most popular miniature portraitists in Paris around the turn of the century.

Rosalba Carriera (1675–1757)

Born in Venice, where she remained for most of her life apart from spending a year in Paris in 1720 at the invitation of the French king's banker, Pierre Crozat, a year which made her name as a brilliant pastel portraitist. She also worked in Modena in 1723 and in Vienna in 1730. Her patrons included Grand Tourists visiting Venice and the Elector of Saxony for whom she did over 150 pastels. Unmarried, she was assisted by her sister. In 1746 her sight began to fail and by 1751 she was completely blind.

Marie-Anne Collot (1748–1821)

Born in Paris, she was trained by Jean-Baptiste Lemoyne, and the sculptor Etienne-Maurice Falconet. In 1766, aged eighteen, she accompanied Falconet to Russia as his assistant. For twelve years she executed portrait busts and medals for members of the court of Catherine the Great and assisted Falconet on his equestrian statue of Peter the Great. In 1778 she married Falconet's son, but left him a year later. She gave up sculpting when Falconet became ill, nursing him for eight years until his death in 1791.

Maria Cosway (1759–1838)

Born in Florence, she studied with Violante Cerroti and Johann Zoffany. In 1779 she moved with her family to London. She married the miniaturist Richard Cosway in 1781 and they had one daughter who died in 1790. The Cosways were famous for their fashionable parties but by the 1790s had separated. She exhibited portraits and history pictures at the Royal Academy between 1781 and 1790. She founded a school for girls in Lyon (1803) and Lodi (1812). She returned to London in 1817 to nurse her dying husband. She died at Lodi.

Anne Seymour Damer (1748–1828)

The only woman sculptor of note in England until the twentieth century, she was born into an aristocratic Whig family. Taught by Giuseppe Ceracchi and John Bacon, she was an amateur sculptor of portrait busts and animals. She married the Hon. John Damer in 1767. She was childless and did not marry again after her husband's death. She exhibited at the Royal Academy as an amateur between 1785 and 1811.

Françoise Duparc (1726–78)

Although born in Spain, her family returned to their home town, Marseilles, in 1730. She received a basic artistic education from her sculptor father, and studied with the painter Jean Baptiste van Loo. She later moved to Paris. She was one of a small group of French artists who specialised in recording the lives of working-class people. She is known to have exhibited in Paris and London, but today only four works can definitely be attributed to her.

Anne Forbes (1745–1834)

Born in Scotland, she was financed by local businessmen to train in Rome, where she spent three years, returning to practise as a portraitist in London. But after a year of ill health and lack of clients, she returned to her native Edinburgh where she worked for the rest of her life. In 1772 she exhibited at the Royal Academy and became portraitist to the Society of Antiquaries of Scotland.

Marguerite Gérard (1761–1837)

She was born in Grasse, Provence. When her older sister married Jean-Honoré Fragonard, she moved to Paris to live with them and became Fragonard's pupil. By the mid-1780s she was the leading female genre painter, executing over 300 genre scenes. Some of her work has been falsely attributed to Fragonard, although they are known to have collaborated on several paintings. She exhibited at the Salon between 1799 and 1824 and was awarded a gold medal in 1804.

Angelica Kauffman (1741–1807)

Born in Switzerland, she was taught by her artist father, who then took her to Italy to study the work of the great masters. In 1766 she came to England where she remained for fifteen years. Highly sought after as a fashionable portraitist, she was also one of the few women to succeed as a history painter. In 1768 she became a founder member of the Royal Academy. After a brief and disastrous marriage to an adventurer, she married the artist Antonio Zucchi in 1781. The couple left England and settled in Rome where she continued with her successful career. By the time of her death, she had achieved such renown that her funeral was directed by the prominent Neoclassical sculptor Antonio Canova.

Adélaïde Labille-Guiard (1749–1803)

Born in Paris, she trained with the miniaturist François-Elie Vincent, then the pastellist Maurice-Quentin de la Tour, and studied oil painting with François-André Vincent. In 1783 she became one of only two female members of the Académie Royale. In 1787 she was appointed official painter to Mesdames, Louis XVI's aunts. Her marriage in 1769 to Nicolas Guiard was unhappy and childless. She supported the Revolution and fought for the recognition of women artists. In 1800 she married François-André Vincent.

Constance Mayer (1775–1821)

Born in Paris, she studied with Greuze, Joseph-Benoît Suvée and briefly in 1801 with David. In 1802 she became the pupil of Pierre-Paul Prud'hon. She collaborated with him professionally and helped to look after his family. At the Salon she exhibited miniatures, genre paintings, allegorical subjects and portraits. She committed suicide when Prud'hon refused to marry her after his wife's death.

Mary Moser (1744–1819)

Born in London, she was the daughter of a Swiss enamel painter and gold chaser, who had settled in England in 1721. Taught by her father, she became such a successful flower painter that she was one of only two women artists to become founder members of the Royal Academy in 1768. As a favourite of Queen Charlotte, she was commissioned to paint an entire room with flowers at Frogmore. She married late in life and thereafter painted only as an amateur.

Catherine Read (1723–78)

Born in Scotland, the fifth of fourteen children. After 1745 she went to Paris and studied pastel panting with Quentin de la Tour. From 1751–53 she worked as a successful pastel portraitist in Rome. She left Rome for London in 1754 and quickly built up a fashionable clientele, including Queen Charlotte. After twenty years she went to India to visit her brother but died on the return voyage.

Rachel Ruysch (1664–1750)

Born in Amsterdam, where her father was a professor of anatomy and botany and established the first Museum of Natural History, all great assets to Ruysch's career. She was taught by the flower and still-life artist Willem van Aelst. In 1693 she married the portrait painter Juriaen Pool and had ten children. She was court painter to the Elector Palatine in Düsseldorf, 1708–16. She is the first woman who not only achieved an international reputation as a flower and fruit painter in her lifetime, but whose paintings have continued to fetch high prices since.

Anna Dorothea Therbusch (1721–82)

Born in Berlin, she and her sister were taught by their father, a portrait painter. In 1742 she married an innkeeper and had three children. She worked at the courts of Stuttgart (1761) and Mannheim (1763) and in Paris from 1765–67, and was elected to the Académie Royale. In 1769 she settled in Berlin where she received commissions from Catherine the Great and Frederick II of Prussia. She was mainly a portraitist, but occasionally painted genre scenes and mythologies.

Anne Vallayer-Coster (1744–1818)

Born in Paris, her father was a goldsmith at the Gobelins Manufactory and she grew up surrounded by artists and craftsmen. She is thought to have studied drawing with the miniaturist Madeleine Basseport. She married a lawyer, Jean-Pierre Silvestre Coster, in 1781. In 1770 she was admitted to the Académie Royale and by 1784 she was the undisputed leader of French still-life painting, her subjects ranging from flowers to sea creatures and beautiful objects of every kind. Her work was bought by the elite in society and at court. Sets of prints made from her flower paintings were used as models for embroidery, tapestries and porcelain.

Elisabeth Vigée Le Brun (1755–1842)

Born in Paris, she was taught by her artist father. She was already
a successful portraitist of the aristocracy when, aged twenty-one,
she married the art dealer Jean-Baptiste Lebrun. She painted many
members of the royal family, including almost thirty portraits of
Marie Antoinette. In 1783 she became a member of the Académie
Royale. She fled France with her daughter Julie on the eve of the
Revolution. She spent the next twelve years in exile, painting portraits
of European and Russian nobility. After spending two years in
London (1803–5), she resettled in France. During her lifetime
she produced a total of more than 600 portraits.

Marie-Denise Villers (1774–1821)

Born in Paris, Villers came from an artistic family and two of her
sisters were also accomplished artists. She was a student of the French
painter Anne-Louis Girodet de Roussy-Trioson and also of François
Gérard and Jacques-Louis David. She was married, but little is known
about her career, although she exhibited at the Salon in 1799. She
specialised in portraiture.

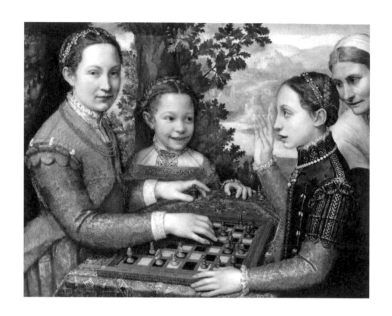

1. Sofonisba Anguissola, *The Chess Game*, 1555
The artist was twenty years old when she painted this picture of her three sisters playing chess. Representing such an everyday domestic scene was very unusual at that date, but it displays to perfection her skill at conveying familial affection. Anguissola was the first Italian woman to become an international celebrity as an artist.

Introduction

It is a great wonder that a woman should be able to do such work.

ALBRECHT DÜRER, JOURNAL ENTRY OF 21 MAY 1521[1]

Albrecht Dürer's amazement that a woman could paint so well was prompted by an illuminated miniature of Christ executed by an eighteen-year-old girl, Susanna Horenboult (1503–*c.* 1554), which he purchased from the artist when he met her and her father in Antwerp in 1521. Susanna's father, Gheraert Horenboult, was an artist, and there lies the key to his daughter's successful career as a painter at the Tudor court from 1522 until her death. Had she not been trained in the family workshop in Ghent, it is highly improbable that she would have become an artist at all, still less a professional one. Until the nineteenth century women were barred from attending art schools or from studying from a nude model, male or female. But Susanna, armed with her training, was able to brave a world hostile to the very idea of women earning money from their work; a woman's proper place was in the home, it was emphatically not in an artist's studio.

There have been successful women artists throughout history. The Roman scholar Pliny the Elder cites six women artists of antiquity in his *Historia Naturalis* (AD 77–79), some of whom reappear in

15

Boccaccio's *Concerning Famous Women* (1413). A later translation of Boccaccio's work contains a delightful illustration of one of these women painting her self-portrait with the aid of a hand-held mirror. Castiglione's *The Book of the Courtier* (1528) conceded that painting was a suitable activity for genteel young ladies, a view that persisted right up to the eighteenth century and beyond. In the mid-sixteenth century, the first edition of painter and architect Georgio Vasari's seminal *Lives of the Most Eminent Painters, Sculptors and Architects* included Pliny's six women and added a sculptor Properzia de' Rossi who, besides carving in marble, executed minute religious scenes on peach stones. In the second revised and enlarged edition of 1568, Vasari discussed the work of some thirteen women artists, one of them being Susanna Horenboult, whose miniature of Christ had so impressed Dürer.

Another of Vasari's featured women, Sofonisba Anguissola (*c.* 1532–1625), is today regarded as one of the most successful female artists of the Italian Renaissance. Her gentle, intimate, often humorous portraits are in stark contrast with the dramatic paintings of the great Baroque artist Artemisia Gentileschi (1593–1653). A follower of Caravaggio, Gentileschi's depictions of Judith beheading Holofernes — one of her favourite subjects — disturb and shock the viewer with their chilling ferocity. Her figures leap out of a velvety darkness, their limbs and faces glowing as if lit from within.

Despite the fact that some of these women made a living from their art — several were employed as court painters, and the Renaissance artist Lavinia Fontana (1552–1614) was the principal breadwinner for a family of eleven — they still struggled to obtain adequate training and for their work to gain acceptance in a man's world. But many of them were remarkably skilful at circumventing the numerous obstacles that society persistently placed in their path.

After 1600 the number of women who became professional artists multiplied; they became more ambitious, their subjects more adventurous. To portraiture and religious subjects they added genre painting and the newly popular still life. Maria Sibylla Merian's (1647–1717) intricate studies of plants and insects show an astonishing ability to render the beauties of nature with scientific precision, while the jewel-like effect of Rachel Ruysch's (1664–1750) great interlaced flower bouquets earned her fame and fortune during her lifetime.

By the eighteenth century the contribution made by upper- and middle-class women to European culture was increasingly in evidence. They hosted 'salons', wrote books and studied history, the arts and sciences. Published documents reveal that almost 300 women were working as professional artists – a remarkable increase on the fewer than ten throughout Europe recorded in the fifteenth century.[2] Between 1750 and 1770 six of the twenty most popular English novelists were female. Women, trumpeted the *Athenian Mercury* (admittedly, a women's periodical), had become 'a Strong Party in the World'.[3]

In France women's role in shaping culture was epitomised by Mme de Pompadour, whose intelligence, charm and exquisite taste set the tone of Louis XV's Versailles. In Paris the nobility and middle classes gathered in the salons to exchange ideas on literature, philosophy and the arts. The French artist Jean François de Troy recorded one such gathering in a charming painting entitled *A Reading from Molière* (around 1728). A group of five women, all exquisitely dressed in satin and brocade, recline in richly upholstered chairs in a luxurious interior. At the group's centre a gentleman reads from a volume of Molière. The only other man present, gorgeous in black velvet, leans against a chair back, exchanging a meaningful glance with one of the women. The relaxed, intimate

atmosphere of the scene perfectly illustrates what Talleyrand called the 'douceur de vivre' ('the sweetness of living') as experienced by civilised society in eighteenth-century France.

Such images were reflected by Jules and Edmond de Goncourt's book, *Woman of the Eighteenth Century*, in which they declared that: 'Woman was the governing principle, the directing reason and the commanding voice of the eighteenth century... She held the revolutions of alliances and political systems, peace and war, the literature, the arts and the fashions of the eighteenth century, as well as its destinies, in the folds of her gown...' And they went further: 'Woman touched everything. She was everywhere.'[4] Published in 1880, this is a retrospective view and one deemed by some as belonging 'to the realm of fiction',[5] but there is enough evidence to show that from the middle of the century until the French Revolution female participation in the arts was too great to be ignored.

Nor was it ignored: opinions ranged from the ambivalent to the downright hostile. Women who sought prominence of any kind were roundly condemned by both male and female commentators. The French philosopher Jean-Jacques Rousseau argued that the influence exercised by women at court and in their salons had 'degraded and feminised' French culture.[6] Their 'natural' roles, he insisted, were carrying out their traditional duties as daughters, wives and mothers.

Yet despite the obstacles experienced by women over the centuries, a surprising number were talented enough and sufficiently obsessive to become successful professional artists. Many of these women were recognised by the exhibition *Women Artists: 1550–1950*, held in 1976 at the Los Angeles County Museum of Art. This hugely popular show brought the subject of women artists into the open and generated a steady flow of exhibitions and publications that rediscovered and reinstated many of the artists whose lives and

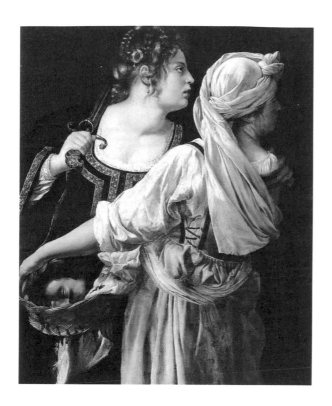

2. Artemisia Gentileschi, *Judith and her Servant*, c. 1618–19
Gentileschi painted up to six versions of the biblical heroine
Judith, either savagely slaying Holofernes or of the act's
immediate aftermath, as shown here. Her repeated return to this
subject is seen as revenge against her tutor Agostino Tassi, who
was accused of raping her. The subsequent trial, during which she
was tortured, damaged her reputation.

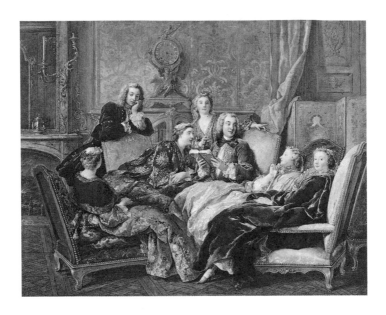

3. Jean-François de Troy, *Reading from Molière*, 1730

The relaxed and intimate atmosphere of the Paris salons, habitually run
by women, was an ideal environment for artists to meet potential patrons.
De Troy is regarded as the inventor of the 'tableaux de modes' ('paintings
of fashions'), which portrayed the elegant social life of Paris.

work had been overlooked or forgotten. The influential art critic Robert Hughes, writing in *Time* magazine, declared it to be 'one of the most significant theme shows to come along in years'.[7] But the organisers, Ann Sutherland Harris and Linda Nochlin, admitted in the catalogue's Preface that it had 'proved extraordinarily difficult to assemble the group of works' that they hoped to exhibit, and that in 'a few cases the remarks of museum directors revealed, we believe, a lack of support for the concept of the exhibition itself and hence an unwillingness to lend major works to the show'.[8] And this resistance to the work of female artists has continued: London's National Gallery has only nine in its permanent collection; only 3.5 per cent of New York's Museum of Modern Art's permanent collection is by women.[9]

Nor have female artists been well served by art historians. In Griselda Pollock's article in the *Grove Dictionary of Art,* she maintains that it 'took an emergence of feminism in the late twentieth century to redress the almost complete neglect of women artists by art history and to undermine the stereotyped views of art made by women'.[10] But from the early 1970s, a wave of new research, books and exhibitions led to the long-overdue retrieval of knowledge about women artists that had been virtually erased in the twentieth century.

The great majority of books about women artists cover at least four centuries. I have chosen to restrict the book's scope to the century in which women's contribution to the arts increased so dramatically and the quantity and quality of professional women artists achieved unprecedented growth. A handful of the artists became celebrities.

With a mere 100 years to play with, I have been able to devote a chapter to each aspect of the working lives of professional artists. The first chapter describes the social and cultural obstacles they faced; the second, their difficulties obtaining training and the

ways some overcame this fundamental handicap. The third chapter describes the complexities of running a busy studio; the fourth, the challenges, pitfalls and dilemmas – to flatter or not to flatter – experienced by a fashionable portraitist. The portraits are a unique record of the way upper- and middle-class people lived at that time and what they say about the artists who painted them: their clothes, cosmetics, etiquette, interior decoration, human relations, social mores. The fifth chapter explains the different genres, from 'history painting' to still life. The sixth deals with a conundrum particular to women: how to sell your pictures when attracting attention to yourself was considered unfeminine, even scandalous. Attracting patrons is the subject of the seventh chapter: though vital to an artist's success, some patrons could prove a mixed blessing, even life-threatening – as several artists found to their cost when their patrons were members of the French royal family. The flourishing world of amateur artists is covered in the penultimate chapter; the tenth describes what lay ahead for women artists in the nineteenth century – called by one writer 'the break-through years'.[11]

This book does not pretend to be a scholarly overview of the subject. Instead, it is a distillation of facts, information and comment garnered from a wide variety of published material ranging from works on eighteenth-century social and cultural history to the most recent biographies and exhibition catalogues, the resultant brew seasoned by my own interpretation of the sources. (Dr Samuel Johnson neatly sums up this process: 'The greatest part of a writer's time is spent in reading, in order to write; a man will turn over half a library to make one book.'[12]) As such, I hope the book will appeal to the general reader who might hesitate to tackle some of the more feminist and academic tomes, some of which are written in impenetrable prose and tend

to see, not Reds, but misogynists under every bed.

Above all, the book is a celebration of the achievements of women artists who were active during the eighteenth century and whose work has triumphantly survived the intervening years.

I

A woman's place

I would have you remember, my dear, that as sure as anything intrepid, free, and in a prudent degree bold, becomes a man, so whatever is soft, tender, and modest, renders your sex amiable. In this one instance we do not prefer our own likeness; and the less you resemble us the more you are sure to charm...
LETTER FROM SAMUEL RICHARDSON TO HIS DAUGHTER IN 1741[1]

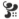

The key words in this passage are 'bold' and 'modest'. Boldness in a man was an asset but dangerously unfeminine in a woman. Modesty was the principal female virtue of the eighteenth century, the one which all women should pretend to possess if they were not already endowed with it naturally. In his poem *The Triumphs of Temper*, William Hayley adds 'Innocence and Ease' and 'a wish to please',[2] but all these virtues sit uneasily with those required by a woman intent on becoming a professional artist. Instead she must work all the hours of daylight and then be sufficiently bold to promote herself and her work in the marketplace. In so doing, she was challenging the unwritten rule of polite society: that a woman's proper place was in the home, performing the traditional roles of docile daughter, dutiful wife and devoted mother.

The education of a middle- or upper-class girl was designed

to enable her to fulfil these roles. She was taught either at home by a governess or sent to boarding school to learn to read, write and do the household accounts. (As an 'extra', young ladies could be taught the correct way to get in and out of a carriage.) Even this much erudition was going too far for Mrs Malaprop in Richard Brinsley Sheridan's play *The Rivals* (first performed in 1775): 'You thought, miss! I don't know any business you have to think at all – thought does not become a young woman.'[3] A working knowledge of French – the lingua franca of European society – was essential, a little Italian useful. A few enlightened parents added a grounding in the classics to these basic skills, but this was rare and often not appreciated, even by the feminine sex. 'I hate to hear Latin out of a woman's mouth', a lady friend complained to Samuel Richardson, 'There's something in it, to me masculine.'[4]

After several years of an English education the finished product could be neatly summed up by Matthew Bramble's description of his niece in Smollett's *Humphrey Clinker* (1771): 'She is a poor good-natured simpleton, as soft as butter, and as easily melted: not that she's a fool; the girl's parts are not despicable, and her education has not been neglected; that is to say, she can write and spell, and speak French, and play upon the harpsichord; then she dances finely...'[5]

In France, girls as young as six would be bundled off to a convent where, according to Jules and Edmond de Goncourt, the aim of their education was 'to make the child play the lady'.[6] Convents, however, were institutions of safe-keeping for other than young girls: discarded mistresses, wives separated from their husbands, a lady seeking to liquidate her husband's debts, an actress confined by a jealous lover, all found refuge within a convent's cloistered walls. The parents of a girl whose formative years were spent rubbing shoulders with such fellow inmates might find to their consterna-

tion that their little darling had learned more about the world than they had bargained for.

For a girl to cultivate 'accomplishments', however, was actively encouraged, so long as it was not taken to extremes. A leading contemporary review smugly recommended painting as an acceptable pastime for women as:

> It demands no sacrifice of maiden modesty nor of matronly reserve ... it does not force her to stand up to be stared at, commented on, clapped or hissed by a crowded and unmannered audience, who forget the women in the artist. It leaves her, during a great portion of her time at least, beneath the protecting shelter of her home, beside her own quiet fireside, in the midst of those who love her and who she loves.[7]

In her novel *Camilla* (1796), Fanny Burney warned that accomplishments should be restricted to 'a little music, a little drawing, and a little dancing; which should all ... be but slightly pursued, to distinguish a lady of fashion from an artist'.[8] Such attributes equipped a girl to shine in the drawing room and added to her charms as a wife. They also helped to alleviate the excruciating boredom of an upper-class woman's life in the eighteenth century.

Although unaccountably omitted by Miss Burney, needlework was looked upon as a highly suitable occupation for a woman. Lady Mary Wortley Montagu, a colourful and eccentric feminist, with strong views on a multitude of subjects, had no doubts about the matter: 'It is as scandalous for a woman not to know how to use a needle, as for a man not to know how to use a sword.'[9] That it was a becoming and natural pastime is borne out by the number of women who chose to be depicted wielding a needle in their portraits.

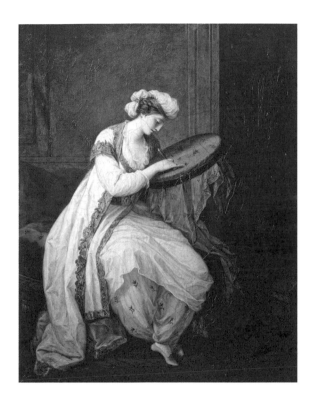

4. Angelica Kauffman, *Morning Amusement*, c. 1773
In the 1770s Kauffman executed a series of paintings of female
sitters in Turkish costume, a fashionable style at the time and one
which perfectly suited Kauffman's preference for depicting women
in graceful, flowing garments. The mezzotint made from this image
was so popular that Queen Charlotte bought a copy of it.

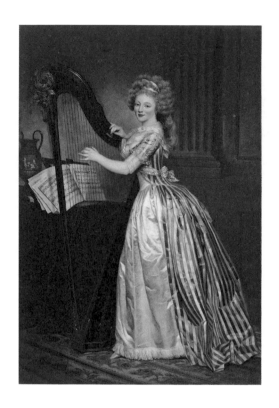

5. Rose Adélaïde Ducreux, *Self-portrait with a Harp*, c. 1791
Harps were a popular accessory for portraits in this period.
Ducreux was not only a talented artist but an accomplished
performer and composer. Another self-portrait, originally
attributed to Jacques-Louis David, shows her playing the
harpsichord. Her pose and the sumptuous fabric of her
dress were much admired by contemporary critics.

Angelica Kauffman (1741–1807) executed several images of women sewing, including a drawing of herself embroidering. One of her most charming works, *Morning Amusement*, shows a lady, dressed in the then fashionable 'Turkish mode', bent gracefully over her tambour frame. The Scottish portraitist Catherine Read (1723–78) seemed to favour showing women peacefully at work, although according to Fanny Burney she was incapable of so much as altering a dress.

The ability to play a musical instrument was encouraged as society admired a girl with artistic skills, but on no account must she become too proficient. The flourishing career of singer Elizabeth Linley was cut short when she married Sheridan, as he forbade her to perform except at exclusive gatherings of the nobility. The father of Anne Ford, an accomplished player of the *viola da gamba*, went further: when she organised a series of subscription concerts, he countered by surrounding the theatre with Bow Street Runners to prevent the first concert from taking place.

Most young girls would have been taught music as well as drawing and painting at school — occupations dismissed by Dorothea in George Eliot's *Middlemarch* (1871–72) as 'small tinkling and smearing'.[10] But women were expected to restrict their artistic endeavours to painting pretty pictures in watercolour and must never take their 'smearing' too seriously. For a woman to shut herself away in an artist's studio all day was awful proof that she had lost track of her priorities. To spend her day belabouring a lump of marble with a hammer and chisel was decidedly *not* what she should be doing. 'To model well in clay', notes George Paston in his *Little Memoirs of the Eighteenth Century* (1901), 'is considered strong minded and anti-feminine but to model badly in wax or bread is quite a feminine occupation.'[11]

As the century progressed the debate about the quality and

validity of female education gathered pace. 'We are educated in the grossest of ignorance', declared Lady Mary Wortley Montagu, 'and no art omitted to stifle our natural reason. If some few get above their nurse's instructions, our knowledge must rest concealed and be as useless to the world as gold in a mine.'[12] Such views, and others in the same vein, were not confined to women. The philosopher Marquis de Condorcet, whose ideas were said to embody the ideals of the Enlightenment, wrote in 1790: 'Why should people prone to pregnancy and passing indispositions be barred from the exercise of rights no one would dream of denying those who have gout or catch cold easily?' Furthermore, if women were to be taxed, they should also be able to vote.[13] One school of thought believed that if women received a more rounded education, they would make better companions for their husbands.

But the voices raised against women being better educated were louder, their arguments based principally on the premise that the female sex just was not up to it. 'Women, then, are only children of a larger growth', the statesman and man of letters Lord Chesterfield asserted in one of his many didactic letters to his son. 'A man of sense only trifles with them, plays with them, humours and flatters them, as he does with a sprightly, forward child.'[14] Even the philanthropist Hannah More, though highly critical of the quality of women's education, shared the majority view that women lacked the intellectual capacity for serious study.[15] And any woman who succeeded in gaining knowledge did not necessarily make herself popular, as Jane Austen's charming heroine in *Northanger Abbey* (1818), Catherine Morland, well knew. 'A woman, especially, if she have the misfortune of knowing anything, should conceal it as well as she can.'[16]

So, having received — by eighteenth-century standards — a fashionable education, a young woman must concentrate all her

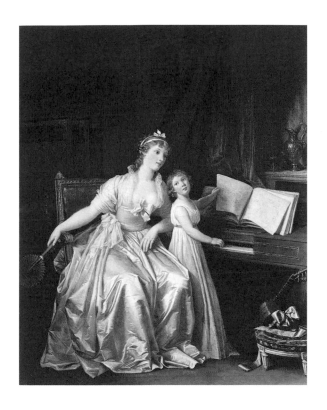

6. Marguerite Gérard, The Piano Lesson, 1785–87

Gérard excelled at painting small-scale sentimental scenes
of everyday life. Here, the devoted Enlightenment mother
has chosen to teach her daughter herself, rather than
delegate the task to a governess. The inclusion of the name
and address of the piano's maker and the date of its
construction are typical of the artist's attention to detail.

efforts on securing a suitable spouse. Without one she was destined to a life of dependency or penury. (The seemingly undignified scramble to find a husband in Austen's *Pride and Prejudice* (1813) is based on the premise that when Mr Bennet dies his daughters will be homeless.) Once married, she was under her husband's authority; she had no separate identity and everything she owned was his, including her children and the very clothes on her back. As Dr Johnson wryly observed: 'Nature has given women so much power that the law has very wisely given them little.'[17] (If the marriage foundered and the couple agreed to a separation – a rare event in itself – or divorced, which was virtually impossible, the wife not only had no say in the children's upbringing but was forbidden to see them.)

The middle- or upper-class woman, having spent her life thus far preparing herself to be a perfect wife, inevitably found there was little to occupy her time other than producing children and ensuring that the household staff carried out their duties efficiently. No sooner had she given birth than her babies were dispatched to a local wet-nurse (Elisabeth Vigée Le Brun (1755–1842) spent the first five years of her life with one). Once weaned and returned to the home, they were cared for by an army of minders. Thus relieved of all domestic responsibilities, and having spent at least an hour a day writing letters, another hour or two paying calls on her circle of acquaintances, she was free to fill her days with cultural pursuits. Some women neither needed nor wanted to settle to a life of quiet domesticity and virtue within the home.

But there, argued Rousseau, was exactly where she ought to be; it was her 'natural' place in the world. In his educational tract *Émile* he urged mothers to bring up their children as one might cultivate a tree. 'Tend and water it ere it dies. One day its fruit will reward your care. From the outset raise a wall round your child's soul...'[18]

Her 'care' should begin with suckling the child herself; she should then continue to be intimately involved in its upbringing.

From its publication in 1762, *Émile* exerted an increasingly powerful influence on society's attitudes to the family and the pivotal role that women should play in its welfare. For a woman who neglected her family duties for the attractions of the wider world, he had strong views: even if she possessed genuine talents, 'her pretentiousness would degrade them. Her honour is to be unknown; her glory is the respect of her husband; her joys the happiness of her family.'[19]

Where did such counsel leave a woman who refused to suppress her genuine talent and instead nurtured it, promoted it and earned money from it? According to Rousseau, she would have strayed a long way from her righteous path. Hannah More endorsed this view, maintaining that 'when a man of sense comes to marry, it is a companion whom he wants, and not an artist'.[20] The numerous examples of women artists who either never married or whose careers were cut short by their husbands illustrate the difficulties of trying to combine the two. For Sir Joshua Reynolds (1723–92) – admittedly a confirmed bachelor – attempting to do so was a great mistake, even for a man. 'Married!' he exclaimed to an aspiring young painter, 'Then you are ruined as an artist!'[21]

Whether married or single, a woman who wished to sell her work must be prepared to promote it in the marketplace, thereby exposing herself to what the philanthropist Priscilla Wakefield termed 'the public haunts of men' and thus beyond 'the most exact limits of modesty and decorum'.[22] Such behaviour made her as morally suspect as an actress or a courtesan. Writing to an actress friend, Denis Diderot, writer, critic and principal editor of the great *Encyclopédie*, cautions her to 'remember that a woman only earns the right to free herself from the limits public opinion assigns

to her sex through outstanding talents and through noteworthy qualities of heart and mind. One needs a thousand real virtues to offset an imagined vice.'[23]

It was not only artists who feared exposing themselves to the public eye. Fanny Burney wrote much of her first novel *Evelina* (1778) at night in order to escape detection by her family, only taking her brother into her confidence when she needed him to deliver the completed manuscript to a potential publisher. 'Nothing is so delicate as the reputation of a woman', she wrote in *Evelina*, 'it is at once the most beautiful and most brittle of all human things.'[24] The rules respecting her conduct were as constricting as her corsets.

If a woman proved herself to be not only a serious artist but a successful one, she risked incurring the rivalry of her male counterparts. Beauty, if she possessed it, might blunt the antagonism of some but others could turn it against her and charge her with exploiting her sexuality. While male artists could fornicate and philander with impunity, if the slightest whiff of impropriety attached itself to a woman's name it could fatally damage her career. As acknowledged beauties, Angelica Kauffman and Vigée Le Brun were both plagued throughout their careers by scandal and innuendo, and were constantly having to prove that their success was due to talent and hard work rather than their feminine charms.

When Angelica Kauffman moved from Italy to England in 1766 her name was already romantically linked – almost certainly erroneously – with Benjamin West and Nathaniel Dance, both of whom she had known during her time in Rome. 'Angelica was universally considered as a coquette', reported the writer and engraver J.T. Smith in his *Life of Nollekens*.[25] And within months of establishing herself in London it was rumoured that she had even caused Reynolds's old heart to flutter.

Despite numerous attempts to besmirch it, Vigée Le Brun

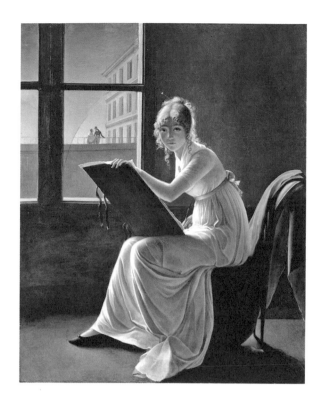

7. Marie-Denise Villers, *Portrait of a Young Woman called Charlotte du Val d'Ognes*, 1801

The quality of this remarkable life-size portrait is so exceptional that it was originally attributed to Jacques-Louis David, who is known to have been one of Villers' tutors. Now thought to be a self-portrait, the girl's intent gaze, and the oddly empty room with its cracked window-pane, make an arresting image.

managed to uphold a virtuous reputation, although it was badly dented when she was accused of receiving immoral earnings as the mistress of France's finance minister, Charles-Alexandre de Calonne, whose portrait she painted in 1785. Female portraitists were at risk whenever their sitters were male, the long hours spent closeted together inevitably giving rise to malicious gossip. To protect themselves, many women chose a family member to act as chaperone: Vigée Le Brun always painted with her mother in attendance, the Venetian pastelist Rosalba Carriera (1675–1757) chose her sister.

If possessing physical attractions required skilful manoeuvering and side-stepping, lacking them also had its disadvantages. According to Diderot, the Polish artist Anna Dorothea Therbusch (1721–82) failed to succeed in France because she was not attractive enough. 'It was not talent she lacked in order to create a big sensation in this country', he explained, 'it was youth, it was beauty, it was modesty, it was coquetry...', adding that it was also advisable to possess 'good breasts and buttocks, and [to] surrender oneself to one's teacher' — the exact meaning of 'surrender' left to the mind of the reader.[26]

One problem unique to women artists was the presumption that their work had been executed by a man. The higher the quality of the work the more likely it was to arouse suspicion. When the French portraitist Adélaïde Labille-Guiard (1749–1803) submitted some pastels for the first exhibition to be held by the Salon de la Correspondance, it was alleged that they had been touched up by her teacher and future husband, François-André Vincent. Labille-Guiard neatly silenced her critics by inviting prominent academicians to sit for their portraits and then allowing their subsequent testimony to disabuse her accusers.[27]

Vigée Le Brun was similarly accused of having her pictures

painted for her by a man. In her case, the finger of suspicion was directed at her artist friend François-Guillaume Ménageot. She stoutly denied these claims by pointing out to her critics that they need only compare her pictures with those of Ménageot's – which were being exhibited in the same room as hers at the French Académie Royale – to see that he 'had a manner of painting entirely opposite to my own'.[28]

Women artists had long suffered from their work being attributed to another, almost always male, painter. Today, extreme care is taken in attributing a painting to an artist, with the result that many museums have had to admit that a number of their swans have proved to be geese. (Of the twelve 'Rembrandts' purchased by the 2nd and 4th Marquesses of Hertford – the principal collectors for what became the Wallace Collection – only one is now attributed to the master.[29])

Paradoxically, these re-attributions have worked both in favour of women artists and against them. In 1922 the Metropolitan Museum of Art in New York bought a delightful painting of a young woman artist entitled *Mademoiselle Charlotte du Val d'Ognes*. As it was believed to be by Jacques-Louis David, they paid a hefty price for it. Some thirty years later the art historian Charles Sterling proved conclusively that it could not be by David and instead attributed it to Constance Marie Charpentier (1767–1849), a French artist known for her portraits and genre scenes. Twentieth-century scholarship can be a double-edged sword for the art world: the fact that one of the Museum's most popular portraits had turned out to be by a woman knocked thousands off its value while at the same time gaining recognition for the little-known Charpentier. However, the story does not end there: since then, the painting has been re-attributed, this time to another female painter, Marie-Denise Villers (1774–1821), and is now called *Young Woman*

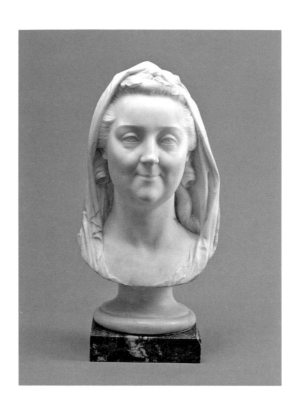

8. Marie-Anne Collot, *Catherine the Great*, 1771

During the fifteen years that Collot spent in Russia as assistant to
Étienne-Maurice Falconet she was also official portrait sculptor to
Catherine II. This is one of three known portrait busts she executed
of the Empress. She always worked broadly and simply, relying
on a few carefully observed features to capture the likeness.

called Charlotte du Val d'Ognes. Yet, even now, the Museum would not like to claim that the attribution is absolutely definite.[30]

Proof that Marie-Anne Collot (1748–1821) was an accomplished sculptor in her own right came from an unexpected and illustrious source: no less a personage than Catherine, Empress of Russia. Mlle Collot had spent twelve years working at the Russian court as assistant to the French sculptor Étienne-Maurice Falconet (1716–1791). Apart from modelling the head of the massive equestrian statue of Peter the Great, commissioned by the Empress, she had produced numerous medals and portrait busts for members of the court. When she returned to Paris for a year, she took with her examples of her work. Falconet wrote to the Empress: 'It is to your protection, to your encouraging generosity that she owes the praises that she vainly desired in a country [France] where everyone believed I did her work. They have seen her model and they have believed it.'[31]

Miss Collot's ambition for her talent to be recognised would be seen by polite society as pretentious or – even worse – bold. 'Of the few who have raised themselves to pre-eminence', warned the author and philanthropist Priscilla Wakefield, 'by daring to stray beyond the accustomed path, the envy of their own sex, and the jealousy and contempt of the other, have too often been the attendants...'[32]

When judging a woman's work, men found it hard, if not impossible, to judge it objectively: either it displayed all the faults or qualities they expected of her sex or, if the painting impressed them, they promptly declared that she painted like a man. Anna Jameson, the first writer to define herself as a specialist in the history of art, believed that there *was* indeed a difference between male and female art: 'I wish to combat in every way that oft-repeated but most false compliment unthinkingly paid to women,

that genius has no sex; there may be equality of power, but in its quality and application there will be and must be, difference and distinction.'[33]

Despite living in a world dominated by men, and by laws and customs designed to keep them in their place, and despite incurring 'jealousy and contempt', a remarkable number of women were sufficiently obsessive, their self-motivation so compelling that they were able to overcome such obstacles and make successful careers as professional artists. The most disabling of these obstacles was their inability to obtain proper training.

2

Training

I cannot help looking on myself as a creature in a very odd situation;
'tis true we are all but strangers and pilgrims in this world, and
I ought not to think myself more so than others, but my unlucky
sex lays me under inconveniences which cause these reflections.

CATHERINE READ TO HER BROTHER, EARLY 1752[1]

Read's letter to her eldest brother demonstrates that while she had already achieved considerable success as a portraitist she still felt that as a woman she was condemned to labour under 'inconveniences' that impeded the progress of her career. Her greatest difficulty was her lack of proper training since eighteenth-century art schools did not accept women students.

This fact alone explains why women who became successful artists were — with few exceptions — the daughters of either craftsmen or painters. Growing up in an artistic household a young girl could hardly fail to assimilate the basic techniques of a parent's trade or profession. The still-life painter, Anne Vallayer-Coster (1744–1818), was taught to paint by her father, a goldsmith and tapestry designer at the Gobelins factory. The same applied to Angelica Kauffman, whose father was a journeyman painter and portraitist.

The English painter Rolinda Sharples (though strictly an early nineteenth-century artist) perfectly illustrates the advantages of being born into an artistic family: both her parents and her three brothers all pursued careers in art. In a self-portrait, painted around 1820, Sharples pays tribute to her mother's encouragement and devoted teaching by showing her hovering beside her as she paints.

Elisabeth Vigée Le Brun was yet another artist who was supported and encouraged by her parents: her father, a pastel portraitist, allowed her into his studio and introduced her to his artist friends who in turn instructed her, while her mother allowed her to paint her semi-nude, a concession of inestimable worth as women were prohibited from studying the nude model, male or female. Since drawing from life was the key to understanding and portraying the human figure accurately, this embargo had a fundamental effect on what kind of pictures a woman chose to paint. Few women, for example, felt qualified to tackle history painting – the representation of scenes from classical or national history or the Bible – as such subjects often required multi-figured compositions. And as history painting was then regarded as the most prestigious of all the genres, women were fatally handicapped from the start and could not be taken seriously as artists. In 1971 the art historian Linda Nochlin wrote a controversial but seminal essay entitled 'Why Have There Been No Great Women Artists?'[2] The reason, she concluded, was their inability to get proper training at art academies until the nineteenth century.

From the mid-seventeenth century, art schools and academies began to replace the earlier craft-based training supplied by artists' workshops. The Accademia di San Luca was founded in Rome in 1577, the Académie Royale in Paris in 1648. The only painting academy in London at this date was the school in St Martin's Lane,

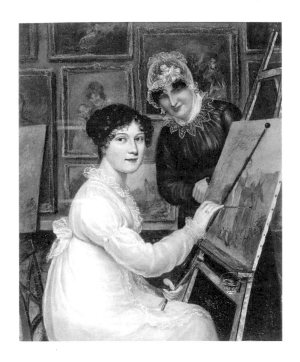

9. Rolinda Sharples, *Self-portrait with her Mother, c.* 1820
Sharples was fortunate to be born into a family of craftsmen
and painters. Her father, a pastel portraitist, taught her to paint
but it was principally her mother's teaching and encouragement
that helped her to forge a successful career as one of the
few working women artists in England. This double portrait
pays tribute to her mother's invaluable support.

which later merged with the Royal Academy on its foundation in 1768. Teaching at these academies was based on Renaissance practices, the male pupils drawing from plaster casts of classical statues and from live models. They were also taught perspective and human anatomy. Dr William Hunter, the Royal Academy's first Professor of Anatomy, famously lectured his students using dissections of criminals hanged at Tyburn which had been flayed to show the structure of the muscles.[3] (The muscles of one of the criminals, said to be a smuggler, were so impressive that a plaster cast was made of the body, positioned in the attitude of the Roman sculpture known as the 'Dying Gaul'. Nicknamed Smugglerius, a later copy of it is still being drawn by students in the Royal Academy Schools to this day.[4])

Female models were available to male students (and, surprisingly, paid more than their male counterparts) in the Royal Academy Schools, except to unmarried students under the age of twenty, presumably on the grounds that the contemplation of so much naked flesh would disturb their concentration. Even the plaster casts on display at the Academy provoked a storm of protest, a shocked visitor begging Reynolds (the Academy's first President) to remove them as they were 'the terror of every decent woman who enters the Antique Room'.[5] (Bowing to public pressure, in 1780 it was decreed that during the annual exhibition, fig leaves would be attached to the genitalia of the male statuary.[6]) The Americans were equally sensitive about representations of the female nude: when the painter Robert Edge Pine left England to settle in Philadelphia, he took with him several examples of art of different periods, including a cast of the Venus de Milo. According to the American artist William Dunlap, 'This cast Pine was obliged to keep shut up in a case which was only opened to oblige those who were particularly desirous of seeing the Venus,' adding in expla-

nation: 'The manners of our country would not then tolerate the public exhibition of such a figure.'[7]

Banned from attending life classes, women were only able to learn human anatomy by copying Old Masters and classical statues. (The Royal Academy's ban continued until after 1893, when the partially-draped figure was at last permitted in female life classes.) There is some evidence that a few women contrived to circumvent the ruling, presumably by hiring their own models, but they would have risked their good name if caught. There are several drawings of male and female nudes by the Venetian artist Giulia Lama (1681–1747), which are so alive, the poses so unlike those of classical statues, that it seems impossible they were not done from life. As Lama specialised in religious scenes and altarpieces, knowledge of human anatomy would have been essential, especially for depictions of the Crucifixion. The French artist Pauline Auzou (1775–1835) also executed drawings of male and female nudes, but whether they were done from life is not known. She was sufficiently daring to exhibit a half naked female *Bacchante* at the Salon of 1783.

Angelica Kauffman, one of the few women to make her name as a history painter, would have felt the same need to understand human anatomy. During the fifteen years she spent in London, she allegedly caused an uproar by studying 'an exposed male living model', and a drawing by her of a young male model, naked from the waist up, is in the possession of the British Museum. Years later, the model concerned was questioned on the subject but insisted that not only had he been half clothed but that Angelica's father had been present throughout.[8] As further proof of women's fear of being accused of impropriety if they drew from life, one of Angelica's surviving sketchbooks includes drawings of male torsos copied from antique casts which entirely omit the genitalia.

No such fear inhibited the Prussian artist Anna Dorothea

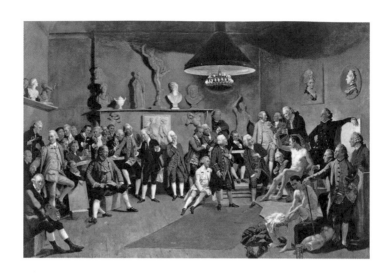

10. Johann Zoffany, *The Academicians*
of the Royal Academy, 1771–72
Zoffany's famous painting shows thirty-eight of
the forty founding members of the Academy attending
the Academy's life class. The other two founders, Angelica
Kauffman and Mary Moser, were unable, on grounds of
decency, to attend a life class in person, so the artist has
depicted them as unfinished portraits on the wall.

Therbusch when Denis Diderot sat for his portrait. Having completed the head, she began on his neck but was annoyed by his collar obscuring her view. 'To stop her being irritated', Diderot recounted, 'I went behind a curtain, undressed and appeared before her like an academy model ... I was naked, stark naked. She painted me, and we chatted with a simplicity and an innocence worthy of primeval times.' But, he adds: 'Since, given the sin of Adam, one cannot control all the parts of one's body as one does one's arm, and there are parts that want to do things when the son of Adam doesn't want to, and don't want to do things when the son of Adam does...'[9]

According to Laura Auricchio, author of a recent book on Adélaïde Labille-Guiard, new scholarship shows that the artist attended classes in the private studios of male Academicians, although not one herself until elected in 1783. In a letter of 1775 the Comte d'Angiviller, France's arts minister, complained that the Académie Royale was breaking the rules by allowing the academicians to study from live male models, but more specifically he criticised 'the entrée given to girls or women artists in these private schools, to draw after the nude model', declaring that 'This is essentially a moral concern.'[10] This is further proof that some determined women, with the right contacts, could achieve what they wanted.

Throughout the eighteenth century, the attitude of official academies towards electing women members was hesitant and contradictory. The Académie Royale admitted a handful of women in the late seventeenth century, but a statement from one of their debates in 1770 illustrates their lack of conviction: 'These admissions [of women to the Académie], foreign in some ways to its constitution, must not be allowed to become too numerous.'[11] Apart from a very few exceptions – the Italian artist Rosalba Carriera

became a member during her visit to Paris in 1720 – no French female artist was elected until 1757. The regional academies in France, however, had a more permissive attitude: by 1755 the Académie at Toulouse had no fewer than thirty female students.[12]

When the Royal Academy was established in London, two women were elected as founder members, Angelica Kauffman and the flower painter Mary Moser (1744–1819). (Apparently, the latter's submission piece was 'a sublime picture of a plate of gooseberries'.[13]) Yet they could not attend its schools, nor could they enjoy any of the privileges available to male members. This ambivalence towards women is vividly illustrated by Johann Zoffany's painting of *The Academicians of the Royal Academy*: Kauffman and Moser are indeed represented but only by their portraits which are relegated to the top right of the picture. For them to have been represented in the flesh, as it were, during a life class with a naked male model would have been unthinkable.

Some women went to considerable lengths to learn their craft. Catherine Read travelled to Paris where she somehow managed to gain access to the studio of Maurice Quentin de la Tour, an eccentric and irascible man but a gifted teacher, who instructed her in the art of the pastel portrait. She then travelled – on her own, aged twenty-seven – to Rome to study oil painting. A letter to her brother stresses the importance to her of this training: 'I have staid [sic] one year in Rome for Improvement, I must certainly stay in it another for Name, and then you'll see I'll top it with the best of them.'[14] The Scotsman Abbé Grant, a Jesuit priest who became something of an institution in Rome, took Read under his wing. Reporting her progress to her brother, he confirmed her 'very great talent' in pastels, but added that 'were it not for the restrictions her sex obliges her to be under, I dare safely say she would shine wonderfully in history painting too, but as it is impossible

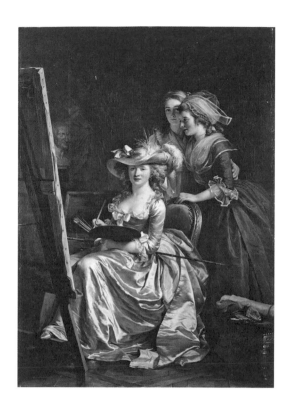

11. Adélaïde Labille-Guiard, *Self-portrait with Two Pupils*, 1785
In the latter half of the century a number of professional women
artists took on female pupils. Some, like Vigée Le Brun, taught
to make money, but Labille-Guiard did so out of conviction that
she was furthering the careers of her pupils. In the crisis years
following the Revolution, she rashly – and vainly – petitioned
the Académie Royale to accept more female members.

for her to attend public academies or even design or draw from nature, she is determined to confine herself to portraits...'[15]

One of the 'restrictions' faced by Read was the refusal by the Italian art collections to allow women to study their paintings. Yet such constraints must have been relaxed as within ten years Kauffman was copying paintings in Milan, Florence and Rome. Evidence that this practice had become commonplace by the end of the century appears in paintings by Hubert Robert which show women sketching in the Louvre. Vigée Le Brun went one better as she managed to gain access to some private collections in Paris: 'As soon as I entered these great galleries', she recorded in her *Memoirs*, 'I behaved just like a bee, gathering knowledge and ideas that I might apply to my own art.'[16] In London the Duke of Richmond and the distinguished collector of antiquities, Charles Townley, allowed artists access to their houses where they could copy their sculpture collections.

Some parents, when faced with a daughter who not only possessed a precocious natural talent but was passionate about pursuing art, accepted the inevitable: instead of grooming her for marriage, they paid for her to receive private tuition. Vigée Le Brun recorded in her *Memoirs* that during her years at the convent she 'was always sketching, covering every available surface with my drawings ...' She even drew on the dormitory walls, in her exercise books and in those of her classmates — for which she was 'often punished'.[17] Labille-Guiard, the daughter of a successful haberdasher, was taught the art of miniature by a friend of her father's, François-Élie Vincent. She was also another of Quentin de la Tour's pupils and later studied oil painting with Vincent's son and, it would appear, received further training in the private studios of male Academicians. Anne Vallayer-Coster was said to have been taught drawing by the botanical artist Madeleine Basseporte and painting

by the great landscape painter Joseph Vernet. Both girls had benefited from growing up in artistic communities: Vallayer-Coster among the artists and craftsmen working with her father at the Gobelins factory, and Labille-Guiard in a street which was home to numerous professional artists and close to the Louvre where members of the Académie Royale had free lodgings.

For the sculptor Anne Seymour Damer (1748–1828), born into a world of wealth and privilege, money was no object. Her parents, recognising her talent, arranged tuition with two well-known sculptors, Giuseppe Ceracchi and John Bacon the Elder, and she was taught anatomy by a leading obstetrician, Dr William Cruikshank. What is remarkable about Damer's story is that she turned her back on a life of aristocratic ease and chose to pursue a career in the least feminine and most physically demanding of the arts, a choice that exposed her to hostility, ridicule and abuse.

For artists whose parents were unable or unwilling to pay for private tuition, other methods had to be found. The Scottish artist Anne Forbes (1745–1834) was financed by a group of businessmen in Edinburgh who paid for her to study in Italy for a period of three years in the hope that she would then establish herself as a portraitist in London and so earn enough money to support her family. Gainsborough taught his two daughters himself for the same reason: their earnings as professional artists would make up for the money he could not afford to give them.

Encounters at an early age with already established artists could have a long-term influence on a young girl embarking on an artistic career. Vigée Le Brun records in her *Memoirs* the advice given to her by Joseph Vernet: 'My child, do not follow any school of painting. Look only to the old Italian and Flemish masters; but above all, draw as much as you can from nature, nature is the greatest teacher of all. Study her carefully and you will avoid falling

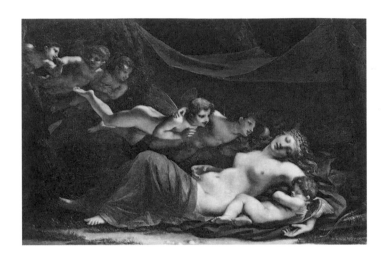

12. Constance Mayer, *The Sleep of Venus and Cupid*, 1806
Prud'hon, Mayer's principal teacher, provided the initial ideas
for the painting's composition, thus giving rise to criticism that
her work was a copy of his. The painting, and its pendant
The Torch of Venus, were acquired by the Empress Joséphine
and hung in her gallery at Malmaison until her death
in 1814. The painting's subject is highly unusual.

into mannerisms.'[18] While travelling with her father in Italy, Angelica Kauffman became acquainted with Benjamin West, Gavin Hamilton and Nathaniel Dance, all artists whose works are exemplars of early Neoclassicism. (Dance, said to possess 'a handsome person and a fine leg', reputedly fell in love with her.[19]) Her growing interest in the classical past was deepened by her friendship with the antiquarian Johann Winckelman, an authority on Greek and Roman sculpture, who sat for her in Rome in 1764.

Throughout the eighteenth century, Italy, with its antiquities, ancient cities and fabulous art collections, was a Mecca for European visitors and an essential learning experience for those artists who could afford to travel. In the course of their studies they met aristocratic Grand Tourists with deep purses and vast mansions, which they sought to adorn with art bought on the Continent. The wealthiest tourists bought works by the Italian masters, then considered to be the apogee of art, but others commissioned work by contemporary artists who were already making a name for themselves, among them Angelica Kauffman and Elisabeth Vigée Le Brun. Some of the English tourists encountered by Kauffman later became patrons of her work when she established herself in London in 1766.

Many of the Grand Tourists visiting Florence stayed at Carlo's, an inn owned and run by a convivial Englishman, Charles Hadfield. One of his daughters, Maria (who later married the English artist Richard Cosway), showed such artistic talent that her father paid for her to receive private tuition. Unusually, her first teacher was a woman, the artist Violante Cerroti, a member of the Florence Academy. Maria Cosway (1759–1838) was also tutored by Zoffany who advised her that the best way to learn was to copy the finest paintings in the Pitti and Uffizi, two galleries that were, almost literally, on her doorstep. On a visit to Rome, Maria mixed with

important artists like Reynolds, Kauffman and Fuseli, all of whom were to influence her style of painting and choice of subject matter.

Bowing to pressure from an increasing number of women seeking tuition, a few French academicians began to take female pupils. Jacques-Louis David, France's most prominent and influential painter of the Neoclassical movement, had been teaching male students since about 1781, but he also set up a separate studio in the Louvre to enable him to teach women – an innovation for which he was severely reprimanded by the Louvre authorities. David responded that the women were not only segregated from his male students but that their morals were 'beyond reproach', adding 'I myself have too much self-respect to keep them for an instant if their conduct were otherwise.'[20] Despite his protestations, it appears that David was obliged to close his studio to women soon after this clash with the Louvre authorities, but not before he agreed to take on some pupils who had been studying with Elisabeth Vigée Le Brun.

In her *Memoirs* Vigée Le Brun maintains that she had only accepted female pupils at the insistence of her husband in order to increase their income. Despite being 'overwhelmed with commissions', she had acceded to her husband's demand without properly considering the consequences and 'soon the house was full of young ladies learning how to paint eyes, noses and faces. I was constantly correcting their efforts and was thus distracted from my own work which I found very irritating indeed.'[21]

In the latter half of the century several professional women artists took on female students, either through conviction or because they needed to supplement their income. The most prominent among them was Adélaïde Labille-Guiard. In 1785 she demonstrated her commitment to teaching women in a huge, flamboyant self-portrait in which she appears improbably arrayed in mounds

of billowing satin, seated at her easel, brush in hand and palette poised, surrounded by the clutter of a busy working studio. Standing behind her, peering over the feathers of her fashionable hat, are two young girls, Marie-Gabrielle Capet and Carreaux de Rosemond. Little is known about the latter but Mlle Capet (1761–1817), the gifted daughter of a domestic servant, was taken on by Labille-Guiard in 1781, lived in her household and remained with her until the artist's death in 1803. Labille-Guiard's patronage and teaching transformed Capet's life and she became one of the most distinguished miniature portraitists of her day. In 1808 she paid tribute to her mentor in a painting which shows a studio crowded with onlookers watching Labille-Guiard, seated at her easel, painting a portrait. Capet herself is preparing the artist's palette.

Labille-Guiard's championing of women artists was frowned on in some quarters: when she applied to the Louvre for lodgings, she was refused on the grounds that she taught female students and 'no-one wanted the Galleries du Louvre to be overrun by young girls'.[22] The first woman to be allocated lodgings within its hallowed walls was Anne Vallayer-Coster, but then only because her most prestigious patron, Queen Marie Antoinette, interceded on her behalf. (She and the other artists in the Louvre lost their apartments in 1806 because their smoking chimneys irritated Napoleon.[23])

Pupils who developed a close working relationship with their teachers could struggle to develop their own style and identity. The French artist Constance Mayer (1775–1821) was first taught by Jean Baptiste Greuze, famous for his sentimental genre scenes, then briefly by David. But as a result of her long association with Pierre-Paul Prud'hon — as student, collaborator and lover — it was often impossible to distinguish her work from his. Many of her pictures were sold as Prud'hons, and even today a correct attribution can

be difficult. A painting, *The Awakening of Psyche*, exhibited by her in the Salon of 1808, was originally sold as a Mayer, but later brought at a much higher price as a Prud'hon. Today it is in the Wallace Collection, London, now entitled *The Sleep of Venus and Cupid* and firmly credited to Mayer.[24] Marguerite Gérard (1761–1837) was another whose work was frequently eclipsed by her teacher and brother-in-law, Jean-Honoré Fragonard. A painting entitled *The Reader* was always presumed to be by the master, but it is now thought that, of the two figures in the picture, only one is by him, the other by Gérard.

Thus, by whatever method they attempted to learn their craft, the most assiduous, talented and determined women artists could not escape the restrictions placed upon them by the male art establishment – particularly the taboo against drawing from life. The German writer, Helfrich Peter Sturz, when appraising the art of Angelica Kauffman, comes to the same conclusion: though he stressed that her work contained 'touches of beauty', that her 'forms were full of grace' and her female figures exhibited an 'inimitable womanliness', he regretted her inability to 'draw altogether correctly ... even in her individual figures she dare not venture difficult poses or any foreshortening; she is uncertain and fearful in her anatomies...'[25]

In his polite way, Sturz has put his finger on Kauffman's problem, one she shared with every other woman artist in the eighteenth century: she had never received a thorough training. There were no art academies for women until the mid-nineteenth century, and even then a student had to be wealthy enough to pay for her tuition. Forbidden by social convention to study the nude human figure, a female artist was reduced to copying classical sculpture or paintings in art galleries – many of which did not give women permission to do so. Thus her knowledge of human anatomy was

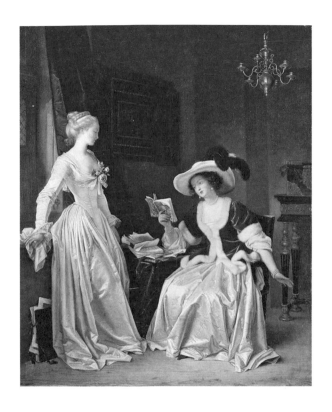

13. Marguerite Gérard and Jean-Honoré Fragonard, *The Reader*, 1806
Scholars, connoisseurs and art dealers tended to assume that able
women artists had received help from their male teachers. Gérard was no
exception: several of her paintings were credited to her tutor and brother-
in-law Jean-Honoré Fragonard. This painting is now thought to be by
both artists, the standing figure by Fragonard, the other by Gérard.

limited to polished marble and the stylised figures in Old Masters. The living, breathing human form remained a mystery to her.

But such impediments did not deter those women who were determined to become painters. Their first essential step was to set up a studio.

3
The artist's studio

I have four rooms, one in white in which I paint, the other where
I set up my finished paintings as is here the custom [so that] the people
[can] come into the house to sit — to visit me — or to see my work;
I could not possibly receive people in a poorly furnished house.

LETTER FROM ANGELICA KAUFFMAN TO HER FATHER, 1766[1]

Angelica Kauffman's letter to her father, written the year she
arrived in London from Italy, describes the studio she had taken
in a house in Charing Cross Road, and stresses the importance of
occupying premises in a part of town which would attract the pres-
tigious clientele required to succeed as a portrait painter. The area
had other attractions: it was a few streets from the grand premises
of her friend Joshua Reynolds in Leicester Fields, and a brisk
ten-minute walk from Covent Garden, then one of the most popular
haunts of painters. Leicester Fields (now Leicester Square) and
Soho were also home to many of the artisans and craftsmen who
were essential to the conduct of an artist's profession, such as
framers, restorers, engravers, colourmen and gilders.

Not only had the studio – or painting room as they were known
– to be in a fashionable area, but it should be furnished in such a

manner that clients felt at ease in their surroundings and not as
if they were slumming it. Judging by a comment in Maria Cosway's
diary in 1802, Elisabeth Vigée Le Brun's studio in Paris fulfilled
all these criteria: 'What a beautiful house!' she exclaims, 'What
studios! What magnificence!'[2] But setting up such a studio was a
risky and expensive undertaking: a friend of Maria's cautioned
her that 'most of the young painters launch out on their first setting
off – and few or any of them have sufficient business to do it with'.[3]

As Kauffman explains to her father, her premises included a
room where she could display her paintings – a great asset at a time
when public galleries barely existed — where prospective clients
could appraise her style and perhaps select a pose they thought
appropriate for their own portrait. (Reynolds kept a portfolio of
engravings of past portraits in his gallery for just this purpose.) A
visitor to Benjamin West's studio records that he was 'conducted
down a long Gallery furnished with drawings, into a large square
Room lighted from the Roof and filled with paintings'.[4] These
galleries were often littered with portraits that had been left on
the artist's hands for various reasons: the death of the sitter, a
family quarrel, a client's inability to pay or those that had failed
to please either the client or the artist. Discarded mistresses were
another hazard for a portraitist: Romney's biographer notes that
'a *chère amie* having been brought to sit for her portrait, both she
and the picture were deserted before the latter was finished'.[5]

In the days before gas and electricity, lighting the studio was a
constant problem for artists working in the northern hemisphere.
According to an instruction manual of 1720, 'the light must be
fair and as it were composed, not broad and scattering, but collected,
free from the Shadows of Trees or Houses, all clear sky light; let
it be Northerly, not Southerly, the which is most steadfast, less
varying, and serenely free from sun-beams'.[6] Sunbeams were

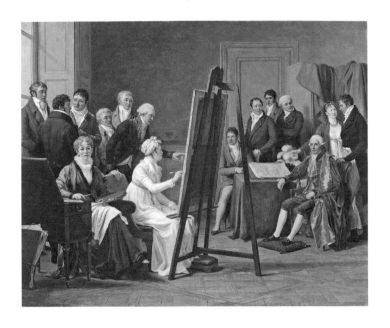

14. Marie-Gabrielle Capet, *Studio Interior,* **1808**
A fashionable portraitist's studio was not just a working
space but also a rendezvous for friends and relatives,
the curious and the idle. This painting is Capet's homage
to her teacher, Labille-Guiard, who is seated at her
easel while Capet prepares her palette. Labille-Guiard's
husband is standing just behind her.

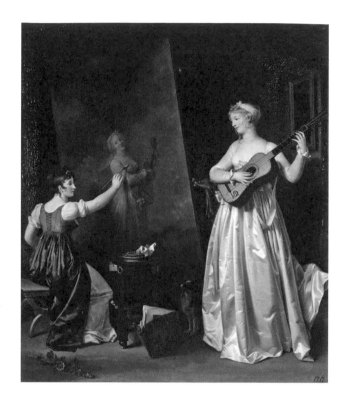

15. Marguerite Gérard, *Artist Painting
a Portrait of a Musician*, 1803

Paintings by women showing female artists at work
are surprisingly rare. Here Gérard has reduced the
normal clutter of a studio to a small table loaded with
her paints, paint rag and a portfolio overflowing with
drawings. It has been suggested that the artist working
on the huge, tilted canvas may be a self-portrait.

scarcely a problem in London, especially during the winter months when it could be dark by 3 pm, or when the city was shrouded by a thick cloud caused by the burning of coal in hundreds of homes. Anne Forbes's mother, writing to her daughter's Scottish backers, described the fogs as having 'been so thick for many days past that in the streets people could not see above 3 or so yards round them and many poor folks have been run over and kill'd with carts and coaches'.[7]

Artificial light – which many artists preferred as it was far more stable than the shifting moods of natural light – was supplied by candles, but good beeswax ones were expensive while the cheaper tallow candles guttered and smoked and were extremely smelly. The artist Ozias Humphry reported that Gainsborough's portraits 'were frequently wrought by candlelight' and that 'his painting room even by day a kind of darkened twilight – had scarcely any light, and I have seen him, whilst his subjects have been sitting to him, when neither they nor the pictures were scarcely discernible'.[8]

Keeping the studio warm was another expense for artists: holding a brush steady required warm hands. A young artist recounts that it was so cold in her studio that 'until she had stitched a piece of velvet round her portecrayon she could not hold it'.[9] For portrait painters it was vital that their grand clients did not freeze to death during the sitting. Large stoves can be seen in many images of artists' studios and art schools of the period. They were safer than open fires due to the inflammability of artists' materials. Reynolds once caused a blaze in his studio by carelessly flinging spirits of turpentine into the fireplace, which required an expensive visit from the local fire engine.[10]

The studio equipment included not only the usual paraphernalia necessary to an artist, but also plaster casts of classical statues and often a 'props' cupboard, which contained an assortment of

clothes, pieces of fabric, hats, the odd sword, perhaps a broken violin and other useful accessories. One of Reynolds's 'props' was a pet macaw, which flew freely about the house and studio. This bird hated the cook, who had 'ill-used it'. When Reynolds's assistant, Northcote, painted the cook's portrait, the bird 'flew over to it with the utmost fury and bit at the hands and face, when he found he could not get hold of it he looked so very cunning, and went to the side and back to examine it.'[11]

Many of the plaster casts of antiquities that were used in eighteenth-century studios had been bought in Italy from a man called Papera 'who ... carried the new things round to the artists in baskets' or were purchased from 'the boys at Luca, who at that time exhibited them for sale at fairs'.[12] Then there was the sitter's chair which was usually placed on a dais in order to raise the sitter above the artist. The one used by Richard Cosway – a splendid rococo object, covered in scarlet damask – was imposing enough for his most prestigious clients and appears in several of his portraits.[13] A large mirror was another useful studio tool. Vigée Le Brun advised her niece: 'You should also have a mirror positioned behind you so that you can see both the model and your painting at the same time ... it is the best guide and will show up faults clearly.'[14] It also enabled the sitter to watch the portrait's progress.

The part of a portrait that was most time-consuming for an artist was painting the sitter's clothes. The fashionable attire of a lady of quality required hours of careful work to capture the shimmering folds of silk, satin or brocade, the intricacies of lace, the softness of an ermine cape or the curling ostrich feathers and ribbons on an elaborate hat. The men's attire was not much better since clients often chose to be painted in uniform. Thus the artist was confronted by great swathes of scarlet, complex frogging, medals, the hilt of a gilded sword and the labyrinthine folds of a

gorget. To save time, many portraitists just painted their sitter's face and hands; the rest of the painting – the drapery, 'attributes' and background – was completed by a studio assistant or sent out to a drapery-painter. That artists routinely employed the latter clearly came as a surprise to Lord Bath who told a friend that while visiting Reynolds to arrange a sitting he had 'discovered a secret ... that I fancy, he is sorry I should know. I find that none of these great Painters finish any of their Pictures themselves.'[15] Reynolds once famously painted 'a fierce cocked hat' on one of his sitters, dispatched it to the drapery-painter who later returned it having painted a standard posture which included a second hat under the sitter's arm.[16]

Artists who could not afford to employ a drapery painter, or who preferred to paint the clothes themselves, might use a lay figure – or mannequin – on which they arranged the garments selected by the sitter. These figures could be either a few inches high or life-sized, with flexible, jointed limbs. Anne Forbes, in a letter unrelieved by much punctuation, describes setting up a lay figure:

> The case is this to paint a drapery I must have it put whatever it is, gentleman's coat or lady's gown, upon a wooden figure which is set in the place where the person sat and is put in the same attitude they were in which figure must not be moved nor one fold of the drapery altered till the whole is finished which is always the work of several days indeed I may say weeks when it is a half length picture.[17]

From her description, it is not surprising that at one stage during the year she practised as a portrait painter in London she had completed the heads on thirteen portraits but had yet to paint the drapery on any of them.[18]

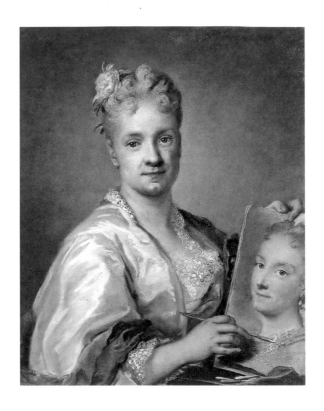

16. Rosalba Carriera, *Self-portrait,*
Holding a Portrait of her Sister, 1715

Although Carriera became one of the century's most
celebrated pastellists, she acquired her skills as an artist
not with any formal training but by learning to design
lace from her mother, who was a lace-maker. She
graduated to decorating snuffboxes, then to miniature
painting. In this double portrait, she pays tribute to her
sister Giovanna, who acted as her studio assistant.

Arranging the drapery over the mannequin required great skill in order to prevent the rigidity of the limbs from affecting the 'natural' fall of the fabric. The critic Anthony Pasquin (a pseudonym for John Williams) was critical of Angelica Kauffman's draperies, maintaining they had 'been copied from the old expedient of the French school, which is to clothe the lay figure with damp brown paper; but this measure is wrong, as it makes the folds too numerous, and too abrupt, and wholly dissimilar to what would be produced by any species of linen...'[19] Apart from the French artist Marguerite Gérard, there appears to be no evidence that any other female artist used a drapery painter.

The majority of successful portrait painters employed one or more assistants, young men who combined learning from the master with carrying out the many tasks associated with the running of a busy studio. These tasks included replenishing the stock of the artist's materials, returning a sitter's clothes which had been borrowed for copying, and arranging the frequent comings and goings of the finished portrait – to the engraver, the gilder, the framer – and finally ensuring that it was safely delivered to the client. For a particularly important commission, the finished portrait would be crated up and sent by coach, accompanied by a chaperone or minder. Some portraits went a great deal further afield: 'Mr. Fitch's Picture to be put in a proper case & packed to go to Jamaica the lid to be slightly screwed on – and sent to Mess. Maitland, Coleman St,' who were presumably responsible for shipping it.[20]

Artists themselves were usually responsible for arranging the sittings and for maintaining a sitters' book. Clients frequently cancelled sittings, changed their minds or forgot to turn up, and as no contracts appear to have been drawn up between artist and client, the sitters' book was the artist's only proof in the event of a

dispute.[21] A page from Reynolds's pocketbook of 1761 shows that he worked every day but Sunday and was receiving four or five sitters a day. Reynolds was as meticulous about his sitters' book as he was about every other aspect of running his studio. Had it not been for his ability to run his business efficiently, it is doubtful that his skill alone would have been enough to keep him at the very peak of his profession.[22]

The mixing of colours — grinding the natural pigments and combining them with various media — was another task usually carried out by assistants. Fortunately for women artists, by mid-century this laborious and messy process was no longer necessary as colours could be bought ready mixed from a colourman. The colours were kept in strips of bladder, tied at the neck like miniature suet puddings, which could be pierced with a sharp tack, the paint squeezed out and the bladder resealed again with the tack.[23] The metal tubes in use today were not available until 1841, invented by an American portrait painter living in London.[24] (Watercolour 'cakes' were developed earlier, in 1780.) Colourmen also supplied pencils, paper and prepared canvases stretched to standard sizes.

Some of the colours were very expensive, especially vermilion and ultramarine, the latter because it was made from lapis lazuli, a semi-precious gemstone then found only in Afghanistan. However, by the mid-eighteenth century, Prussian blue — a synthetic pigment — was discovered and immediately became popular with artists throughout Europe as it was far cheaper than ultramarine. Some pigments came from surprising sources: sepia was made from cuttle fish; purple from the shell of murex sea snails found in the Mediterranean; and 'Indian yellow from the urine of Indian cows that had been fed on mango leaves and then deprived of water'.[25] The colours had to be arranged, or 'set' on the palette in a precise order, one that changed very little during the course of the century.

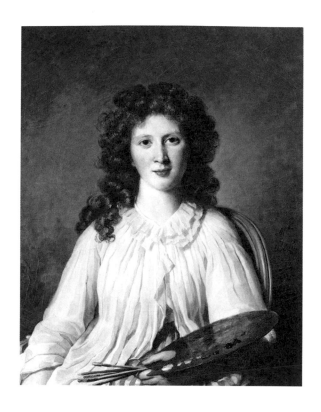

17. Marie-Geneviève Bouliar, *Adélaïde Binart*, 1796
Forever alert to their public image, few women artists
portrayed themselves in working clothes. This portrait is
unusual in that it shows Binart, wife of the painter and
archaeologist Alexandre Lenoir, dressed in an artist's
smock. A striped silk gown is just visible beneath it.

For a woman, employing assistants was problematic: having young men in her studio would have been thought improper, while trained girls were hard to find. Gossip had it that Anne Damer was helped by assistants: a certain Mr Smith claimed that he had 'carved most of her busts for her',[26] but it was normal practice for male sculptors to employ others to do the heavy, preliminary work on a marble sculpture. Rosalba Carriera avoided gossip by training her sister Giovanna to run her studio, to complete the drapery and to make copies of Rosalba's finished pastel portraits. In a wonderfully candid self-portrait, Carriera pays tribute to Giovanna by showing herself holding her sister's portrait. The seventeenth-century artist, Mary Beale, was lucky enough to have a husband who ran her studio for her, leaving her free to paint the portraits that earned the family's income.

Exactly what a woman artist wore when she settled to work is something of a mystery. It is scarcely credible that she arrayed herself like Adélaïde Labille-Guiard in her *Self-portrait with Two Pupils*; the relatively simple gowns worn by the two girls are a more likely form of dress. But women artists constantly had to safeguard the image they presented to the world. When they depicted themselves as working artists – holding a brush and palette – they tended to emphasise their charm and femininity, not their profession. Failing to achieve this delicate balance could result in the sort of scathing comment made by Fanny Burney following a visit to Catherine Read's studio: '... she dresses in a style the most strange and queer that can be conceived and which is worst of all, is always very dirty'.[27]

Elisabeth Vigée Le Brun was adept at promoting herself as a woman first, an artist second. In her best known self-portrait (in the National Gallery) she is sweetly pretty in ruffles and lace, her lips parted in a dewy smile. But in another self-portrait she wears what could be working dress – a simple gown, her hair bound up

in a white scarf. In her *Memoirs* she records that on one occasion, when expecting two smart lady visitors to her studio, she had quickly changed out of her cap into a fashionable wig but had forgotten to remove her paint-spattered smock. Unusually, Adélaïde Binart, the subject of a portrait by Marie-Geneviève Bouliar (1762–1825), was quite prepared to be painted in her working clothes, although she is still well-dressed underneath, as can be seen by the glimpse of striped blue satin where the smock parts at the waist.

In general, male artists tended to dress respectably when at work, especially when their sitters were wealthy or aristocratic. But two portraits, one of the painter Hubert Robert by Vigée Le Brun and the other of the sculptor Augustin Pajou by Labille-Guiard, show both artists in workmanlike clothes, an informality of dress that few women would dare to adopt in a self-portrait.

For a sculptor like Anne Damer, working conditions were more arduous, not only because of the sheer physical effort required but because of the suffocating clouds of dust that permeated every-thing. One source states that she 'wore a mob cap to keep the dust of the marble from her hair, and an apron to preserve her silk gown and embroidered slippers'.[28]

Physical stamina was important for all painters, not just sculp-tors. The mother of Anne Forbes demonstrates her concern for her daughter's fragile health, comparing her to Angelica Kauffman who 'added to her great facility has such a constitution that she is able to work from 5 in the morning till sunset in summer and during the whole daylight in winter, whereas Anne can not rise till eight or fall to work till ten...'[29] Vigée Le Brun, though she was subject to neurotic disorders throughout her life, was physically robust and able, like Kauffman, to work long hours standing at her easel. In her *Memoirs* she recounts with pride that she even continued to paint into the last stages of pregnancy.[30]

Vigée Le Brun was also a formidable organiser, a great advantage to any artist trying to earn a living as a fashionable portrait painter in the latter half of the century, when competition in London was at its fiercest. Capturing a client's likeness and producing an attractive picture were only half the battle: running an efficient studio, with a quick turnover, could make all the difference between success and failure.

So too could a portraitist's ability to act the convivial host to the numerous visitors who invaded his or her premises. Gabrielle Capet's painting of Labille-Guiard's studio shows the artist seated at her easel painting her client. She is surrounded by no less than eleven onlookers, some watching her work while others are deep in conversation. Vigée Le Brun, who painted fast and with enormous concentration, went so far as to beg her sitters 'not to bring their friends to the sitting, for they all want to give advice and will spoil everything...'[31]

At that date a portrait painter's studio played a distinctive role in society as one of the few places where people of a different class could meet on equal terms: where a sitter's friends and relations could pass an idle hour, courtesans, actors and artists' models could mingle with the aristocracy, or lovers could make illicit assignations. The Earl of Ilchester's daughter, Lady Susan Fox-Strangways, had been conducting a secret affair with the actor William O'Brien, often meeting him at Catherine Read's studio. Read, clearly aware that things were not as they should be, reported their meetings to Lord Cathcart who immediately informed Lord Ilchester. Lady Susan had to swear to give up her lover but was allowed one last rendezvous. But the couple hatched a plan to meet at Read's studio and it was from there that they eloped.[32] Thus the studio was a haven for those who had, by their actions, placed themselves beyond the boundaries of polite society. When Sarah Bunbury

18. Elisabeth Vigée Le Brun, *Hubert Robert*, 1788

Male artists did not hesitate to show themselves in working
clothes. Vigée Le Brun's superb portrait of her close friend and
mentor shows him dishevelled and scruffy but wonderfully alive.
Robert made his name with his depictions of classical ruins and
contemporary architecture. In his series of paintings of the galleries
in the Louvre female artists can be seen copying paintings.

(one of the four daughters of the 2nd Duke of Richmond) left her husband but refused to marry the father of her illegitimate child, the only place where she could meet her friends was in an artist's studio.[33]

Reynolds's visitors were greeted by a footman who 'knows by heart all the names, real or imaginary, of the persons, whose portraits, finished or unfinished, decorate the picture room'.[34] William Hazlitt completes the picture of Reynolds's studio as a popular rendezvous:

> Lords, ladies, generals, authors, opera-singers, musicians, the learned and the polite, besieged his doors, and found an unfailing welcome. What a rustling of silks! What a fluttering of flounces and brocades! What a cloud of powder and perfumes! What a flow of periwigs! What an exchange of civilities and of titles! What a recognition of old friendships, and an introduction of new acquaintances and sitters. It must, I think, be allowed that this is the only mode in which genius can form a legitimate union with wealth and fashion.[35]

This drawing-room atmosphere naturally only applied to the studios of portrait painters. For artists engaged in other genres, such as history painting, their working day was more peaceful, even isolated. But history painting required more of everything: more studio space, larger canvases, more paint and more equipment, such as scaffolding and ladders. These factors had to be taken into account when any artist set up a studio, but women, who seldom had the aid of assistants and were handicapped by their lack of proper training, were limited in their choice of genre. For them, portraiture was ideal.

4
Portraiture

*Mr Lilly I desire you would use all your skill to paint my picture truly like
me & not flatter me at all but remark all these ruffness, pimples, warts,
& everything as you see me; otherwise I never will pay a farthing for it.*

SAID TO BE OLIVER CROMWELL ADDRESSING SIR PETER LELY, AROUND 1720[1]

Judging by the result, Oliver Cromwell's instructions to Sir Peter
Lely were carried out to the letter. But few sitters had either the
nerve or the lack of vanity to want to appear to posterity as they
really were. Before the advent of photography, a painted portrait
was the only visual proof that a person had existed. As the German
writer Johann Wolfgang von Goethe noted, 'A man's fairest memo-
rial is ... his own portrait ... It is the best text to the music of his
life.'[2] (What a gap would have been filled if Romney or Thomas
Lawrence had painted Jane Austen. Instead, posterity must make
do with a watercolour sketch by her sister Cassandra, the only
authenticated full-face image of an author who is now world famous.)

Dr Johnson agreed with Goethe; when Boswell asked him which
kind of portrait he preferred, 'fine portraits or those of which the
merit is resemblance', Johnson replied: 'Sir, their chief excellence
is being like.' Boswell questioned him further: 'Are you of that

opinion as to the portraits of ancestors whom one has never seen?' Johnson replied: 'It then becomes of more consequence that they should be like; and I would have them in the dress of the times, which makes a piece of history... Truth, sir, is of the greatest value in these things.'[3]

By mid-century, London had become the portrait capital of the world.[4] By 1759 Horace Walpole estimated – possibly a trifle wildly – that there were some 2,000 portrait painters at work in the city.[5] Portraits were 'ordered almost as an article of utility' noted Michael Levey, 'not, however, from grocers or haberdashers but from artists'.[6] Men commissioned them to celebrate some achievement or to mark a special occasion: succession to a title, coming of age, a victory in battle. Nearly all portraits of women were in some way nuptial.[7] Portraits could be statements of social success: a family 'on the make' could advertise its arrival on the social scene by having its members painted by a fashionable artist, a development which prompted Fuseli to complain that portraiture was no longer restricted to the high-born, talented or beautiful but open to all.[8]

Portraits were a form of social currency: numerous copies were made and distributed throughout the family or presented as gifts to friends, lovers or admirers. Copies enhanced, rather than diminished, the value of a portrait. Portraits of leading members of royal or aristocratic families required extra copies so that they could be distributed between the various houses and palaces. Mary Beale once painted thirty portraits for a huge society wedding, some of which were copies to be given to relations.[9]

The English infatuation with 'face-painting', as it was called, is evident from the high proportion of portraits in the annual Royal Academy exhibitions: 40 per cent in 1782 and nearly 50 per cent in 1784.[10] In the view of writer Louis-Sébastien Mercier, there

were far too many portraits 'of nameless people' exhibited in the Paris Salon: 'What are we to make of these financiers, these middle-men, these unknown countesses, these indolent marquises ... as long as the brush sells itself to idle opulence, to mincing *coquetterie*, to snobbish fatuousness, the portrait should remain in the boudoir; but it should never affront the vision of the public..!'[11]

Considering the important part they played in society, portraits were surprisingly cheap. To earn a living an artist had to work efficiently and fast. For some it became a form of drudgery: 'I begin to be really uneasy at finding myself so harnessed and shackled into this dry mill-horse business', lamented Thomas Lawrence.[12] Gainsborough referred to his trade as 'that cursed face business', and resented every moment that kept him from his real love, painting landscapes. As society flocked to him to have their portraits painted, he exclaimed: 'Damn Gentlemen! There is not such a set of enemies to a real artist in the world if not kept at a proper distance. They have kept but one part worth looking at and that is their purse.'[13]

A cause of this disdain for their profession was the hierarchy of genres imposed on the art world by the French Royal Academy when it decreed that history painting — with its intellectual and technical demands — was the highest form of art and its practitioners the most prestigious artists. Portraiture came a poor second because it was considered mere imitation. In England it also suffered from a lack of royal patronage; neither George I nor George II appreciated the arts, the latter famously remarking, 'I hate painting and poetry, neither the one nor the other ever did any good.'[14] But the courts of Europe, including the papal court, were more supportive of the arts, not only commissioning works but displaying them in semi-public galleries where they could be seen by potential patrons.[15]

19. Elisabeth Vigée Le Brun, *Charles Alexandre de Calonne*, 1784
As Calonne was France's Comptroller-General of Finance, this
was an important commission for Vigée Le Brun, and she has
placed him in an appropriately grand setting. Rumours that she
was his mistress pursued her for years, despite her insistence that
she could never have taken a lover who wore a wig.

For women artists, portraiture was the natural choice. Compared to history painting, it was relatively small scale and far less dependent on mastery of the human figure. Women were 'peculiarly fitted to this branch of art', declared the German writer August von Kotzebue when praising Kauffman, 'for in truth they have been naturally endowed with a strong instinct for reading physiognomies, quickly grasping and interpreting man's entire play of features.'[16]

However, the practice of portraiture for women was not without its risks or its detractors: Boswell reported that Dr Johnson thought 'portrait painting an improper employment for a woman ... Publick practice of any art (he observed), and staring in men's faces, is very indelicate in a female.'[17] Johnson's comment highlights a problem faced by female portraitists: instead of the demure, downcast gaze expected of their sex, staring into their sitters' faces was precisely what they had to do – a supremely intimate act that would have been unthinkable in any other circumstances.

Some men naturally tried to take advantage of this intimacy. Elisabeth Vigée Le Brun notes in her *Memoirs* that if any of her sitters showed an inclination to look at her with '*les yeux tendres*', she made them turn their heads so that they were gazing into space, a stratagem that amused her mother who always sat with her when she painted men – a practice adopted by most female painters, more to avoid gossip than for protection.[18] Conversely, a woman being painted by a man would be attended by a chaperone.

The pose adopted by sitters had to be carefully selected. The art critic Roger de Piles wrote in *The Principles of Painting* in 1743 that 'the attitudes are the language of portraits, and the skillful painter ought to give great attention to them'.[19] In England a military man might adopt a heroic stance in imitation of an antique Roman sculpture, one arm raised as if quelling multitudes – often called

'swagger portraits'; a landowner might favour a more relaxed atti-
tude, his family acres stretching to infinity behind him, his dog
at his feet; some women struck a regal pose or leant against a broken
pillar. By the end of the century, many English women chose to
be depicted enjoying the delights of walking in the countryside,
possibly a popular choice for the artist as painting a landscape
behind a sitter was far less time-consuming than painting a detailed
interior scene. Kauffman occasionally painted her sitters against
what Angela Rosenthal describes as 'a landscape of the soul, which
represents not the exterior world, the expanse of nature, but rather
an internal world'.[20] An example of these 'soulscapes' is Kauff-
man's portrait of Lady Elizabeth Foster, painted in contemplative
mood beneath the spreading branches of a tree. She is fashionably
dressed in frothy white muslin with her beloved island of Ischia
— where she had planned to give birth to one of her two illegitimate
children by the Duke of Devonshire — in the background. This
portrait illustrates one of the hazards faced by portraitists: although
painted in 1786, Kauffman had to wait six years for final payment.

French women, on the other hand, preferred to be shown at
home among their possessions and were often depicted at their
toilette, a lengthy process that took up most of the morning. The
'toilette' portrait was a neat way for the husband (who had commis-
sioned the portrait) to display his wealth and taste by showing the
rich furnishings of the boudoir, the expensive toilette service — a
traditional wedding gift from a husband — and to record the beauty
of his young bride.[21] Such scenes were painted by artists like Boucher
and Lancret but, oddly enough, seldom — if ever — by women.

The sister of Anne Forbes commented that in France history
painting and portraits were kept entirely separate whereas in Britain
'the misses are not pleased without they be flying in the air, or
sitting on a cloud or feeding Jupiter's eagle'.[22] Vigée Le Brun records

that when she painted a Miss Pitt as Hebe 'seated upon some clouds with an eagle drinking from a goblet in her hand', the eagle, accustomed to its perch outdoors, was so furious 'at finding himself in my room that he wanted to attack me. I must confess that I was not a little afraid.'[23]

Care had to be taken that the pose did not send the wrong message: Gainsborough's portrait of Ann Ford shows her seated with her legs crossed *above* the knee, a pose considered to be masculine and immodest. On seeing the portrait, Mrs Delany – a member of the Bluestocking Circle (discussed in Chapter 7) and a friend of nearly everyone – commented that it was 'a most extraordinary figure, handsome and bold; but I should be sorry to have any one I loved set forth in such a manner'.[24] (Miss Ford had already broken several of society's taboos, so possibly the pose was deliberate.)

In her *Memoirs*, Elisabeth Vigée Le Brun included a section on 'Advice on the Painting of Portraits'. She began by recommending that the model should be seated 'at a higher level than yourself', and that 'You should be as far away from your model as possible.'[25] To encourage the sitter to relax, she advised the artist to engage him or her in conversation before beginning work. Some of her own portraits, especially the later ones she painted of women during her years in Russia, convey exactly the impression that she and the sitter had been chatting amicably and that the sitter had just looked up to answer a question: they are like snapshots. The Dutch artist William Wissing did more than talk: as reported by Roger de Piles, 'when any Lady came to sit to him, whose Complexion was any ways Pale, he would commonly take her by the Hand, and Dance her about the Room till she became warmer, by which means he heightened her natural Beauty, and made her fit to be represented by his Hand.'[26] (Such vigorous treatment also helped to prevent the sitter from going to sleep – another hazard experienced by portraitists.)

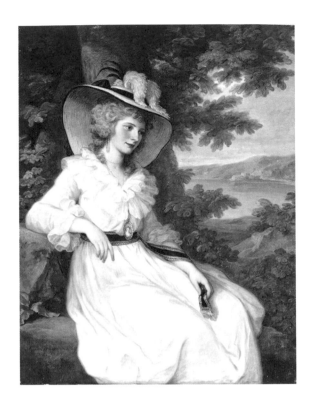

20. Angelica Kauffman, *Portrait of Lady Elizabeth Foster*, 1785–86
Kauffman painted the head in Naples in 1785, then completed the
picture in Rome in 1786. If she had painted the body first, it might have
been difficult to disguise the fact that Lady Elizabeth was some eight
months' pregnant with the Duke of Devonshire's child. The medallion
shows a portrait of her intimate friend, the Duke's wife Georgiana.

However, it is highly unlikely that a woman artist would try anything so saucy and improper.

Portraits contain symbols and conventions, the significance of which are easily lost on today's viewer. Single flowers seldom appear without a purpose: a red rose is the flower of Venus; red and white carnations are symbols of love. One of the most haunting examples of this symbolic language appears in a portrait of *Louise-Elisabeth of France, the Duchess of Parma and her Son*, painted in 1788 by Adélaïde Labille-Guiard. The Duchess leans against a balustrade, her head turned towards the observer, holding her small son by the hand. It is the emphasis on shadows — on her face and on the wall behind her — that would have alerted the eighteenth-century spectator that this was a posthumous portrait: the duchess had died of smallpox thirty years before the portrait was painted.[27]

Some sitters wanted to be represented with certain objects, or attributes, which showed their occupation, interests or, occasionally, their pretensions. A woman holding a portfolio indicated her wish to appear highly educated; dogs tended to show a love of animals, proof of 'sensibility', a virtue much admired at the time. Kauffman's portrait of Cornelia Knight represents her as both a writer and an artist by showing her pausing in the act of drawing while her published book, *Marcus Flaminius*, lies on the table beside her.[28]

What the sitter was to wear was an essential element of any portrait. Some clients had clear ideas of how they wished to be represented, others would accede to the artist's dictates. Reynolds liked to dress his female clients in loose robes, explaining his preference in his *7th Discourse on Art*: 'He ... who in his practice of portrait-painting wishes to dignify his subject will not paint her in modern dress, the familiarity of which alone is sufficient to destroy all dignity.'[29] For his portrait of the Duchess of Rutland

he apparently made her try on eleven different dresses before finally settling on what she described as a 'bedgown'.[30] Kauffman enjoyed painting some of her female clients in 'turqueries' — a loose-fitting Turkish garment — but in general she followed current fashions. Vigée Le Brun boasted that she had *changed* fashion by encouraging her sitters to adopt softer, simpler styles and to leave their hair unpowdered. She held to these views in her own style of dress: her self-portraits always show her dressed in loose flowing garments and her hair left in its natural state. 'Doing my hair', she claimed, 'cost me nothing, I arranged it myself... '[31]

Women's dependence on powder and artificial aids in their coiffures continued until late in the century, their extravagance and height reaching a bizarre climax between 1770 and 1780 when the hair, reinforced with wire, horsehair, pomade and heavily powdered, was built into a monstrous pillar up to a metre in height, so tall that ladies could no longer sit in their carriages but had to squat on the floor. 'Their heads became landscapes', wrote the de Goncourts, '... groves, with brooks running through, with shepherds and shepherdesses and sheep appearing in them'.[32] In Kauffman's 1774 portrait of *Viscount Althorp with His Sisters*, the coiffures of Georgiana and Harriet Spencer, though not taken to quite such extremes, are powdered and piled high in obedience to the current fashion — a fashion led by Georgiana (later Duchess of Devonshire), the leading style icon of her day. Their joined hands signal their affection while their brother stands beside them in the cross-legged pose that had become standard at that date for denoting a country gentleman. His hair, unpowdered, appears to be bound back into a bag-wig, a style that had succeeded the heavy full-bottomed wig worn by men in formal dress until the 1750s. The siblings' close relationship is emphasised by the antique urn — a symbol of eternal fidelity — that stands on a pedestal behind them.[33]

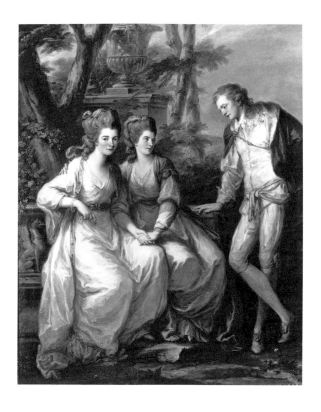

21. Angelica Kauffman, *Lord Althorp and His Sisters*, 1774

This portrait was painted shortly before Lady Georgiana Spencer (on the left) married the 5th Duke of Devonshire and became the undisputed queen of London society. She and her sister Harriet (later Countess of Bessborough) were devoted to each other, signalled by their clasped hands. The attitudes of all three mirror the willowy figures in many of Kauffman's paintings.

The fashionable face of the late eighteenth century in France is epitomised by Vigée Le Brun's portrait of Marie Antoinette, painted in 1783: the Queen's hair is frizzed and powdered, her complexion chalk white, the lips bright red, the cheeks enlivened by hectic spots of rouge. (Her mother, Empress Maria Theresa would have disapproved of the feathers which she thought were only fit for actresses.[34]) Much worn in France, rouge was seen both as a mark of nobility and a prerogative of youth.[35] Tobias Smollett, who took a dim view of most things foreign, was disgusted by the way French women 'primed and painted' themselves, particularly by their use of rouge which they 'daubed on their faces, from the chin up to the eyes, without the least art or dexterity [which] not only destroys all distinction of features, but renders the aspect really frightful...'[36] In England rouge was used more sparingly, applied to give just a touch of colour to the refined pallor to indicate modesty, one of a young woman's most precious virtues. To maintain their white complexions, women employed a lead-based cosmetic, which may have given the desired effect but also wrecked their skin and allegedly caused the death of several famous beauties, including Lady Coventry. White lead was the principal cosmetic used by fashionable Roman ladies – but no rouge.

The dry chalk pigments used in cosmetics were similar to those used for pastels, a medium that had existed since the late fifteenth century. Pastel was a very sympathetic medium for women as it was less messy than oils and the colour range was vast. It was also quicker to use and thus lent itself to a more spontaneous likeness. Its main drawback was its fragility, as the soft chalks could be easily smudged or dislodged from the paper surface. However, it was not until the early 1700s that Rosalba Carriera's more impressionistic technique popularised pastel as a medium for serious portraiture.[37] (Fanny Burney said of the pastel portraits of Catherine Read that 'while

they are new, nothing can be so soft, so delicate, so becoming'.[38])
In 1720 Carriera was persuaded by a wealthy patron to spend a year
in Paris, where she became an instant success. One of her early
clients was the ten-year-old king Louis XV but, as she confided in
her diary, the first sitting had not gone altogether smoothly as 'his
gun fell over, his parrot died, and his little dog fell ill'.[39]

Such incidents had to be dealt with at the time, but there were
other eventualities over which an artist had no control and which
could result in a commission mouldering away, unpaid for, in the
studio. Such hazards included the high incidence of infant mortality
in the eighteenth century that could leave a large hole in a group
portrait;[40] a stylish sitter insisting on changes being made to her
dress or coiffure to keep up with the latest fashion (much to Vigée
Le Brun's irritation, Caroline Murat, Queen of Naples, changed
both her dress and hairstyle every day during the time her portrait
was being painted[41]); or an elderly gentleman's rejection of his
young wife's portrait because the artist had made her look too young
'and I find some of my friends ridicule me upon it'.[42]

A portraitist had to possess the confidence and charm to take
charge from the moment a client entered the studio, an unfamiliar
role for any woman in the eighteenth century and a very difficult
one for some. Fanny Burney noted on a visit to Catherine Read's
studio that the artist was 'so very deaf, that it is a fatigue to attempt
any conversation with her. She is most exceedingly ugly, and of a
very melancholy, or rather discontented, humour.'[43] But others
were more adept: one of Kauffman's clients recorded that she put
him at his ease by asking him 'to talk during the whole time, and
upon such subjects as interest me most. By this means the coun-
tenance becomes more animated and of course can be drawn to
much greater advantage.'[44] Vigée Le Brun, ever the consummate
professional, simply appealed to her client's vanity: 'My experience

22. Elisabeth Vigée Le Brun, *Marie Antoinette 'à la rose'*, 1783
This formal portrait was painted to correct the artist's earlier
image of the Queen 'en chemise' which had caused such outrage
at the Salon in 1783. The artist has captured the brilliance of
the Queen's complexion and successfully disguised the notorious
heavy Habsburg lower lip. The Queen's slightly fixed gaze
is a reminder of her short-sightedness.

with women has led me to believe the following', she wrote in her *Memoirs*, 'you must flatter them, say they are beautiful, that they have fresh complexions etc. This puts them in a good humour and they will hold their position more willingly...'[45]

Flattery, of course, was the cornerstone of a portrait painter's profession. In his theatrical satire, *Taste* (1751), Samuel Foote lampoons the relationship between an artist, Mr Carmine, and his sitter, Lady Pentweazel, a flirtatious personage of plump proportions. 'I have heard', says the lady, 'that every body has a more betterer and a more worserer side of the face than the other – now which will you choose?' Carmine, pretending to find the choice quite beyond him, hesitates. 'The right side, Madam – the left – now, if you please, the full – Your Ladyship's countenance is so exactly proportioned, that I must have it all; no feature can be spar'd.'[46]

Satire apart, when confronted by the ravages of smallpox, which disfigured a good quarter of the women at that time, what else could an artist do but conceal the scars? This was clearly the solution adopted by the various artists who painted Lady Mary Wortley Montagu. According to Horace Walpole, an attack of smallpox had left her with a face 'swelled violently on one side with the remains of a pox, partly covered with a plaister, and partly with white paint...', yet her portraits all show her with an unblemished complexion.[47] That her appearance did not deter her from having her portrait painted implies that she took it for granted that artists would gloss over any defects. Similarly, Angelica Kauffman's portrait of Joshua Reynolds ignores both his smallpox scars and his disfigured upper lip – the result of a riding accident.[48] The fact that few women could boast a mouth full of healthy teeth was never disclosed because artists, bound by certain conventions which dictated how women should be represented, could not show their teeth, their hair unbound or their legs crossed.[49]

In the entry for 'Portrait' in the *Encyclopédie*, Diderot stressed that 'In every portrait, it cannot be overstated, likeness is the essence of perfection.'[50] But in the quest for likeness — urged by both Diderot and Dr Johnson — an artist could reveal more imperfections than the client either knew about or wished to have brought to their attention. Judging by Lady Jerningham's comment on her portrait by John Opie, the artist had achieved a skilful compromise: 'Everybody finds it very like, and I believe it is so — only with 10 or 13 years taken off, so that it will do for Posterity. I don't dislike the flattery, as it makes a decent Picture'.[51]

Others argued that it was character that made a good portrait. In *An Essay on the Theory of Painting* (1715), Jonathan Richardson likened a portrait to 'a sort of General History of the Life of the Person it represents...'[52] A tall order, and one that often flew in the face of female vanity.

Goethe, painted by Angelica Kauffman in 1787, was well aware of the problems facing portraitists: 'They are supposed to incorporate into their portrait everyone's feelings towards the subject, everyone's likes and dislikes; they are supposed to show not merely how they see a particular person, but how everyone would see him. I am not surprised when such artists gradually grow insensitive, indifferent and self-willed.'[53] For women artists, however, such attitudes were luxuries they could not afford. Struggling to survive in a man's world, and faced by ferocious competition from established male artists, they needed all their skill, allied to a compliant nature, a good head for business and a well-run studio to succeed as a fashionable portrait painter in the eighteenth century. But there were other genres which women tried, some of which perfectly suited both their sex and their abilities.

23. Rosalba Carriera, *Louis XV as a Boy*, 1720–21
When the artist was invited by a rich banker to leave her
native Venice and spend a year in Paris at his expense, one
of her first clients was the ten-year-old King Louis XV. The
success of the royal portrait brought the cream of French
aristocracy to her studio. Her soft, impressionistic technique
with pastels was particularly suited to portraits of children.

5
The genres

*I would rather see the painting of a dog that I knew than all
the allegorical paintings they can shew me in the world.*

DR SAMUEL JOHNSON[1]

꧁

The hierarchy of genres dictated that history painting – the repre-
sentation of themes from ancient literature, history and mythology
– was the most prestigious, followed some way behind by portraits.
Taking up the rear was the depiction of everyday scenes (confus-
ingly called 'genre' painting), flowers, landscapes and still-life.
History painting depicted universal truths and ideals whereas the
lesser genres merely represented people or things. While anyone
could appreciate a portrait of Great Aunt Maud or a vase of flowers,
a painting depicting Hercules choosing between Virtue and Vice
– one of the century's most popular subjects – required viewers to
possess a classical education in order to understand what they were
looking at. Mercier in his *Tableaux de Paris* (1781) describes the bemuse-
ment of spectators at the annual Salon: 'A typical idler takes the
characters of myth to be heavenly saints, Typhoeus to be Gargantua,
Charon to be St Peter, a satyr to be a demon, and Noah's Ark to
be the Auxerre coach.'[2] Only too aware of this problem, artists did

their best to enlighten their audience by attaching long explanatory titles to their pictures, Angelica Kauffman's *The Tender Eleanora Sucking the Venom out of the Wound which Edward I, her Royal Consort, Received with a Poisoned Dagger from an Assassin in Palestine* being a case in point.

To create such complex works, an artist required not only a high standard of education but the imagination and intellect to interpret the various themes — abilities not required of them when painting Great Aunt Maud. However, few English painters of either sex came from the upper echelons of society where a classical education was the norm. Nor was there much inducement for artists to produce history pictures as few people wanted to buy them. British collectors very rarely commissioned them, preferring instead to buy imported Old Masters or to scour the European picture dealers in the hope of finding works by artists like Domenichino, Guido Reni, Claude Lorrain or Nicolas Poussin.

Thomas Gainsborough, who only painted one history picture during his illustrious career, dismissed the genre as 'tragicomic' and little more than a crafty ruse to enable middle-aged men to look at naked ladies while convincing themselves they were viewing high art. (Such urges are understandable in an age when it was unusual for men and women to see each other naked, even when they were married.[3]) The French art critic Étienne La Font de Saint-Yenne took a loftier view, declaring that history painting was the noblest and most prestigious genre because 'the history painter alone is the painter of the soul, the others paint only for the eye'.[4] Cosmetti, in *The Polite Arts, Dedicated to the Ladies* (1767), concurred: 'In Historical painting the greatness of the subject usually proves the rock on which the painter's skill is split. None but a sublime soul can colour the majesty of kings and heroes, or admire the performance.'[5]

If few male British artists attempted history painting, it is all

the more remarkable that Angelica Kauffman, a woman and a foreigner, should arrive in England determined to succeed in this, the most challenging of genres. Her achievement was recognised by the Royal Academy when she became one of only six artists out of its thirty-six original founder members to be designated a history painter.[6] In 1777 a reviewer for *The London Chronicle* noted: 'It is surely somewhat singular, that while so many of our male artists are employed upon portraits, landscapes, and other inferior species of painting, this lady should be almost uniformly carried, by the boldness and sublimity of her genius, to venture upon historical pieces...'[7]

Added to her 'boldness' and 'genius' were the classical education she had received from her father, the years she had spent studying Old Masters and antique sculpture in Italy, and her association with Neoclassical artists and the Roman antiquarian Johann Winckelmann. However, these assets were offset by one huge disadvantage: the taboo against women studying from a live nude model. History painting, with its emphasis on the actions and emotions of human beings — who were often naked or scantily clad — demanded a sound knowledge of anatomy. Any amount of time spent copying classical statues could not make up for women's inability to study warm flesh as opposed to cold dead marble.

Kauffman circumvented this problem by cleverly selecting scenes that placed women at the centre of the action. By careful research into a variety of subjects, ranging from classical history and literature through to scenes from English medieval history and Shakespeare, she focused on women who were faced with some moral dilemma or had been left to mourn the death or departure of their loved ones. These swooning, grieving women occur again and again in her paintings and became a hallmark of her style. In her painting of *Cleopatra Adorning the Tomb of Marc Antony*, the Egyptian

24. Angelica Kauffman,
Cleopatra Adorning the Tomb of Mark Antony, 1770
Kauffman may have taken this scene from Plutarch's *Life
of Antony*, in which Cleopatra is given permission by
Augustus to visit the tomb of Antony. When researching
subjects for her history paintings she frequently chose
moments when women were left alone to grieve for the
death or departure of their loved ones.

queen, her robe a luminous white against the dark background, droops gracefully over her lover's tomb as she garlands it with flowers. It must have been images such as this that prompted the politician John Wilkes to declare that Kauffman's paintings had 'the grace of Raphael, the warmth of Correggio's colouring, and the delicacy of Guido [Reni]'.[8]

One of Kauffman's most successful subjects was the terminally miserable 'Poor Maria' who makes her first appearance as the 'disordered maid' in Laurence Sterne's *Tristram Shandy* (1760–67), then briefly reappears in *A Sentimental Journey* (1768). Maria was tailor-made for Kauffman: beautiful, jilted and abandoned – even by her pet goat – she takes to wandering forlornly through the countryside or sitting on the banks of a stream, a picture of utter dejection. An engraving of the image was adapted for use on decorative objects as diverse as a watch case and a tea tray.[9]

Homer supplied Kauffman with one of her favourite tragic heroines, Penelope. In *Penelope Awakened by Eurycleia with the News of Ulysses's Return,* the virtuous wife reclines in peaceful slumber while her husband's aged nurse tries to wake her. Ulysses is kept well out of the way, a shadowy figure poised at the door of his wife's apartment.

Kauffman's stratagems to sideline men in her paintings did not prevent critics from complaining that all her male figures looked like women in disguise. The journalist Anthony Pasquin, while pointing this out, acknowledged that there were extenuating circumstances. '[Women's] situation in life, and compulsive delicacy prevents them from studying nudities, and comparing these studies with muscular motion, though without such aid, they cannot do more than this lady [Kauffman] has effected, which is, to design pretty faces and graceful attitudes, without any authority from nature to warrant the transaction...'[10]

That she was able to continue to produce history paintings,

despite their lack of popularity in England, was largely due to the patronage of two enlightened collectors, John Parker and George Bowles. Without their generosity and support she would have been forced to concentrate on portraiture to make a living and would never have achieved the rare distinction of being ranked among her male contemporaries as a history painter.

Kauffman was not the only female history painter, but none of those who portrayed historical subjects achieved her phenomenal success. Vigée Le Brun, ever ambitious, longed to follow in Kauffman's footsteps but was enough of a pragmatist to accept that it was her skill at portraiture that earned her lucrative commissions and critical acclaim. Maria Cosway also undertook history painting, exhibiting more than thirty works at the Royal Academy between 1781 and 1789, though few of them have survived.[11] Her work was greatly influenced by Kauffman and Fuseli in terms of style, handling and range of subject matter. She chose her subjects from various sources, from Homer to Shakespeare.

Pauline Auzou, though principally known for her sentimental genre scenes, was one among numerous artists who became involved in Napoleon's propaganda campaign to make his divorce from Josephine and marriage to Marie Louise of Austria acceptable to the French people. One of the two known images painted by Auzou of this subject shows the eighteen-year old Archduchess (dismissed by one hostile historian as possessing 'but one social talent on which she prided herself not a little – the power of moving her ears without stirring a muscle of her face'[12]), arm in arm with the Emperor, being greeted at the Château de Compiègne by white-clad young maidens bearing garlands of flowers.

Anna Dorothea Therbusch was another artist to brave the world of history painting, executing several mythological subjects. But her flouting of the prohibition of women depicting nudes caught

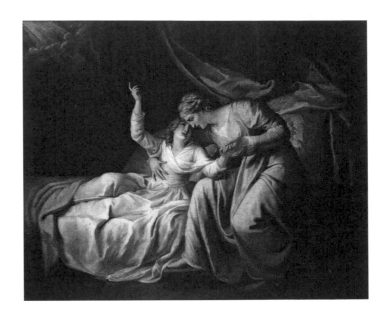

25. Maria Cosway, *The Death of Miss Gardiner*, 1789
History painting, with its emphasis on portraying universal
ideas and human emotions, naturally appealed to a woman
of Cosway's complex and passionate temperament. Her
life-long ambition, though never realised, was to enter
a convent, and she depicts the dying Miss Gardiner
reaching out to heaven with great feeling.

up with her when in 1767 a history picture she had submitted to
the Salon was rejected on the grounds of impropriety. According
to Diderot, she was so distraught that 'she cried out, she pulled her
hair, she rolled on the ground, she grasped a knife, uncertain
whether to use it on herself or her painting'.[13]

Despite efforts by Reynolds, Benjamin West, Kauffman and
James Barry to popularise history painting in England, the buying
public failed to respond. Nor did the genre fare much better in
France, partly due to the great changes that took place in the way
in which people lived – on both sides of the Channel – during the
first quarter of the century. Gone were the opulence and pomp,
gone were the long sequences of rooms (called an *enfilade*) designed
to impress. People now wanted smaller, more intimate rooms, with
large windows (glass was now much cheaper), efficiently heated by
small fireplaces. (In Louis XIV's palace at Versailles it was not
unknown for wine to freeze in the glass.[14]) For the first time, houses
had corridors. This innovation was accompanied by the emergence
of new types of rooms, each one dedicated to a specific use. Houses
now had dining rooms, dressing rooms, salons and bedrooms.
Between the bedroom and the salon came the boudoir – the name
comes from *bouder*, to pout or sulk. Women could now withdraw to
their own rooms to write letters, curl up with a book or, indeed,
to sulk. 'The art of living comfortably and by oneself', commented
a French architect in 1728, 'was previously unknown.'[15] In short,
people wanted privacy. What they no longer needed were large
expensive history paintings. Instead, they bought small-scale deco-
rative pictures and family portraits.

When all these factors are taken into account, it is hardly
surprising that women artists, faced by history painting's intel-
lectual demands, dependence on a thorough knowledge of anatomy
and lack of customers, chose portraiture as the most likely way of

making a living. Portraiture is such a large subject that it has had a chapter to itself (Chapter 4, pp. 75–91).

Interest in genre painting increased in the second half of the eighteenth century, inspired by the rise of bourgeois values, the more intimate style of living and a new reverence for the family fostered by the writings of Jean-Jacques Rousseau and others. Wet nurses were out, a mother suckling her own babies was in; children were no longer portrayed as miniature adults, ramrod stiff beside their parents, but romped about in loose garments, their cheeks glowing from their exertions. Nature and the countryside were to be enjoyed for their beauty and interest, not seen as simply somewhere to pass through. These developments were reflected by the French artist Jean-Baptiste Greuze (1725–1805), whose paintings sentimentalised family and domestic life and dramatised the lives of the rural poor.

Genre painting suited women as they could take their themes from the life about them. There was also a ready market among the wealthy middle classes who had neither the space to hang, nor the education to appreciate, large history pictures. The first female artist in France to achieve success in genre painting was Marguerite Gérard. Her meticulously painted small-scale pictures, heavily influenced by seventeenth-century Dutch genre painters, specialise in scenes depicting a devoted mother's involvement with her children, albeit while swathed in gleaming satin unblemished by sticky infant fingers. Images such as a child's first steps or a mother teaching a daughter to play the piano reflected Rousseau's cult of happy motherhood and sold like hot cakes. Françoise Duparc (1726–78) took a different view of women, portraying members of the bourgeoisie and working class quietly engaged in simple everyday tasks. Pauline Auzou's sentimental genre scenes, such as *The First Sense of Coquetry,* depict young girls on the cusp of woman-

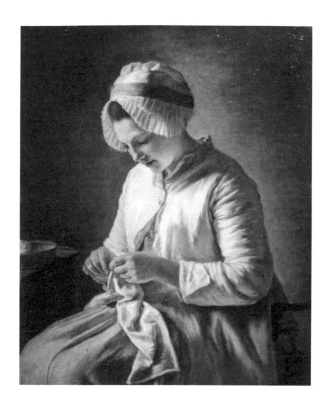

26. Françoise Duparc, *A Woman Knitting*, undated
Duparc chose as her subject matter the daily lives
of bourgeois men and women, rather than those
of the gilded aristocracy painted by most of her
contemporaries. All of her surviving paintings – there
are only four – seem to blend portraiture and genre.

hood, the partly-clothed images lending credence to the suspicion that she had somehow found ways to study from the nude.

The paintings of Constance Mayer also focus on women, but unlike Gérard's elegant ladies, hers are clad in wispy fabrics or nothing at all. Her tangled and ultimately tragic relationship with Prud'hon, and their collaboration on each other's pictures, has made it difficult to separate her work from his. Her masterpiece, *The Dream of Happiness*, based on preliminary sketches by Prud'hon, shows a boat containing a blissfully contented mother languishing in the arms of her husband, her child asleep on her breast. It has all the drama of a film set.

By the end of the eighteenth century the lowly status of still-life had improved significantly, largely due to the influence of Jean Siméon Chardin, who could invest the most mundane subject — from a scullery maid to a loaf of bread — with dignity. With its focus on objects rather than on the human figure, still life was an ideal genre for women, although it came so low in the hierarchy that its practitioners could never hope to achieve the sort of reputation accorded to history painters.

Anne Vallayer-Coster burst on to the art world at the ridiculously young age of twenty-six when in 1770 she submitted two still lifes as reception pieces to the Académie Royale and was unanimously elected a member. It was an auspicious start to what proved to be a long and highly successful career. Her work inevitably attracted comparison with Chardin's, but whereas he concentrated on modest, bourgeois subjects, she delighted in the reflections cast on silver and glass, sumptuous fabrics, delicate Meissen, the rich hues of lobsters and fruit, pearly corals and elaborate bouquets of flowers — the latter rarely attempted by Chardin. In the view of Charles Sterling, author of a seminal book on the art of still life (1959), it was 'quite unfair' that she should be 'written off as a mere

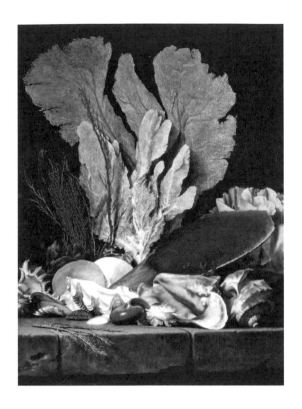

27. Anne Vallayer-Coster,
Still life with Seashells and Corals, 1769
The artist excelled at producing paintings rich in
colour and detail. Here she displays her ability to
knit together a bewildering array of seashells
and corals into a glorious whole. Her technique
was to build up her paintings in several layers: for
the spiky red coral on the left she used up to four
layers of different shades of red.

imitator' of Chardin. 'The truth is that, after Chardin and [Jean-Baptiste] Oudry, she is the best French still-life painter of the eighteenth century.'[16] One of her masterpieces, *The White Soup Bowl*, is as exquisite as anything by Chardin,

Flower painting, which had originated as a branch of still-life painting, became a major genre in the Netherlands during the seventeenth century. It appealed to women as it was generally small-scale and required no knowledge of human anatomy. Flowers had the added attraction of being considered a more natural and acceptable subject for women than depicting half-naked gods in episodes from the Trojan War.

One of the most successful flower painters early in the century was the Dutch artist, Rachel Ruysch. Her exuberant, elaborate floral pieces contain a bewildering number of species, both cultivated and wild, and crawl with bugs and menacing reptiles, each one exact in every detail. Any flower piece can be read as a Vanitas (a still life which contains a collection of objects symbolic of the inevitability of death), and Ruysch's inclusion of buds that are just opening, fully opened flowers and wilting leaves all hint at the transience of beauty.

As a Dutch woman, Ruysch would have had easy access to tulips, the flower that became so sought after during the height of 'Tulip-mania' in the 1630s that a single bulb could change hands for as much as £80,000 at today's value. Thus a bowl full of cut tulips was a declaration of outrageous affluence.[17] Ruysch's paintings commanded high prices, considerably higher than Rembrandt's, and she became an international celebrity.

In England the genre's principal exponent was Mary Moser, the only woman apart from Angelica Kauffman to be elected as a founder member of the Royal Academy. Although she became one of the century's most celebrated British women artists, she is

virtually unknown today. Ambitious and clever, she was 'so near-sighted, that her nose when she was painting was within an inch of the canvas'.[18] Ignoring exotic imported species, she painted the sort of flowers that would be found in an English garden. Her most important work was a complex floral scheme for Frogmore House, Windsor, commissioned by Queen Charlotte, for which she was paid the princely sum of £900 (equivalent to about £55,000 today).

Sculpture, the least feminine of the arts, had attracted few women since the early sixteenth century when Properzia de' Rossi had achieved such fame that Vasari included her in his *Lives of the Artists*. A nineteenth-century author has defined the problems faced by women who chose sculpture over painting as a career: 'The palette, the pencil, and colours fall naturally to their [painters'] hands; but mallets and chisels are weighty and painful implements, and masses of wet clay, blocks of marble, and castings of bronze are rude and intractable materials for feminine labours.'[19] Added to these difficulties were the taboos against women studying the nude, employing male assistants – vital when undertaking large-scale works – and the perception that sculpture was an unsuitable occupation for women.

The French sculptor Marie-Anne Collot turned one taboo on its head when she became an assistant to her teacher Falconet, accompanying him to Russia in 1766. Although she became the most sought-after society portrait sculptor at the Russian court, she continued to assist Falconet with the statue of Peter the Great.

Angelica Kauffman, while best known for her history pictures and portraits, also produced numerous designs suitable for repro-duction on objects ranging from furniture to porcelain, and from walls to chimney pieces. Porcelain manufacturers such as Wedg-wood, Derby, Sèvres and Meissen are all known to have adapted her work in its engraved form to their own purposes. Her work was

28. Rachel Ruysch, *Spray of Roses with Beetle and Bee*, 1741
Trained by Willem van Aelst, the leading Dutch flower-painter,
and with a father who owned a vast collection of scientific
specimens, Ruysch was well-equipped for what proved to be
a spectacularly successful career as a painter of flowers, fruit,
insects, reptiles and sea creatures. She continued to paint until
three years before she died, aged eighty-three.

everywhere, leading one eighteenth-century commentator to exclaim 'the whole world is angelicamad'.[20] The ceiling of the Royal Academy's entrance hall at Burlington House is one of only two of her designs which is definitely known to have been painted by Kauffman herself.

Maria Cosway was equally versatile: the series of drawings she made to illustrate poems by her friend Perdita Robinson, actress and one-time mistress of the Prince of Wales, provide a fascinating – if somewhat eccentric – picture of Regency life. She was also one of the few artists of her time to produce designs for advertisements.

Miniature painting – or limning as it was called then – had long been seen as particularly suitable for female artists. Described by the great English miniaturist Nicholas Hilliard as 'sweet and cleanly to use...', it took up little space.[21] Miniatures were popular as love tokens as they could be carried about by the loved one, worn next to the heart or on the wrist as a bracelet. Rosalba Carriera initially made her reputation as a miniaturist and is said to be responsible for introducing the use of ivory as a support. At the beginning of her career Adélaïde Labille-Guiard painted miniatures, but later abandoned the art for pastels. One of her most devoted pupils, Gabrielle Capet 'was simply one of the best and most popular miniature portraitists active in Paris in the late eighteenth and early nineteenth centuries'.[22]

A genre that women seldom attempted was landscape painting. This is hardly surprising since painting *en plein air* (sketching out of doors directly from nature), although long practised by artists, did not become popular until the mid-nineteenth century following the example of the earliest *en plein air* painter Charles-François Daubigny. Besides, for a woman to set herself down in the countryside, even if accompanied by a chaperone, would have been asking for trouble. Nor were most women sufficiently trained in

perspective, so vital for painting a view. But perhaps the most telling reason was the lack of demand: considered as little more than decorative space-fillers, landscapes fetched extremely low prices.[23]

However, towards the end of the century landscape portraiture grew increasingly popular, influenced by the penchant of British subjects for being portrayed sauntering through their rolling acres, usually with some hairy canine at their heels. Sitters now wanted to be shown against a background that held some special significance for them, like Kauffman's portrait of Lady Elizabeth Foster, which shows her beloved island of Ischia in the distance (see p.82), or Labille-Guiard's portrait of Madame Victoire (one of Louis XVI's aunts), standing in the Bellevue gardens which had been renovated under her supervision.[24]

The fact that professional women artists had undoubtedly proliferated and prospered during the century was observed with some disquiet by the predominantly male art establishment. 'Up to now we only expected amusement and neatness from their brushes: they [women artists] show today vigour and nobility. They are finally the worthy rivals of our sex; and men, who had previously assumed their own talents to be superior in all respects, can from now on worry about real competition.'[25] The arena in which such competition would be most keenly felt was the marketplace.

6

The marketplace

... when you view a painting, take particular care not to go, like ignorant people, excessively near; but rather beginning far off, approach gradually, till it appears rough; then recede a little, till it looks sweeter; it is what connoisseurs call finding the proper light of a painting.

COSMETTI, *THE POLITE ARTS, DEDICATED TO THE LADIES,* 1767[1]

This advice may seem obvious, even condescending, but in 1767 it would have been welcome counsel not only 'to the Ladies' but to a British public with little experience of viewing art for the simple reason that there was virtually no opportunity to do so. Before the 1760s, there were no public galleries, no access to the royal collections, no displays of pictures in public buildings or churches. Foreign observers accused the British of philistinism, yet there were great collections of fine art. However, they were owned by aristocrats who had acquired them either on their Grand Tours or from English picture dealers, a fact noted by Elisabeth Vigée Le Brun during her brief residence in London; 'It is not that one cannot find a wealth of precious objects in England, but most are owned by rich private citizens who adorn their estates in the country and the provinces with them.'[2] But apart from commissioning

family portraits, these wealthy collectors gave little or no support to living British artists. Instead, they bought 'Old Masters' of the Renaissance and the seventeenth century. Devonshire House on Piccadilly, home of the Cavendish family, owned not only one of England's finest collections of Italian masters, but also Rembrandt's *Old Man in Turkish Dress* and Poussin's *Et in Arcadia Ego*. When Gustav Waagen, the Director of the Berlin picture gallery, travelled round English country houses in 1835, he confirmed that as collectors of art the English were unrivalled, the number of outstanding works in their possession 'probably exceeded only by Italian private collections'.[3]

Few, if any, of these great houses were closed to those who sought admission, provided they came armed with references. Even the interested amateur could gain access: Elizabeth Bennett, heroine of Jane Austen's *Pride and Prejudice*, touring the Peak District with her aunt and uncle, grew weary of visiting them; 'after going over so many, she really had no pleasure in fine carpets or satin curtains'.[4] A surprising number of them allowed visitors at certain times of the year. Chatsworth, the Cavendish family's country estate in Derbyshire, held weekly Public Days when the house was thrown open to the Duke's tenants and to respectable strangers. The visitors were greeted at the door by their hosts and were even invited to dine with them. However, things did not always go according to plan. 'Some of the men got extremely drunk,' Georgiana, Duchess of Devonshire, recorded after one such dinner. Her own friends, 'if they had not made a sudden retreat, would have been the victims of a drunken clergymen, who very nearly fell on them'.[5]

Without public spaces to show their work, artists had to find other ways of reaching potential customers. Setting up galleries or show rooms at their studios was one method: when Angelica

Kauffman arrived in London she had carefully selected a property that had an extra room where she could 'display her finished paintings as is here the custom'. Maria Cosway and her diminutive husband, the miniaturist Richard, filled their large house in Pall Mall with three floors of pictures – including their own works – and threw grand parties to which they invited everyone of note, including the Prince of Wales (later George IV).

Selling at auction was another method. André Rouquet, the Swiss miniature painter, notes in his *L'Etat des Arts en Angleterre* (1755): 'Sales of this kind have made the taste for pictures general in London; they have awakened interest and the public has acquired from them some knowledge of the different schools and masters.'[6] Between 1711 and 1760 more than 25,000 pictures were sold under the hammer.[7] Christie's, the auctioneers, was established by James Christie in 1766.

Selling through dealers would have been another possibility had it not been for their preference for long-dead Continental artists. Rouquet comments that dealers, unable to make sufficient profit from selling work by contemporary artists, 'make a point of depreciating it in the eyes of collectors and cultivating in their minds the absurd notion that the value of a picture depends upon its age'.[8] Unscrupulous dealers also had a nasty habit of altering an artist's signature to that of a better-known, more saleable artist who worked in a similar style.[9] 'Between the 1720s and the 1770s ... as many as 50,000 paintings, and half a million etchings and engravings were imported into Britain from Italy, France and Holland.'[10] The shop sign of a Parisian art dealer called Gersaint, painted by Antoine Watteau, shows the shop crammed with paintings. The customers examining them are not wealthy aristocrats but prosperous members of the bourgeoisie, who now have the money and the inclination to buy art.

29. Thomas Rowlandson, *The Exhibition Stare Case*, c. 1800
Since its foundation in 1768, the Royal Academy of Arts has been
located successively in Pall Mall, in the old palace of Somerset
House, in 'New' Somerset House (now the Courtauld Institute)
and finally in its present home in Piccadilly. Somerset House had
a precipitous staircase, which tested the stamina of many of the
visitors. Rowlandson satirised it mercilessly.

William Hogarth, who took a poor view of this cult for 'Old Masters', led the demands that native artists should no longer be ignored, berating the 'Picture-Jobbers' for 'continually importing Ship Loads of dead Christs, Holy Families, Madona's [sic], and other dismal Dark Subjects...'[11] But it was no good raising the profile of British artists if there was nowhere for them to show their work. Undaunted, Hogarth arranged for a group of artists to decorate the supper boxes and pavilions at the Vauxhall Pleasure Gardens with their paintings, and for Thomas Coram's Foundling Hospital to allow him, together with other leading British artists, to display their paintings in its public rooms. The exhibitions at the Foundling Hospital proved a huge success with fashionable society, revealing a real hunger for viewing art and for the work of contemporary British artists.

The first opportunity to satisfy this appetite came in 1760 when the Society for the Encouragement of Arts, Manufactures and Commerce (later known as the Royal Society of Arts) held the first public exhibition of domestic art ever mounted in Britain. Some 20,000 visitors took advantage of the free entry, with unfortunate results: amid scenes of 'tumult and disorder' the *bon ton* found themselves rubbing shoulders with 'menial servants and their acquaintances ... kitchen-maids and stable boys'; windows were broken and there were some scuffles. They were not amused. The organisers hurriedly decreed that in future there was to be no 'smoking, drinking, etc.', that the riffraff would not be allowed in and 'disorderly persons' would be thrown out.[12]

The exhibition was like the bursting of a dam: more exhibitions followed, and in other locations. Angelica Kauffman exhibited three of her history paintings at the Society of Artists in 1768. The following year she showed four at the Royal Academy's first ever exhibition.

The founding of the Royal Academy of Arts in 1768 fundamentally altered the character of the London art world. British artists at last had a well-staffed art school and a public space devoted to the exhibition of their work. By today's standards, however, the space – as it appears in a print by Richard Earlom of the 1771 summer exhibition – is positively claustrophobic. At that stage the Academy's exhibitions took place on the top floor of a house in Pall Mall, the pictures stacked frame to frame from floor to ceiling. The exhibition was attended by 22,485 visitors. Only fifteen of the 256 paintings were by women.[13] Mrs Delany wrote to a friend: 'This morning we have been to see Mr [Benjamin] West's and Mrs Angelica's paintings... My partiality leans to my sister painter; she has certainly a great deal of merit, but I like her history still better than her portraits.'[14]

Mrs Delany is a perfect representative of what was known in the eighteenth century as 'polite society', a term that then had a very different meaning to today's connotations. Previously, standards of conduct had been set by the court, but this new philosophy grew out of much humbler, more democratic soil: the coffee houses and the newly-founded periodical press. Ideas about politeness were disseminated by journals like Addison and Steele's *Spectator* which were read – often out loud – discussed and argued about by frequenters of the coffee-houses. Politeness embraced every aspect of manners, morals and cultural life, defining how a person like Mrs Delany should behave, think, feel and act.

While they spread this new philosophy, the journals also set standards of taste and discernment. In 1741 the Scots philosopher David Hume declared that 'a cultivated taste for the polite arts ... improves our sensibility for all the tender and agreeable passions.'[15] From mid-century 'sensibility' came to mean 'the expression of heightened, intense human feelings', or, put simply, the language

30. Elisabeth Vigée Le Brun,
Peace Bringing Back Abundance, 1780
Vigée Le Brun's ambition was to be admitted to the
Académie Royale and to do so with a history painting,
the most prestigious genre. She had painted this picture
while France was embroiled in the American War of
Independence, and the signing of the peace treaty in 1783
underscored the relevance of the painting's subject matter.
She was accepted by the Académie in the same year.

of the heart. Mrs Delany and her ilk now knew what they ought to be reading, even if they preferred trashy novels; spectators at an exhibition knew what artists they ought to admire, whether they did or not. Thus public opinion — formed by the media — played an increasingly important role in shaping an artist's reputation. This was all quite new, and a development which the Royal Academy, as the centre of London's artistic life, took into consideration when selecting artists for its exhibitions.

The Academy, now desperately cràmped for space in its rooms in Pall Mall, moved in 1780 to much larger premises in Somerset House on the Strand. Although it was hoped that an admission fee of one shilling would discourage 'improper Persons' from attending, the opening exhibition took £500 in one day and altogether sold 20,000 catalogues.[16] Pietro Martini's well-known engraving (after a drawing by Ramberg) of the 1787 exhibition shows the spectators in the Great Room crushed together like sardines in a tin.

The Great Room lived up to its name: it was some 16 m long by 13 m wide and 9.7 m high.[17] Martini's engraving shows Sir Joshua Reynolds, clutching his ear trumpet to aid his deafness, conducting the Prince of Wales round the exhibition. The Prince, holding a catalogue of the exhibition, is surrounded by bewigged gentlemen and ladies, the latter sporting enormous hats, which would have been a considerable irritant to those spectators who had actually come to see the pictures rather than to ogle His Royal Highness.

To reach the Great Room visitors had to climb a vertiginous winding staircase. Although advertised by the Academy as 'easy and convenient', this staircase became notorious, a major obstacle to some and a butt of jokes to others. Queen Charlotte required a chair to be placed on each landing so that she could rest between flights, while Dr Johnson, aged seventy-five and within a year of his death, proudly reported that he still did 'not despair of another

race upon the stairs of the Academy'.[18] A journal commenting on the sights around town noted: 'Exhibitions are now the rage and though some may have more merit, yet certainly none has so much attraction as that at Somerset House; for, besides the exhibition of pictures living and inanimate, there is the raree-show [peep show] of neat ancles [sic.] up the stair-case which is not less inviting...'[19] This image was irresistible to Rowlandson (whose output of pornographic prints was prodigious), who produced a print showing the staircase jammed with visitors nervously picking their way upwards. Several of the ladies have lost their footing and are tumbling head over heels downwards, their plump thighs and tender parts exposed (Georgian ladies did not wear knickers) to the delighted gaze of several lecherous old gentlemen.

For the exhibitors, the staircase posed as much of a challenge as it did for the spectators. Their paintings, some of them full-length portraits, had to be either lugged up the stairs or hauled up the stairwell by ropes.[20] Once they had survived this perilous journey, they were hung cantilevered forward from the walls. This 'tilt' made them much easier to see from below and also eliminated shadows and reflections. At a height of 2.4 m from the floor ran the all-important 'line', which was like a thick picture rail.[21] The smaller paintings were hung below the line, the larger ones above it. Those positioned immediately above the line were the most visible and thus the place where every artist wanted to be.

The success of the Royal Academy raised the status of artists in general and of British painters in particular. 'The rage to see these exhibitions is so great', Horace Walpole told his friend Horace Mann, 'that sometimes one cannot pass through the streets where they are.'[22] This was all very gratifying, but when compared to the Continent, these innovations had been desperately slow in coming. Rome had had an academy — the Accademia di San Luca — since

1577; France's Académie Royale had been founded in 1648 and the Académie de Saint-Luc in 1751. By the end of the century there were royal academies all over Europe.

The Académie Royale administered the École des Beaux-Arts and sponsored the annual Salons, held in the Salon carré of the Louvre, which had begun as regular events in 1737 and rapidly became the most important public entertainment in Paris. These exhibitions were as much of a heterogeneous scrum as the Royal Academy's. One veteran art critic describes what it felt like to arrive in the Salon carré after having safely negotiated the crowds on the stairs: '... you cannot catch your breath before being plunged into an abyss of heat and a whirlpool of dust. Air so pestilential and impregnated with the exhalations of so many unhealthy persons should in the end produce either lightning or plague. Finally you are deafened by a continuous noise like that of the crashing waves in an angry sea.' But he then praises what 'would delight the eye of an Englishman: the mixing, men and women together, of all the orders and all the ranks of the state... This is perhaps the only public place in France where he could find that precious liberty visible everywhere in London.'[23] While it may have all been very democratic, to judge by Mercier's description in his *Tableaux de Paris*, viewing the actual pictures was a bewildering experience for the spectator: 'The sacred, the profane, the pathetic, the grotesque; the pictures offer every subject of history and myth all in a jumble; the sight is confusion itself...'[24]

How were women artists faring in this, 'the era of exhibitions', as Rouquet described the latter part of the century? Needless to say, they were still struggling, not just to find ways of selling their pictures but to surmount the cultural taboo against women doing anything so bold and improper as exposing their work to the public gaze. Such high visibility was for actresses and courtesans, not for respectable women who wished to be accepted by society.

For the handful of women who were members of one of Europe's royal academies, exhibiting their work in the biennial shows was guaranteed: non-academicians had to submit their pictures for selection. The Académie de Saint-Luc, though less prestigious than the Académie Royale, accepted women: over the eighteenth century 130 of its 4,500 members were female.[25] Two of these women, Labille-Guiard and Vigée Le Brun, made their names in its exhibitions before being accepted in 1783 by the Académie Royale, Vigée Le Brun's membership due to the intervention of Marie Antoinette whose portrait painter she became in 1778. Vigée Le Brun submitted a mythological subject, *Peace Bringing Back Abundance* as her reception-piece in the vain hope that she would be classed as a history painter. Labille-Guiard's *morceau de réception* was a portrait of her friend, the sculptor Augustin Pajou. Their election brought the number of women artists up to four, the limit stipulated by the Académie. One of the four, Vallayer-Coster, had been elected in 1770, submitting *The Attributes of Painting, Sculpture and Architecture* and *The Attributes of Music* as her reception-pieces.

Once Vigée Le Brun was accepted by the Academy, there was no stopping her: in all, she exhibited no less than forty paintings at the Salon.[26] The author of the *Mémoires Secretes*, Louis-Petit de Bachaumont, greeted her debut in 1783 with this apparent paean of praise:

> When someone announces that he has just come from the Salon, the first thing he is asked is: have you seen Mme Le Brun? What do you think of Mme Le Brun? And immediately the answer suggested is: Mme Le Brun — is she not astonishing?... the works of the modern Minerva are the first to attract the eyes of the spectator, call him back repeatedly, take hold of him, possess him, elicit from him

exclamations of pleasure and admiration ... the paintings in question are also the most highly praised, talked about topics of conversation in Paris.[27]

Bachaumont, however, qualifies his praise by pointing out that her celebrity was aided by her youth, appearance, powerful contacts and elegant entertainments.[28]

The greatest advantage of membership of the Académie was that it enabled artists to exhibit in the annual Salons, the supreme marketplace. The majority of women artists, however, had to rely on alternative institutions to display their work, such as the Salon de la Correspondance in Paris and other exhibiting societies which grew up to cater for the growing number of artists and spectators. (Membership of the Académie Royale did not, however, allow women to compete for the coveted Prix de Rome.)

In 1791 fresh attempts were made to persuade the Académie Royale to admit more than four women members. The response from Louis XVI's imperious arts minister, Comte d'Angiviller, was unequivocal: 'this number is adequate to honour talent: women can never be useful to the progress of the arts since the modesty of their sex prevents them from studying nude figures in the school established by Your Majesty.'[29] Since being unable to draw from life had nothing to do with women's modesty but everything to do with the Académie forbidding women to attend its schools, this was a wonderfully Catch-22 answer.

If the Académie Royale's attitude to women artists appeared unjust, admitting four women was double that of London's Royal Academy, which had elected Angelica Kauffman and Mary Moser as founder members in 1768 but declined to elect another (Dame Laura Knight) until 1936, 168 years later.

By exhibiting their work, women naturally laid themselves open

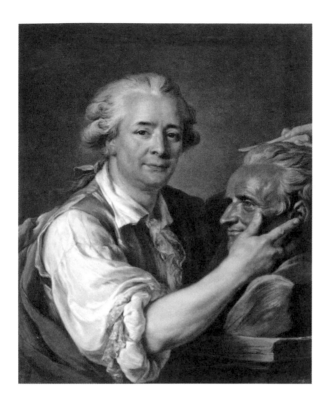

31. Adélaïde Labille-Guiard, *Augustin Pajou*, 1782

This painting, submitted by the artist as her reception piece
for the Académie Royale is, in effect, a double portrait as
it shows not only the sculptor Pajou but his teacher Jean-
Baptiste Lemoyne. Both Labille-Guiard and Vigée Le Brun
were accepted for membership on the same day,
encouraging the perception that they were rivals.

to critical appraisal which, in their case, was seldom objective because of their sex. Critics seemed unable, or unwilling, to judge their paintings purely on their merits. When Diderot reviewed Anna Dorothea Therbusch's reception-piece for the Académie, *The Drinker*, he first damned it as being 'empty and dry, hard and red', then added that 'it is not nevertheless without merit for a woman...'[30] His review of Vallayer-Coster's paintings exhibited in the Salon of 1771 carries the same sting in its tail: 'Excellent, vigorous, harmonious: it is not Chardin, but while it is below the level of that artist, it is greatly above that of a woman.'[31]

Despite the risks inherent in displaying their work, it was the principal way for any artist to reach a large audience without having to depend on middlemen and dealers. Portraitists, in particular, hoped thereby to gain commissions. An artist with as acute a head for business as Vigée Le Brun did not hesitate to paint subjects which she knew would attract buyers. Her portraits of herself embracing her daughter Julie brimmed with 'sensibility' and the virtues of motherhood popularised by Rousseau. These, and her other 'maternités' were extremely popular.

With typical foresight, Kauffman sent her portrait of David Garrick (he had sat for her in Naples in 1764) a year before she moved to London. It was exhibited at the Free Society of Arts where it attracted considerable attention, one critic proclaiming that she had 'burst upon the hemisphere of painting as a luminous wonder'.[32] This was a clever way of advertising her arrival in a city where the competition among portrait painters was fiercer than in any other European capital.

Labille-Guiard tried an even more audacious method of attracting a new clientele: her huge *Self-portrait with Two Pupils* (see p. 49) declared to the world her consummate skill at composition, sumptuous fabrics, warm glowing skin, intricate still life and her

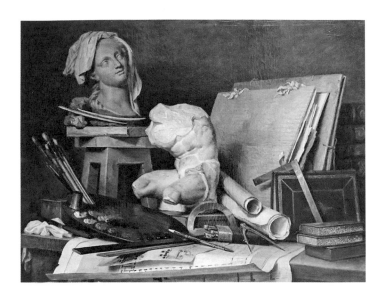

32. Anne Vallayer-Coster, *The Attributes of
Painting, Sculpture and Architecture*, 1769

On the basis of this painting, and its pendant *The Attributes of
Music*, the artist was unanimously elected as a full member of
the Académie Royale in 1770, the only woman to be accepted
during this period who was neither the wife nor the daughter of an
academician, and without official support from the royal family.

own physical attractions. Even the way she sits at her easel, splendidly attired and looking straight out of the painting, challenges the viewer to think otherwise. When the picture was exhibited at the Salon of 1785, it caused a sensation. One critic, clearly intending his comments to show his admiration, wrote: '... this artist is of very distinguished and rare merit, since she joins to the graces of her sex the vigour and the force which characterise the work of a man'.[33] (The painting was bought by Thomas Jefferson, then living in Paris as the American Minister, and is now in the Metropolitan Museum of Art, New York.)

The self-portrait that Angelica Kauffman presented to the Grand Duke of Tuscany for his gallery in the Uffizi fulfills the same purpose: though not on as grand a scale as Labille-Guiard's, it is nonetheless one of the largest in the collection. Arrayed in dazzling white, she presents herself not so much as an artist but as a mature and beautiful woman, poised, alluring and quietly confident of her achievements and of her place in the world. The fact that it was hung next to a self-portrait by Michelangelo was possibly fortuitous, but cannot have done her any harm.

The era of exhibitions had awoken an interest in art among every stratum of society. The response to this new awareness was a phenomenal spread of the print trade, especially in England. Prints played a vital role in promoting artists' work and there was a constant flow of paintings from their studios to the engravers. Mezzotints – the great reproductive process of the eighteenth century – produced prints that were close in appearance to oil paintings. Prints were cheap and easily acquired at print sales, from dealers and print shops. By 1800 no English town of any size was without its print shop. Now everyone, from the aristocrat in his mansion to the peasant in his hovel, could possess prints of the work of their favourite artists, dead or alive, British or European. Their walls

could be adorned with everything from portraits to satirical prints, from Hogarth's *Marriage à-la-Mode* to Greuze's sentimental and moralising domestic scenes.

It became fashionable to devote an entire room to prints. Louisa Conolly (one of the Duke of Richmond's daughters), wife of the richest man in Ireland, assembled her print room at Castletown by pasting prints on to cream-painted wallpaper which she then decorated with elaborate frames, bows and swags that she cut from pattern sheets purchased ready-made from printers. The prints themselves could be bought either singly or in packets of up to ten or more. Louisa wrote to her sister Sarah in England: 'any time that you chance to go into a print shop, I should be obliged to you if you would buy me five or six large prints.'[34] She then specifies the artists she hopes to add to her collection.

For Angelica Kauffman, who specialised in dramatic scenes showing 'affecting moments' — heroines facing dire dilemmas — the explosion of the print market in England could not have been better timed. Nor could she have been in a better place because of the high quality of the engravers. Of the over seventy-five who copied her paintings and drawings,[35] William Ryland was the one most responsible for spreading her fame, initially with mezzotints, later with stipple engravings, a technique mastered by Ryland and Francesco Bartolozzi which imitated a red or sepia chalk drawing and which perfectly suited Kauffman's flowing lines and soft draperies. Ryland's stipple engraving of her painting of Maria was a multi-media sensation. There were more singly issued stipples engraved in England after Kauffman's work than after any other painter.[36]

Even when Kauffman moved to Italy, she continued to send paintings back to London to be engraved, thus keeping her name in the public eye. Her subjects had a special appeal for women and

many of them were probably bought as 'furniture prints' by women like Louisa Conolly.

Vigée Le Brun, ever alert to ways of making money, records the effect of her self-portrait, inspired by Rubens's *Chapeau de Paille*, when an engraving of it was exhibited at the Salon. She had taken great trouble to capture the brilliance of Rubens's technique, filling the picture with light. 'I must say', she recorded in her *Memoirs*, 'it did much to enhance my reputation,' but she felt that 'the black shadows of an engraving take away all the particular effect of a painting such as this'.[37]

Vallayer-Coster took advantage of the fashion for engravings of flowers by commissioning sets of prints that could be used by painters, designers, embroiderers, craft manufactories and fan makers. Some of her exquisite flower pieces also provided models for tapestries woven at the Gobelins Manufactory, where her father had worked for many years. Print sets also served as examples for use by female amateur artists. One set declared that it would 'offer riches to the amiable sex to embellish those moments of the day that it will devote to drawing and to embroidery' – which gives a depressing glimpse of how women attempted to while away their time in the eighteenth century.[38]

The printer and bookseller Rudolph Ackermann published dozens of prints after drawings by Maria Cosway. In his introduction to one series of drawings, he wrote: 'Mrs Cosway's designs, it must be admitted, are sometimes eccentric, but it is the eccentricity of genius, and we have seen instances where she has "snatched a grace beyond the reach of art".'[39]

By 1787 English prints had become so sought after that at print sales French buyers outnumbered English buyers by three to one, and by the end of the century London had become the centre of the European print trade.[40] One Dutch collector commented in

33. Angelica Kauffman, *Maria*, 1777
Kauffman was one of the artists who most benefitted from
England's print revolution in the latter part of the century.
Her depiction of Maria remains faithful to Laurence Sterne's
description of the abandoned and inconsolable maiden in
A Sentimental Journey. Engravings after this painting became
one of Kauffman's most popular and widespread images.

1821: 'The craze for English engravings during the last fifty years is extraordinary. Everyone has developed a taste for them.'[41]

One of the dealers most responsible for establishing the supremacy of English engravings was John Boydell. When he opened his Shakespeare Gallery in Pall Mall, it displayed thirty-four paintings by eighteen British artists. Nearly all the big names, from Reynolds to Benjamin West to Fuseli contributed paintings depicting scenes from Shakespeare's plays. Angelica Kauffman supplied two stipples, one from *The Two Gentlemen of Verona* and one from *Troilus and Cressida*.

By selecting which paintings were to be engraved, a leading print-seller like Boydell exerted an enormous influence on the shaping of public taste. And his influence did not end there: he commissioned many new works by native artists, employed a host of printmakers to make reproductive engravings and then, as part of an international network of dealers, distributed them not just to Europe but to the Americas, Russia and even to India. He was, in effect, a powerful patron.

The tiny number of women who were fortunate enough to attain membership of an academy — which ensured their work was exhibited annually — attracted buyers far more easily than those who did not enjoy the protection of such institutions. For them, other resources had to be found. But what resources did they have? Society frowned on a woman who promoted herself; there were very few public spaces where she could show her work and if she had yet to establish her reputation she could not sell her paintings through an art dealer or auction house. However, securing a patron, preferably several, could save her from languishing in obscurity. For artists who were already well-established, patronage — especially royal patronage — could transform them into celebrities.

7

The patrons

Is not a Patron, my Lord [Chesterfield], one who looks with
unconcern on a Man struggling for Life in the water, and,
when he has reached ground, encumbers him with help?
DR SAMUEL JOHNSON TO LORD CHESTERFIELD, 7 FEBRUARY 1755[1]

In 1748 Samuel Johnson dedicated his *Plan of a Dictionary of the English Language* to Lord Chesterfield. His Lordship accepted the dedication but then promptly forgot about him. Seven years later, when the great work was completed, Chesterfield bestirred himself sufficiently to send two short letters of recommendation to a fashionable newspaper. It was this belated aid — when it was no longer needed — rather than the years of neglect that riled Johnson. He recorded his view of patronage in the *Dictionary* by defining a patron as 'One who countenances, supports or protects. Commonly a wretch who supports with insolence, and is paid with flattery.'

Happily for them, many women artists enjoyed more fruitful and congenial relations with their patrons: Angelica Kauffman could not have succeeded as a history painter without the support of two major patrons; Anne Forbes was able to study in Italy thanks to the financial backing she received from a group of Edinburgh

businessmen; numerous artists, like Labille-Guiard and Vigée Le Brun, benefitted immeasurably from royal patronage. Securing a royal patron was the dream of every artist, male or female.

Patrons were essential to an artist's success. But how to attract them? Reynolds gave his nephew a piece of shrewd advice: 'To make it peoples' interest to advance you, that their business will be better done by you than by any other person, is the only solid foundation of hope, the rest is accident.'[2] To this recipe could be added some discreet wooing, a degree of calculation, occasional manipulation and being in the right place at the right time.

Patrons came in several guises: there is no evidence that Abbé Grant, a Jesuit priest and antiquary, supported the Scottish portrait painter Catherine Read financially during her years in Rome, but he acted as her chaperone and helped her to establish a clientele among the Italian aristocracy and visiting Grand Tourists. Although well known in her native Venice, Rosalba Carriera's fortunes were transformed when the wealthy financier and collector, Pierre Crozat, invited her to Paris, installed her in a large suite in his house and introduced her to a wide circle of *cognoscenti* and to members of the Court. Print-sellers like John Boydell brought an artist's work to the attention – and within the financial reach – of a very different stratum of society than those who dwelt in marble halls.

In general, patronage was a male preserve since it was men who possessed the education, the contacts and the money. Just how much influence a wife exercised on her husband's taste is impossible to estimate since women, by their very nature and by virtue of their position in society, worked behind the scenes. The Goncourt brothers, with their possibly inflated view of the power wielded by women in the eighteenth century, maintained that 'Woman loved art' and that 'the arts depended upon her... Accordingly, from

Watteau to Greuze, not a great name arose, no talent or genius won recognition unless it had the merit of pleasing woman, unless it had caressed, touched or pleased her eye and paid court to her sex.'[3]

There was one group of women who undoubtedly influenced the world of art and letters: the hostesses of the Paris salons. Learned women like Mme du Deffand, Mme de Sevigné and Mme Geoffrin brought together in their homes men and women of intellect and breeding to exchange ideas on everything from religion to philosophy and science. These *salonnières* had the confidence to throw their net wide enough to include individuals who fell outside their own social milieu but had something interesting or original to contribute. Mme Geoffrin not only entertained many of the leading *philosophes* and *Encyclopédistes* of her time but was considered by many contemporaries to be one of the most influential patrons of art, supporting numerous artists and commissioning a number of works.

Vigée Le Brun was one of the artists who mixed with the *habitués* of Mme Geoffrin's salon, several of whom commissioned her to paint their portraits.

One of them, the Comte de Vaudreuil — a member of Marie Antoinette's intimate circle, although she was said to dislike him — was to become her most important private patron, owner of three of her best works including the immensely seductive *Self-Portrait in a Straw Hat* which is now in London's National Gallery. Her portrait of him, painted in 1784 is rather insipid — despite the rumour that they were lovers — and does little to confirm her glowing description of him in her *Memoirs* as being 'a fine figure of a man' and 'remarkably noble and elegant'.[4]

In England, the only assembly of intellectuals that could be compared to the French salon was the Bluestocking Circle, presided

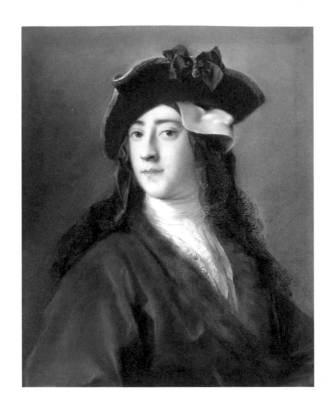

34. Rosalba Carriera, *Portrait of Gustavus
Hamilton, 2nd Viscount Boyne*, 1730–31

Having their portraits painted was almost de *rigueur*
for young English aristocrats travelling in Italy on their
Grand Tours, and Viscount Boyne was no exception.
In Rome they tended to patronise the reigning king of
portraiture, Pompeo Batoni, but in Venice it was often
Carriera. Boyne arrived in the city during Carnival, and
looks as if he chose to be painted in his Carnival hat.

over by a rich widow and patroness of the arts, Elizabeth Montagu. (The name was said to derive from the blue worsted stockings worn by members of the group.) Meetings were held either in her house in Hill Street or Montagu House in Portman Square in London's fashionable Mayfair district, and were almost entirely composed of literary ladies, with a sprinkling of male writers and gossips such as Horace Walpole.

Among the artists Mrs Montagu employed for the embellishment of Montagu House was Angelica Kauffman: several of her 'mechanical paintings' are said to have been incorporated into its decorative schemes. (The house was blown to smithereens by an incendiary bomb during the Blitz, the site now occupied by the Radisson Hotel.)

Adélaïde Labille-Guiard also had cause to be grateful to a powerful female patron: the Comtesse d'Angiviller, wife of the Director of the Académie Royale. In the 1760s and 1770s the Countess hosted 'all the court' and 'all the famous men of the century' at weekly gatherings at her house in Paris, achieving a reputation as a *salonnière* to rival that of Mme Geoffrin.[5] The Countess commissioned two portraits from the artist, but it was as a protector of her reputation that she proved invaluable. Labille-Guiard had become the butt of a libellous pamphlet accusing her of trading sexual favours for help with her painting. The Countess interceded on her behalf and, as a result, copies of the pamphlet were taken out of circulation.[6]

Italy was a particularly fertile ground for artists to find patrons. Young English milords, dispatched abroad on today's equivalent of a gap year — although the eighteenth-century version could last as long as three — roamed through Italy in search of culture, enlightenment and other less elevated amusements. Equipped with a classical education, they believed that all roads led to Rome and

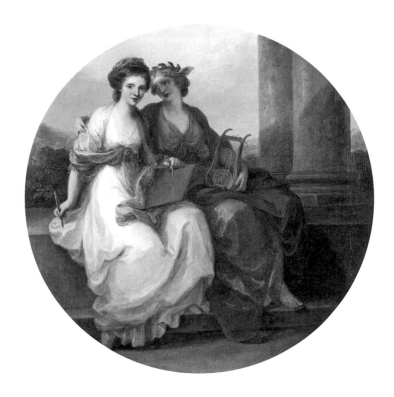

35. Angelica Kauffman, *Self-portrait in the
Character of Painting Embraced by Poetry*, 1782
This painting was a gift from the artist to one of her most
important patrons, George Bowles. She has depicted herself
as Painting while Poetry, cradling a lyre, embraces her. In the
Memorandum of Paintings compiled by her husband Antonio
Zucchi, Painting 'is listening eagerly to the suggestions of Poetry'.
This type of 'friendship' portrait usually featured married couples.

that only those acquainted with Italy's treasures could aspire to a knowledge of great art. Frequently heirs to vast ancestral piles, they sought to enhance them further with statuary and works by High Renaissance artists. Inevitably, they fell easy prey to persuasive dealers, returning to Britain with booty of often doubtful worth: a statue which was 'a patchwork head of *Trajan* set upon a modern pair of shoulders, and made up with *Caracalla's* nose and *Nero's* ears…' or 'a veritable daubing of *Raffaelle*, copied from the very print which is given to prove its originality…'[7]

Once home, they built galleries to house their purchases. The eccentric Earl of Bristol and Bishop of Derry, who was known as the Earl-Bishop, designed Ickworth in Suffolk as a museum in which to display his collection of paintings and antiquities; domestic comfort was the least of his concerns. A familiar figure around Europe — where he spent a great deal more of his time than he gave to his episcopal duties — he was a compulsive buyer and commissioner of art, though an erratic payer. 'The Earl of Bristol [...] had given a great many commissions besides to different artists here [in Rome]', wrote the sculptor John Deare, 'and just as we all expected orders on his banker his Lordship suddenly (as usual) left Rome without giving any orders.'[8]

He even bought the famous Temple of Vesta at Tivoli, planning to carry it off to England but, fortunately for posterity, was prevented from doing so by the Roman government. Among his numerous commissions were paintings by both Kauffman and Vigée Le Brun. The latter painted him twice, once in Rome and later in Naples, with Vesuvius, a curl of smoke at its summit, in the background. (He was obsessed by the volcano, climbing it repeatedly.) He also conceived a fancy for the self-portrait that Vigée Le Brun had painted for the prestigious Medici collection of self-portraits in the Uffizi and she duly painted a replica of it for him. It was

rumoured that the Earl-Bishop was so charmed by the painting that he hung it where he could see it from his bed.

Kauffman painted the Earl-Bishop in 1790, seated by a bust of the great Roman patron Maecenas, a suitable attribute for one who saw himself as emulating his distant predecessor. In his view Kauffman should be ranked on a par with other major artists, both past and present. 'What say you', he wrote in 1796 to his daughter Lady Elizabeth Foster, 'to my idea of a gallery of German painters contrasted with a gallery of Italian painters, from Albert Dürer to Angelica Kauffman [who was born in Switzerland], and from Cimabue to Pompeo Batoni...?'⁹ However, none of this was to come to pass as his collection was confiscated in Rome by Napoleon's troops in 1798, then dispersed by auction in 1804.

Kauffman's beautiful portrait of Lady Elizabeth (see p. 82) was painted many years before she became the second wife of the Duke of Devonshire. When the Duke died, leaving her a wealthy widow, she moved to Rome and spent her last years indulging her passion for art and patronising many of the artists resident in the city. One, the great Neoclassical sculptor Antonio Canova, she introduced to her stepson Hart (later 6th Duke of Devonshire) who was so enraptured by his work that he bought six pieces of his sculpture for Chatsworth. In the view of Angelica Goodden, Kauffman's most recent biographer, the 'charm of some of Canova's works – his Chatsworth *Hebe*, for example' – seems indebted to Kauffman.¹⁰ The sculptor became a great friend of Angelica's when she and her husband returned to Italy and took up residence in Rome.

Despite the general rule that patrons were usually men, Angelica Kauffman proved herself adept at attracting female patronage throughout her life, and it was the advice of one of these women that fundamentally altered the course of her career. Bridget, Lady

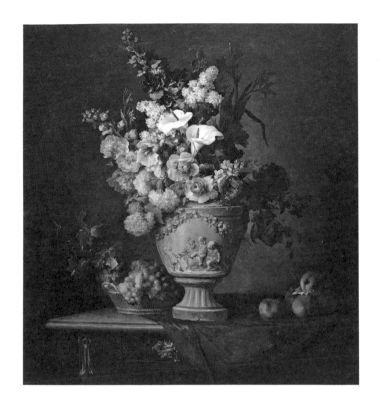

36. Anne Vallayer-Coster, *Bouquet of Flowers in a
Terracotta Vase, with Peaches and Grapes, 1776*
Throughout her life Vallayer-Coster attracted the support
of powerful patrons among a Parisian elite who were committed
to buying French art, especially work by contemporary
artists. In 1780 she was made painter to Marie Antoinette.
Sets of prints made from her flower paintings were
used as designs by Gobelins and Sèvres.

Wentworth, wife of the British consul in Venice, had met Kauffman, then in her twenties, when she was living in Italy with her father. Kauffman had already built up a considerable clientele, not so much among the Italian aristocracy – who had little interest in portraits – but among the English Grand Tourists. Lady Wentworth persuaded her that London – acknowledged as the portrait capital of the world – would open its arms to an artist of her calibre and character. She then accompanied Angelica to London, helped her to establish her first studio and introduced her to her society friends.

At that time 'society' consisted of a tiny élite of no more than 300 families – 'all cousins', as Lord Melbourne once described them – and within a year Kauffman was caught up in a veritable network of female patronage. Commissions for portraits included the Marchioness of Townshend, the Duchess of Richmond, her friend Frances Anne Hoare of Stourhead and a large state portrait of Augusta, Duchess of Brunswick (George III's sister) with her baby son. Kauffman depicted the Duchess standing in a graceful pose, wearing one of the flowing, shapeless garments recommended by Reynolds as a more dignified style for a female sitter than modern dress. This portrait prompted a visit to Kauffman's studio by the King's mother, the Princess of Wales, an unheard of distinction for an artist and proof that as a portraitist Angelica's success in England was assured.

While these commissions undoubtedly paid the rent, Kauffman's principal ambition – and one that set her apart from most of her fellow artists – was to succeed as a history painter. That she did so was due not only to her classical education and early training in Italy, but to the consistent patronage of Englishmen, George Bowles and John Parker.

Kauffman first met John Parker in 1764 in Naples while he

37. Marie-Guillemine Benoist, *Portrait of Pauline Bonaparte, Princess Borghese*, 1808
Wealthy patrons were essential for an artist's success and royal – or, in this case, imperial – patrons were the most valuable. The sitter was Napoleon's favourite sibling. Her second husband, Prince Borghese, was one of the richest men in Italy. Benoist has depicted her as demure and chaste, whereas in reality she was sexually rapacious.

was on honeymoon with his first wife (who died the same year) and had painted his portrait. On his return to England Parker had married again to Theresa, daughter of the 1st Baron Grantham. The second Mrs Parker — who was only three years younger than Kauffman — was, by all accounts, a delightful young woman. Reynolds, a close friend of Parker's, wrote her eulogy when she died at the age of thirty-one, describing her as a woman of 'skill and exact judgement in the fine arts', and it was almost certainly Theresa's artistic taste that influenced the redecoration of Saltram Park in Devon which her husband inherited in 1769.

Robert Adam, the most fashionable Neoclassical architect and interior designer of the day, was commissioned to design the Grand Saloon at Saltram, and it seems likely 'that four of Kauffman's history paintings were specifically commissioned as part of the decorative scheme for this room'.[11] She had exhibited three of the paintings — all of subjects taken from the Trojan legend — at the Society of Artists in 1768, and these three, with one other on the same theme, were shown a year later at the Royal Academy's first ever exhibition. Her paintings were a critical success, a reviewer describing her as 'an Italian young lady of uncommon genius and merit'.[12]

The patron who was to hold the largest collection of Kauffman's work was George Bowles, a wealthy glass manufacturer, who bought or commissioned more than fifty of her paintings, continuing to do so even when she left England in 1781 to return to Italy. Kauffman demonstrated her gratitude to him for his loyal patronage by sending him as a gift a charming picture, *Self-Portrait in the Character of Painting Embraced by Poetry*.[13]

Kauffman and Vigée Le Brun shared several patrons in common. Sir William Hamilton, Britain's envoy to the Kingdom of the Two Sicilies, based in Naples, commissioned both artists to

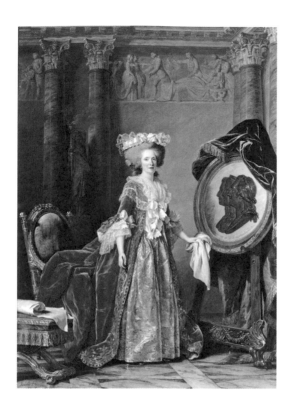

38. Adélaïde Labille-Guiard,
Madame Adélaïde, 1787

This painting of Louis XVI's aunt received rave
reviews from several critics and consolidated the
artist's reputation as a portraitist. But her climb up
the professional ladder could not have been more
badly timed: within two years of her painting this
portrait, the Revolution broke out and the monarchy
– and with it many of her clients – was doomed.

paint his beloved mistress (later wife), Emma Hart. In a letter to a former lover — which reveals that Emma's grasp of written English was rudimentary — she wrote proudly: 'The house is ful of painters painting me. He as now got nine pictures of me, and 2 a painting ... All the artists is come from Rome to study me, that Sir William as fitted up a room, that is calld the painting-room.'[14]

Emma was the most sought-after sitter of the century, portrayed by everyone from Romney (said to have painted her up to sixty times) to Benjamin West, Lawrence and Reynolds. They caught her legendary beauty early, before she grew monstrously fat. Vigée Le Brun painted several portraits of her: in sultry mode, languishing on a leopard skin (Admiral Nelson, Emma's last lover, later bought this portrait from Sir William); as a ruby-lipped sibyl gazing heavenwards in a huge turban; and as a flirtatious bacchante, laughing over her shoulder as she twirls away from the viewer in a joyous dance. Vigée Le Brun also painted a miniature of her, which Nelson kept hung around his neck on a ribbon. When he lay dying on board *HMS Victory*, he entrusted it to Captain Hardy for safekeeping, with the injunction: 'Pray let my dear Lady Hamilton have my hair, and all other things belonging to me.'[15]

Kauffman's only portrait of Emma, commissioned by Sir William to celebrate their recent marriage, shows her in one of her 'attitudes', dressed in virginal white and holding aloft a theatrical mask. Her head is cocked at an anatomically-impossible angle as she regards the viewer with a look of sweet innocence. Kauffman had seen Emma as an alluring but submissive charmer; Vigée Le Brun portrayed her as a temptress.

Another client they shared in common was the beautiful young wife of Count Skavronsky, Russian plenipotentiary in Naples. The Countess, one-time mistress of her uncle Prince Grigory Potemkin — who had been one of Empress Catherine's many lovers — was

painted three times in Naples by Vigée Le Brun, who left a lovely description of her in her *Memoirs*: she was 'as sweet and as pretty as an angel. I remember her telling me that in order to go to sleep she had a slave under her bed who told her the same story every night. She was utterly idle all day, she had no education, and her conversation was quite empty. But in spite of all that, thanks to her lovely face and her angelic sweetness, she had an incomparable charm.'[16] The brilliance of Vigée Le Brun's portraits is that they reflect every part of this description. Kauffman painted Skavronskaya twice, once in Naples in 1785 and then in Rome four years later, but neither portrait captures the countess's languid beauty.

While wealthy and devoted private patrons were invaluable, royal patronage could change the course of an artist's career. In the eighteenth century well-established monarchies ruled most of Europe, and once an artist got a foot in a royal door, he or she had access to numerous members of the royal family who required not just one portrait but several copies to distribute among their relations and friends. Labille-Guiard's portrait of Louis XVI's aunt Mme Adélaïde was so successful that she was commissioned to supply three copies, all over 1.8 m in height, to be given as gifts to noblewomen in Madame's entourage.[17] In the portrait Mme Adélaïde, wearing a robe of sumptuous red velvet embellished with gold embroidery, stands against a background of Corinthian columns. Yards of frothy lace cascades down her bosom and adorns her sleeves. A frilled butterfly cap is perched – like a poached egg on toast – on top of her fashionably outsized coiffure. An aged Madame gazes sternly out of all this finery, her mouth set in a prim line – possibly to conceal her complete lack of teeth, except for the front two. Although financially rewarding, having to repeat this immensely complex image must have been not only wearisome but have entailed months of exhausting work for Labille-Guiard.

Working at a royal court had particular advantages for women artists: it relieved them of the unfeminine activity of promoting themselves in the marketplace, gave them a secure income and raised their status in society. That it was often female royals who commissioned portraits was yet another advantage as it was considered more suitable for a woman to spend hours closeted with a female rather than a male artist.

Germany — then a jigsaw of small states — was a particularly fruitful hunting ground for artists. The Polish painter Anna Dorothea Therbusch worked at both the Mannheim and Palatine courts and also painted Frederick the Great, King of Prussia, trussed up in black velvet and pointing to his hat which — for some inscrutable reason — is balanced on a rock beside him. Britain's Hanoverian king, George III, was a major collector of Rosalba Carriera's work, and she also sold more than 150 of her pastels to the Elector of Saxony, who devoted a gallery in his court at Dresden to their display.[18]

While painting at court offered a safe haven, especially to a woman artist, it was also full of traps for the unwary. Protocol could be stifling, the web of relationships within the court labyrinthine, gossip and rumour all-pervasive. Woe betide the artist who did not tread carefully through this quagmire. However intimate they might become with their royal sitters, however attractive their appearance and personality, they must never forget that they were outsiders and commoners, there simply to perform a task. Only a handful of women artists managed this skilful balancing act, among them Adélaïde Labille-Guiard and Elisabeth Vigée Le Brun.

Vigée Le Brun became the most important painter at the French court, portraying all of the royal family except for the King and one of his brothers. Over the course of ten years she painted Marie

Antoinette some twenty times. Two of the portraits stand out from the rest: one because it presented the Queen so informally; the second because it deliberately set out to reverse this impression.

The first, painted in 1783, shows Marie Antoinette wearing a dress of ruffled white muslin, an enormous straw hat and holding a rose, a flower she had adopted as her symbol. The style of dress had originated with the Creole women of the West Indies, who used indigo to blue-rinse the muslin to a startling white.[19] This image suited the Queen's romantic idea of herself playing at being a shepherdess in the hamlet at the Petit Trianon, and freed her from wearing the elaborate court dresses she so abhorred. Vigée Le Brun, with her love of simple clothes and unpowdered hair, recorded in her *Memoirs* how much she had 'preferred to paint [the Queen] without any ostentatious dress', but when the portrait was exhibited at the Salon it caused an uproar.[20] Vigée Le Brun was accused of painting the Queen in 'her underwear', and the portrait had to be withdrawn.

The second painting, *Portrait of Marie Antoinette with Her Children*, could not be more different. Painted barely two years before the Revolution, it was a conscious attempt to change the public's perception of Marie Antoinette from the extravagant, licentious, monstrous (she was accused of lesbianism) and hated *l'Autrichienne* to that of a wife, mother and gracious Queen of France. The fact that the portrait was commissioned by the office of the King's Director of Buildings shows that Vigée Le Brun had been instructed to produce what was, in effect, a piece of political propaganda.[21]

The painting depicts Marie Antoinette robed in crimson velvet, seated in the Salon de la Paix at Versailles, surrounded by her three children. The absence of her fourth child Sophie, who died while the portrait was being painted, is indicated by the Dauphin who points to the empty cradle. The Queen manages to look both regal

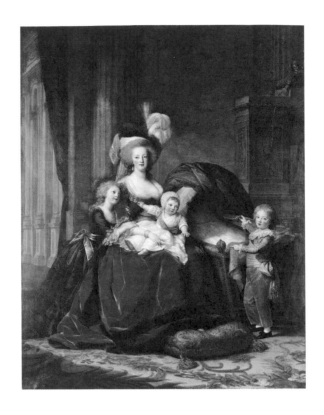

39. Elisabeth Vigée Le Brun,
Marie Antoinette and Her Children, 1787
When the artist was commissioned to paint this
monumental image of the Queen and her children, she
took the advice of Jacques-Louis David and conceived of
a triangular composition to mirror Renaissance depictions
of the Holy Family. The painting was not a success. One
of several criticisms was the radiance of the Queen's
skin, considered unlikely for a woman of thirty.

and motherly at the same time, the children bright-eyed and endearing, the background majestic. But when it was exhibited at the Salon in 1787, viewers were struck by the sadness of the faces.

The painting had a poignant history: when the Dauphin also died, in June 1789, less than a month before the fall of the Bastille, the heartbroken Queen ordered it to be removed from its prominent position in the Salon de Mars and hidden away out of her sight.[22] Its banishment almost certainly saved it from being slashed to pieces by the Parisian market-women when they invaded the Palace on 5 October, running riot through the glittering halls, bent on killing the Queen. On the following day, the royal family was forced to accompany the mob back to Paris. That night Vigée Le Brun, an ardent and unrepentant royalist, went into exile. When she returned to France in 1802, she found the painting in a private room at Versailles, its face turned to the wall. She was never paid for it – 'allegedly because émigrés were ineligible for such payments'.[23]

Vigée Le Brun's years of court patronage had enriched her financially and socially. She was one of the few of her class to be invited into the Queen's private apartments, where they sang duets together during the sittings, although, as she recalls, 'her voice was not always perfectly pitched'.[24] But this favouritism proved to be a double-edged sword: as the French monarchy imploded, all those with royal connections were in mortal danger, and Vigée Le Brun took the only course open to her by leaving France.

Labille-Guiard, despite the huge success of her two life-size portraits of 'Mesdames' (Louis XVI's aunts), managed to survive the Revolution without having to go into exile. Being named 'premier Peintre des Mesdames', however, was not a happy title to possess in 1789. The previous year she had had every reason to feel optimistic as she had received a career-changing commission to

paint the Comte de Provence (Louis XVI's elder brother) in his role as grand master of the Chevaliers de Saint-Lazare, for which she was to receive a handsome fee. The painting was enormous, with over a dozen figures, most of them individual portraits. But the fate of the painting proved far worse than Vigée Le Brun's portrait of the Queen and her children.

In 1791 the Comte de Provence fled abroad, as did many of Labille-Guiard's clients, including the Mesdames, who did so without paying her for several completed portraits.[25] In January 1793 the King was guillotined; in June the Reign of Terror began; four months later Marie Antoinette was led to the scaffold. In the ensuing chaos, it was decreed that anything which glorified the monarchy was to be burnt. The sight of bonfires of works of art became commonplace in Paris. As Labille-Guiard's painting undoubtedly fulfilled this criterion, it was among those consigned to the flames. She was paid neither her expenses nor her fee for this giant work of art – but she was alive.

Despite the patronage of Marie Antoinette and other members of the royal family, the still-life artist Anne Vallayer-Coster also survived the Revolution without having to leave France. The political neutrality of her subject matter, her seriousness of purpose and the modest charm of her personality were all factors that saved her from the guillotine. A cousin to Louis XV, the Prince de Conti – one of the most prestigious collectors of the second half of the century – was an important client, buying one of her best known paintings, *Still life with Seashells and Coral*.[26] Her beautifully composed, vibrant still lifes also appealed to wealthy bankers and merchants who bought them to decorate their grand houses in Paris.

In Britain, association with the court brought no such dangers. For Angelica Kauffman, her arrival in London in 1766 – four years after George III came to the throne and within two years of

the founding of the Royal Academy — was perfectly timed. That she was born in Switzerland, spoke fluent German and was, indeed, considered German (since 'in eighteenth-century terms the word "deutsch" referred as much to language as to geography and culture'[27]), were positive advantages to an artist seeking royal patrons among members of the House of Hanover.

The King's sister, Augusta, Duchess of Brunswick, was the first of the family to have her portrait painted by Kauffman. It received high praise in the newspapers, verses were written in its honour, and the visit by the Princess of Wales to Kauffman's studio to see the picture was later followed by an introduction to Queen Charlotte. The Queen had already proved herself a keen patroness of female artists by supporting Mary Moser and Catherine Read, and also by lobbying for the admission of Kauffman and Moser as founding members of the Royal Academy. Kauffman's portrait of the Queen, *Her Majesty Queen Charlotte Raising the Genius of the Fine Arts*, painted in 1772, pays tribute to this patronage.

Kauffman's ability to attract female patrons continued when she left England to live in Italy. In Naples, she was pounced upon by Maria Carolina, Queen of the Two Sicilies, a fearsome woman who already owned a large collection of Kauffman's prints and tried vainly to persuade her to accept the position of court painter. The group portrait Kauffman painted of the Queen, her husband, Ferdinand IV, and six of their seventeen children (no fewer than eight died in their infancy of smallpox) is ludicrously flattering, and tells viewers all they need to know about being a successful portraitist. The King, who in reality was short and scrawny, with a huge bulbous nose, pig's eyes and a 'forest of coffee-coloured hair, which he never powders',[28] is portrayed by Kauffman as tall and ineffably elegant, while his dumpy wife is the epitome of relaxed grace. The three dogs in the picture are probably the only figures

to be faithfully represented. But the price she was paid for this travesty was gratifyingly large.

Kauffman also painted a 'monumental and many-figured'[29] history painting for Catherine the Great, who already owned a number of her works and whose exalted patronage ensured that other Russian clients commissioned her, including her son Paul. Catherine made no bones about her preference for the work and character of Kauffman over that of her principal rival, Vigée Le Brun, declaring that Kauffman 'unites elegance with nobility in all her figures' and that they all 'possess ideal beauty'. Vigée Le Brun, she complained, had made her granddaughters look like 'two pugs basking in the sun'.[30]

Kauffman and Vigée Le Brun achieved celebrity status in their lifetimes, and it was their ability to attract patronage that played a great part in their success. Vigée Le Brun's title of 'Painter to Marie Antoinette', though lethal in France following the Revolution, preceded her arrival in cities throughout Europe and Russia, bringing wealthy and aristocratic clients to her door. Kauffman's patrons were not so widely spread, but they were numerous and faithful, particularly the two great collectors whose patronage enabled her to continue with her history painting, George Bowles and John Parker.

The two artists, though very different in character and style of painting, shared one overriding feature: their private lives took second place to their working lives. The same applies to the great majority of women who achieved success as professional artists during the eighteenth century.

8

Private lives

*Do not be angry if at first my heart bled in making this decision — a decision
demanded by a social prejudice to which one must submit after all. But so much
study, effort, a life of hard work, and after the long trials, the success, and to
see them almost an object of humiliation — I could not bear that idea.*

MME BENOIST TO HER HUSBAND, 1 OCTOBER 1814[1]

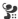

This cry from the heart came from the French artist Marie-
Guillemine Benoist (1768–1826) in a letter to her husband when
his acceptance of an important government appointment forced
her to abandon her career as an artist. For him to be married to a
wife who earned money from her art would have been considered
highly improper. And society at that time was so small, so close knit
that it was almost impossible to offend against its norms and get
away with it. Any woman who put her work before marriage and
child-bearing attracted attention; if she was also good-looking, she
laid herself open to gossip and speculation. This was the age of the
newspaper and periodical, the political broadside, the wicked satires
of Alexander Pope and Thomas Rowlandson. In France, no-one
suffered more from attacks by the press and the *libellistes* (pamphle-
teers) than Marie Antoinette, who was accused of everything from
unspeakable perversions to spying for her native country, Austria.

When contemplating the private lives of the women artists featured in this book it is hard to resist the conclusion that a major factor in their success as professional artists was their ability to focus their time almost exclusively on their careers. They either remained single, married for convenience, or married late in life. Very few of them had children (although the Dutch flower painter, Rachel Ruysch, overturns this generalisation by giving birth to ten), thus they were free of many of the domestic ties and complications inherent in family life. This prompts a 'horse and cart' question: did the pursuit of their art push the need for a husband and children into second place, or did they pursue their careers to fill the void caused by the lack of fulfilling private lives? The nineteenth-century American sculptor, Harriet Hosmer (1830–1908), who left America for Rome in 1852 to study sculpture, answers the question without hesitation: she considered marriage 'a moral wrong' for a woman artist, 'for she must neglect her profession or her family, becoming neither a good wife and mother nor a good artist'.[2]

Whether a male artist married or not caused little interest, although in his *Advice to Painters, Art Lovers, and Poets, and For People of All Ranks* (1604), Carel Van Mander reminded the aspiring young artist that as 'Painters belong in the environment of princes and learned people', they should behave themselves: 'Do not waste time. Do not get drunk or fight. Do not draw attention by living an immoral life. Thank God for your talent and do not be conceited. Do not fall in love too young and do not marry too soon...'[3]

Against her better judgement, Elisabeth Vigée Le Brun married at the age of twenty, partly at the urging of her mother and partly to escape her hated stepfather. She had already built up an impressive clientele and earned enough money to remain independent. Once married, all her earnings would become the property of her

husband, Jean-Baptiste-Pierre Le Brun, a distinguished art connoisseur and dealer in Old Masters. In her *Memoirs*, she repeatedly accused him of squandering her money on gambling and on 'his overwhelming passion for extravagant women'.[4] But, as her biographer Angelica Goodden so delicately puts it, Vigée Le Brun's 'artistic licence is as apparent in her memoirs as in the more flattering of her portraits',[5] and her life-long obsession with money – which she undoubtedly worked ceaselessly to earn – probably coloured her feelings for her husband. Nevertheless, he was a tolerant and accommodating spouse who allowed her the freedom to pursue her career as a professional artist – which is more than can be said for the majority of eighteenth-century husbands. When her association with Marie Antoinette and the French court drove her into exile in 1789, Le Brun, fearful that his wife's status as an *émigrée* would result in the confiscation of his property, divorced her in 1794.[6] This did not prevent his later attempts to have her name removed from the list of *émigrés* so that she could return to France. In this he was not alone: several well-known artists, including Fragonard, David and Vigée Le Brun's friend Hubert Robert were all signatories to a letter to the Director of the Académie Royale arguing for her reinstatement as a French citizen. She was finally removed from the list in 1800 and was back in Paris in early 1802.

Vigée Le Brun had been in exile for twelve years. She was a natural traveller, exalting in the beauty of the landscapes she passed through. Her reputation as a woman of beauty and talent preceded her and she was received by Europe's nobility with fascination and lucrative commissions. She painted her way from Naples to St Petersburg, returning to Paris a wealthy woman. Her work during those years reflects the *douceur de vivre* that she continued to cling to, despite evidence that the old realities were crumbling – and nowhere

more so than in her own country. Some of her Russian portraits display a new intensity: women like Countess Golovina and Varvara Ladomirskaya gaze directly at the viewer, their faces alive with intelligence and personality – a far cry from the vacuous beauties she had so often portrayed.

During all these travels she was accompanied by her daughter Julie (a second daughter had died in infancy) whom she adored but was accused of neglecting for her art. During their years in Russia, Julie's marriage to a man Vigée Le Brun thought unsuitable caused a major rift between them, and when Vigée Le Brun returned to France she was alone. It was five years before they met again. By then, Julie and the 'unsuitable' husband were in Paris, but they eventually separated. Mother and daughter remained on uneasy terms until Julie's early death in 1819 at the age of thirty-nine.

In 1809 Vigée Le Brun bought a house in the village of Louveciennes, but continued to entertain at her house in Paris. As a fervent royalist, she welcomed the Bourbon restoration and was elated that she was recognised and warmly received by both Louis XVIII and later Charles X.

Vigée Le Brun was typically quick to appreciate that self-portraits were an essential tool for keeping her name and image in the public eye. Altogether she painted up to forty of them, skillfully presenting herself to the world in several guises: as some luscious fruit – as in the National Gallery's *Self-Portrait in Straw Hat*; as a working artist; and as a mother – two of the self-portraits show her cradling her daughter Julie in her arms. In the latter paintings, both she and Julie are gloriously pretty, large-eyed and positively breathe Rousseau's doctrine of tender love between mother and child. (That Vigée Le Brun depicts herself smiling was considered scandalous by some critics. This was, as one commented, 'an affectation which artists, connoisseurs and people of good taste are unanimous in condemning'.[7])

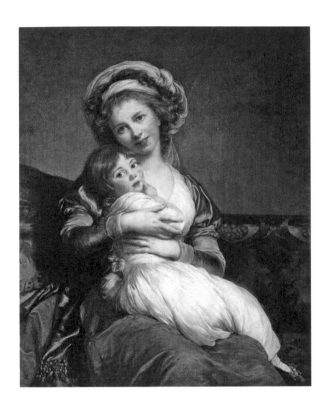

40. Elisabeth Vigée Le Brun,
Self-portrait with Her Daughter Julie, 1786
Self-portraits were a form of self-promotion: artists
could demonstrate their skills while presenting
themselves as they wished to be seen. Here, Vigée
Le Brun is showing herself not just as an artist, but
as a devoted parent. In reality, she seldom allowed
motherhood to interfere with her work.

In one of her best-known self-portraits, which she painted for the Uffizi Gallery's Vasari Corridor of self-portraits, she is wearing a simple but elegant black velvet dress, caught at the waist by a scarlet sash. A flouncy lace collar emphasises her slender neck, and her dark curls are bound up in a gauzy white turban. She is turning from her work to look at the viewer, her lips parted in a beguiling smile. Just visible on the easel is a portrait of Marie Antoinette, still in its early stages. This was a bold move on Vigée Le Brun's part as she is clearly signalling her stubborn adherence to the *ancien régime* and to one of its most hated figureheads. The portrait was rapturously received by the Uffizi's director and by visitors to the Gallery. The artist Ménageot declared it to be one of her finest productions. 'In my opinion she has scaled new heights since her departure from Paris. This picture has astounded everyone who has so far seen it...'[8] Not content with leaving only her pictorial image to posterity, in 1825 she began to write her memoirs.

Vigée Le Brun lived until well into her eighties, still painting furiously, still producing work of high quality. 'To attain high eminence', commented a reviewer, 'it demands the entire devotion of a life; it entails a toil and study, severe, continuous and unbroken,' a course faithfully adhered to by Vigée Le Brun throughout her long life.[9] The exquisite finish of her paintings, the richness of her colouring and the glamour and allure of her subjects constitute an invaluable record of the brilliant world of eighteenth-century European high society, a world light years from the drab uniformity of today.

Angelica Kauffman, the only other artist of the period to achieve Vigée Le Brun's celebrity, also married, but the marriage was a fiasco for which she paid dearly at the time. Her quiet beauty and huge talent had attracted possible suitors as soon as she arrived

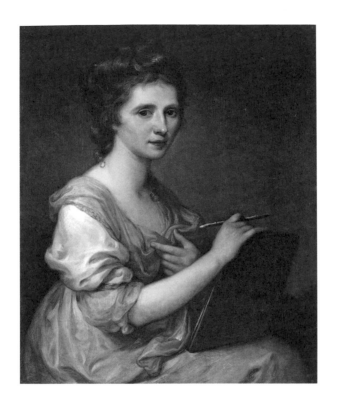

41. Angelica Kauffman, *Self-portrait*, c. 1770–75
In several of her self-portraits Kauffman presents
herself in the same pose: holding the tools of her
trade and turning to look over her right shoulder at the
viewer. The air of quiet dignity and the virginal white
dress are perhaps intended to counteract the gossip
that plagued a beautiful woman who had the temerity
to become a highly successful professional artist.

in London in 1766. Gossip soon abounded that Reynolds was one of them, fuelled by the fact that she painted his portrait within a year of her arrival. There is no doubt that she and Reynolds became mutual admirers as both artists and friends, but nothing more. However, that did not prevent tongues from wagging, and in 1775 she was made the butt of a malicious attack by the Irish artist Nathaniel Hone when he submitted a picture entitled *The Conjuror* to the Royal Academy's annual exhibition that depicted Reynolds as a plagiarist and showed several naked revellers in the background, one of whom was taken to be Kauffman. It appeared to be not only an attack on the two artists but to be enforcing the rumours that they enjoyed a special relationship. Following Kauffman's letter of protest to the Academy, the painting was withdrawn.

A gentler satire was executed by Nathaniel Dance, possibly to chide her for what he perceived as her rejection of him for Reynolds: the drawing shows a squat, large-nosed Angelica seated beside a very deaf Sir Joshua and struggling to converse with him. Dance's caricature bears little resemblance to the graceful and charming woman she depicts in her self-portraits.

Another supposed proof of an amorous liaison was prompted by a mischievous verse published by the great English actor, David Garrick, whose portrait Kauffman had painted in Italy: 'While thus you paint with Ease and Grace,/And Spirit all your own,/ Take, if you please, my Mind and Face,/But let my Heart alone.'[10] Again there is no evidence that their relationship went beyond that of artist and sitter.

The man Kauffman actually married — in secret — was Count Frederick de Horn, a Swedish nobleman apparently possessed of great taste, a handsome appearance, ancestral castles and vast wealth. The reality proved somewhat different: he was an impostor possessed of none of these assets — even his name was not his own.

What he possibly did have was another wife. But many of the circumstances surrounding the marriage and its aftermath are beyond disentanglement, despite the best efforts of her biographer Angelica Goodden who suggests that perhaps it was 'just a bad marriage that was subsequently turned into a good story',[11] The union was speedily dissolved (by papal annulment as she was a Catholic), leaving Kauffman traumatised but unencumbered with children and free to do what she most wanted – to paint. Shortly before she left England in 1781 to take up residence in Italy, she married an impeccably dependable man, the distinguished Venetian artist Antonio Zucchi, who managed her business affairs efficiently thereafter. While it may have been a marriage dictated by prudence rather than passion, it proved to be one of great affection.

During the fifteen years she had lived in London, Kauffman had established a reputation as a fine portraitist and one of the few artists of either sex to succeed as a history painter, the most prestigious of the arts but one that remained sadly unappreciated in England. Her intelligence, linguistic prowess (she spoke four languages), business acumen, modesty and devotion to her work had earned her the respect and admiration of society.

One of her self-portraits demonstrates that she possessed talents other than painting. Executed in 1792, *Self-Portrait Hesitating Between Painting and Music* – possibly based on the popular myth of Hercules choosing between Vice and Virtue – shows her decision to concentrate on a career as an artist despite her undoubted talent as a musician. Dressed in white, she is caught between the two allegorical female figures representing the arts. It is clearly Painting, who gestures seductively towards the horizon, who is winning the battle. Angelica acknowledges the fact by smiling sweetly and regretfully at beseeching Music.

But of all her self-portraits – she was not so prolific as Vigée

Le Brun, producing a mere twenty-four — it is the one painted between 1770 and 1775 (now in London's National Portrait Gallery) that seems to reflect most accurately the woman described by her contemporaries. Wearing a loose 'classical' garment, she gazes calmly at the viewer. In her right hand she holds a portecrayon and a portfolio. There is modesty and gentleness, both in her pose and in her expression. The image contains no hint of her steely ambition, nor does it idealise her appearance or knock several years off her age — an irresistible urge for many artists, especially for women. Instead, it reveals a woman of great depth and charm. Some of her self-portraits were reproduced in large numbers as engravings and circulated throughout Europe, thus helping to spread her fame.[12]

When Kauffman arrived in Italy, it was with nearly a third of her life left to live, twenty-six years during which she became the most famous portraitist in Rome. (Her only rival, Pompeo Batoni, who had been a great favourite with the Grand Tourists, died in 1787.) In Venice she enjoyed the patronage of Grand Duke Paul of Russia, just one of the many European nobility who would commission works from her in the coming years. The spacious house she and Zucchi bought in Rome became a focus for painters and for foreign visitors who wanted to meet the woman who had achieved cult status as an artist.

One of these visitors was Goethe, poet, playwright, novelist and natural philosopher, who came to Rome in 1786. Angelica conducted him everywhere and taught him how to look at art. 'It is extremely gratifying looking at pictures with Angelica', he wrote, 'as her eye is so highly trained and her technical knowledge for art so great.'[13] She painted his portrait, but it was not a success. 'It annoys her greatly that it doesn't and won't resemble me,'[14] he complained, wounded by the 'pretty boy' image she had created. In Goodden's view, the friendship that developed between them

was perhaps the most important in Angelica's life:[15] she idolised him, and felt bereft when he finally left Rome.

Her last years were saddened first by the death of Zucchi, then by worries over money and the general disruption of Europe caused by the Napoleonic wars. Despite ill health, she continued to accept commissions, her urge to paint undiminished. When she died in 1807, Rome honoured her with a splendid funeral, choreographed by her friend the sculptor Antonio Canova who based it on the funeral of the Renaissance master Raphael. A great train of human mourners — 'an immeasurable concourse' — wound through the city's streets, two of her paintings carried aloft in triumph by members of the Accademia di San Luca. An account of her funeral was read aloud with great pomp at the next meeting of the Royal Academy's General Assembly.

Little is known about Adélaïde Labille-Guiard's marriage to a financial clerk, but it produced no children and after ten years ended in a legal separation. Her name had been linked with François-André Vincent, the son of her former teacher, not only romantically but maliciously as it was alleged that some of the works signed by her had actually been painted by him. These rumours did not prevent her from building up an impressive clientele, which included Louis XVI's aunts. Nor did malicious gossip hinder her from opening her studio to women and teaching them with skill and dedication. In her magnificent, life-sized *Self-Portrait with Two Pupils* (see p. 49), Labille-Guiard shows herself not just as a teacher but as a superb painter of fabrics, a woman of fashion and altogether a force to be reckoned with. It is a brilliant piece of propaganda. When it was exhibited in the 1785 Salon it was greeted with widespread acclaim.

Unlike Vigée Le Brun, who remained a staunch royalist, Labille-Guiard sympathised with certain aspects of the Revolu-

tion, particularly its promise of a new role for women, a cause which she rashly and openly espoused by petitioning for the Académie Royale to accept more female members. But as France lurched from crisis to crisis, she struggled to overcome personal attacks on not just her royal connections but her virtue. She kept her nerve, however, and gradually built up a new circle of patrons among the supporters of the Revolution, exhibiting portraits of eight members of the National Assembly in the 1791 Salon, one of which was of Maximilien Robespierre. But her position continued to be precarious and in 1792 she and the Neoclassical painter François-André Vincent (they were to marry in 1799) prudently retired to the country where they remained until the end of the Terror. When they returned to Paris it was to find the political landscape irrevocably altered. Many of her patrons had been executed or had fled abroad. Undaunted, she continued working, her portraits now of sitters more soberly dressed and in less ostentatious settings.

So few women artists achieved public prominence that it is hardly surprising that comparisons should be made between them. As exact contemporaries, both painters of royalty and as regular exhibitors at the Salon, Labille-Guiard and Vigée Le Brun were natural targets of the press, which delighted in casting them as sworn rivals. In the 1787 Salon their paintings – Vigée Le Brun's *Marie Antoinette and Her Children* and Labille-Guiard's *Madame Adélaïde* – were hung within a few feet of each other, thus making comparison unavoidable.

In her *Memoirs*, Vigée Le Brun claimed that another woman artist had, for reasons she could not fathom, 'always shown herself to be my enemy' and that this unnamed artist – who must surely be Labille-Guiard – 'had tried by every imaginable means to blacken my reputation in the eyes of these princesses', by which

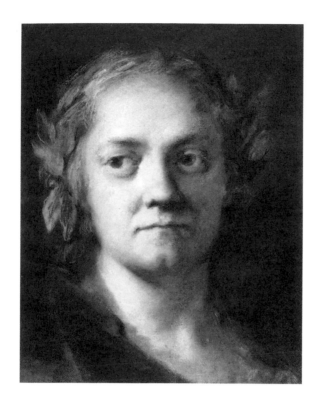

42. Rosalba Carriera, *Self-portrait*, 1746
In this intensely moving image Carriera does not
hesitate to show the effects of years of hard work,
grief for the death of her sister Giovanna, the onset of
blindness and the sadness of old age. The laurel wreath
has prompted some scholars to assign the portrait the
allegorical title *The Artist of the Tragic Muse*.

she means Mesdames, the King's aunts, Labille-Guiard's most important clients.[16] It seems entirely out of character for Labille-Guiard, who championed the rights of women artists, to seek to discredit Vigée Le Brun with Mesdames.

The two women could be compared in other ways: Vigée Le Brun's extraordinary stamina and the speed at which she worked enabled her to produce up to thirty paintings a year, her output during her lifetime amounting to nearly a thousand works,[17] whereas Labille-Guiard, though she worked with great diligence, painted no more than twelve a year.[18] Vigée Le Brun had the confidence and the nerve to charge spectacularly high prices for her portraits while Labille-Guiard's demands were far more modest.

As the two stars among eighteenth-century women artists, Vigée Le Brun and Angelica Kauffman also provoked comparison, not just as artists but for their looks and personalities. Kauffman was the less flamboyant of the two, celebrated for her reserve and sense of decency. The travel writer Friedrich Johann Meyer, who met her when she was nearing fifty, admitted that she no longer looked young, 'but that character of goodness, which moulds the features and outlives the charms of youth in imperishable beauty, dwells in her face'.[19] Her friend Catherine Wilmot felt that 'the pale transparency of her complexion, one attributes less to her declining health, than to the idea that no other light has ever shone on her, but the silver beams of the moon'.[20] But for all her mildness and amiability, to have achieved such phenomenal success required immense dedication allied to a good head for business.

Vigée Le Brun was altogether brasher, less intellectual, more beautiful, more obsessed by money and status. She dazzled people with her looks and her talent. Using her quick wits and charm, she adroitly navigated her way among the privileged and powerful, extricated herself more or less intact from several scandals,

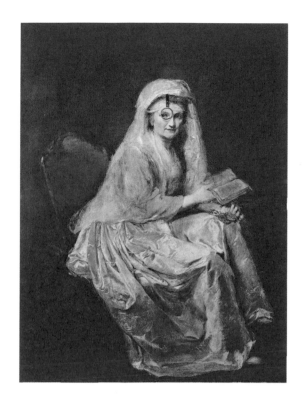

43. Anna Dorothea Therbusch, *Self-portrait*, 1776–77
In this self-portrait Therbusch shows herself not with
brush and palette but holding a book, an attribute
intended to demonstrate her education and refinement.
Nor has she made any attempt to reduce her age or
add to her charms. Oddly enough, it is the prominent
monocle that makes this image so memorable.

disdained what she referred to as the 'poisoned shafts of calumny' levelled at her, and seldom failed to intrigue and enchant everywhere she went.[21] Her salons attracted the nobility, glitterati, artists and intellectuals. According to the author of *Mémoires Secrets*, 'infinitely more amusement was to be had at Madame Le Brun's than at Versailles'.[22] Above all, it was her fierce devotion to her work that commanded respect.

Although she never achieved the success of Kauffman and Vigée Le Brun, Anne Vallayer-Coster is today recognised as one of the most prominent still-life painters of the period. Closeted alone in her studio with her still-life subjects, she was less vulnerable to the slings and arrows of the media. Her marriage to a wealthy lawyer produced no children, but the fact that the ceremony took place at Versailles in the presence of Marie Antoinette – whose influence had helped her to secure lodgings in the Louvre – demonstrates the degree of her acceptability at court, and she continued to attract the support of powerful patrons throughout her life. Her royal connections should have put her life at risk following the Revolution, but it was probably the political neutrality of her subject matter and her natural modesty and goodness that saved her.

As connections go, it would be hard to beat the one enjoyed by Marguerite Gérard: her sister married no less a person than Jean-Honoré Fragonard. Marguerite lived with them in Paris and was taught by her illustrious brother-in-law, a piece of unimaginable good fortune for a girl born to a perfume producer in southern France. Her exquisitely painted sentimental genre scenes attracted wealthy clients. She was too young and still too unknown to be endangered by the Revolution.

While Gérard seems to have led a charmed life under Fragonard's guidance and protection, the connection of Constance Mayer with another great artist, Pierre-Paul Prud'hon, though

initially beneficial, proved ultimately disastrous. She lived next door to Prud'hon in Paris, helped to look after his children, worked with him and was treated by him with great affection. They collaborated on numerous works, many of which are catalogued under his name. In spite of this seemingly happy and productive relationship, she suffered from periodic fits of depression. When his wife died, and she realised he had no intention of marrying her, she cut her throat with his razor.

Marie-Anne Collot also surrendered her life to her teacher Falconet, her senior by thirty-two years. As his pupil, studio assistant and possibly mistress, she spent twelve years with him at the court of Catherine the Great. Although their working relationship was fruitful, he was a narcissistic and unpleasant man who quarrelled with everyone except Collot. She eventually married his son, who was abusive, and she left him (taking their only child) to nurse Falconet until his death eight years later.

The life of the pastellist Rosalba Carriera was more domestic. She seldom stirred from her native Venice, never married but lived with her widowed mother and worked with her sister as her studio assistant. When she did leave Venice in 1720 to spend two highly successful years in Paris, and in 1730 when she went to Vienna, she was accompanied by her artist brother-in-law. For one so dedicated to her work, her great tragedy was the gradual onset of blindness. Already prone to periods of intense depression, this led eventually to a complete mental collapse. Her self-portraits illustrate her melancholic temperament, and her plainness, with unflinching honesty. The most moving of these portraits, painted the year her eyesight began to fail, is suffused with sadness, her face emerging from a sombre background, her mouth set in a hard, despairing line.

Carriera's lifestyle, so rooted in her family and so dedicated

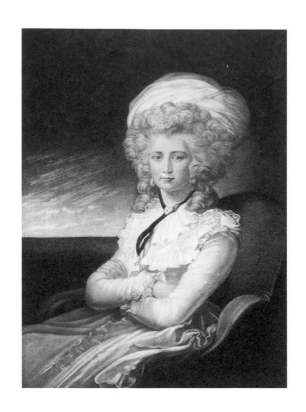

44. Print by Valentine Green after a painting by
Maria Cosway, *Self-portrait with Arms Folded*, 1787
Cosway falls uncomfortably between two stools:
amateur and professional. Although she exhibited
regularly at the Royal Academy, her husband
prevented her from selling her work. Possibly her
firmly crossed arms – an extremely unusual pose –
and enigmatic expression signal her frustration
that she never achieved her potential.

to her work, protected her from the gossip and innuendo endured by more high-profile women artists whose lives, whether they sought it or not, were lived in the glare of publicity. Her name was never coupled with would-be suitors or besmirched by rumours of secret lovers – the fate suffered by Kauffman and Vigée Le Brun.

Maria Cosway was another artist who chose to present herself with uncompromising boldness. In her self-portrait of 1787 (known today only from an engraving) she is wearing a frilly white gown, a large turban perched on her elaborate coiffeur and looks coolly at the viewer. What is so arresting about the image is that her arms are crossed in a gesture that seems almost defiant. There is no sign of a palette, let alone an easel, indeed nothing to indicate that she was an artist who had been exhibiting at the Royal Academy since 1781. When she painted it, her promising career as a portraitist and history painter was being frustrated by her husband, the miniaturist Richard Cosway, who prevented her from selling her work. With her golden hair, violet eyes, singing and harp-playing, he preferred her in the role of hostess at the fashionable, some say immoral, parties the couple frequently held in their splendid house in London.

Maria's life was a mass of contradictions. She had been born in Florence, and had survived while three of her younger siblings had been murdered by a mad nurse, but spent much of her life in London. While the self-portrait shows her as a beautiful and desirable woman, the image is belied by the large cross hung around her neck, evidence of her devout Catholicism. She and her husband both had affairs – she, reputedly, with Thomas Jefferson, among others – yet she maintained a life-long ambition to become a nun. She longed for a child, but soon after giving birth to a daughter, she left her with her husband to paint and travel in Europe (the child later died, aged six). Despite her estrangement from Cosway,

she returned to nurse him with great devotion through his final illness. Her last years were spent as headmistress of a girl's school she established at Lodi in Italy.

Thus, through pressures often beyond her control — and no doubt compounded by her emotional and mercurial temperament — she had subsided into the realm of the amateur. As she explained in an autobiographical letter: 'Had Mr C permitted me to rank professionally, I should have made a better painter; but left to myself, by degrees, instead of improving, I lost what I had brought from Italy of early studies.'[23]

Of course, such pressures were not confined to Maria Cosway. The eighteenth century is littered with women who had been frustrated in their ambition to become painters, musicians or writers. If it was not society's conventions that stood in their way, it might be a husband like Richard Cosway who was determined that his wife should not embarrass him by earning money, or perhaps feared that her work might outshine his. However, there was one section of society that was wholly free of such strictures: the lady amateur artist.

9

A polite recreation

The most active and busy stations of life have still some intervals of rest,
some hours of leisure... And if these are not employed in innocent
amusements, they will either lie heavy on our hands, and instead of
raising, depress our spirits; or what is worse, tempt us to kill the time,
as it is called, by such amusements as are far from being innocent.

PORTIA (PSEUD.), THE POLITE LADY: OR A COURSE OF FEMALE EDUCATION

IN A SERIES OF LETTERS FROM A MOTHER TO HER DAUGHTER, 1769[1]

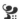

Finding ways 'to kill the time' was a pressing preoccupation for middle- and upper-class ladies in the eighteenth century. Taking the air, attending church, paying calls and performing charitable deeds were about all a respectable young girl could hope for, with the occasional rout or 'ball' to relieve the chronic boredom. But genteel accomplishments were allowed, even encouraged, so long as they remained amateur and did not develop into skills. And whatever form the accomplishment might take, it was done for the enjoyment of family and friends, never for money.

Accomplishments took many forms. During a discussion between Mr Bingley and his sister in Jane Austen's *Pride and Prejudice*, Bingley exclaims: 'It is amazing to me how young ladies can have

patience to be so very accomplished, as they all are.' 'All young ladies accomplished! My dear Charles, what do you mean?' 'Yes, all of them, I think. They all paint tables, cover skreens and net purses. I scarcely know any one who cannot do all this, and I am sure I never heard a young lady spoke of for the first time, without being informed that she was very accomplished.'[2]

Ladies of rank and fortune had been drawing and painting for at least 200 years, but in the second half of the eighteenth century the practice became positively fashionable. It was now no longer limited to the upper classes, but trickled downwards to the rapidly emerging middle class or bourgeoisie. Developing such skills was seen as a form of self-improvement: it made a woman a better wife and mother and equipped her with the taste and discernment to decorate her home – increasingly seen as an appropriately feminine task. In their book *Practical Education,* Maria Edgeworth and her father went so far as to suggest that accomplishments would 'increase a young lady's chance of a prize in the matrimonial lottery'.[3] Lady Mary Wortley Montagu, who can be relied upon to give advice on almost anything, advised her friend Lady Bute to allow her daughter to pursue an education but that it 'was absolutely necessary' that she should 'conceal whatever learning she attains, with as much solicitude as she would hide crookedness or lameness.'[4] Lady Mary admitted that she herself was 'once extream [*sic*] fond of my pencil and it was a great mortification to me when my father turn'd off my Master, having made a considerable progress for the short time I learnt'.[5]

An ability to draw and paint was useful in other spheres than the home. A young lady accompanying her family on a Grand Tour would not dream of setting off without her sketchbook and paints. Her journals, filled with diligent descriptions of art and architecture, 'indifferent' inns, bad food and appalling roads, were

relieved by little sketches of the waterfalls at Tivoli (a great favourite), a classical ruin or the Bay of Naples, a new awareness of the beauties and wildness of nature, promoted by the writings of Rousseau, lending inspiration to her brush.

That such sketches could be produced on the hoof, as it were, was made possible in the 1780s by the development by William Reeves of watercolours in the form of little cakes or pans of colour. This invention eliminated the laborious, time-consuming process of grinding the pigments, mixing them with gum arabic (to bind the colour to the surface of the paper) and honey or glycerine to stop them from drying out.[6] Watercolours could now be bought in boxes that held up to forty colours and were equipped with everything required to paint outdoors or while travelling. By mid-century a wide range of artists' materials, such as paint brushes, pastels, pencils and commercially manufactured paper, could be bought over the counter at one of the numerous shops that had sprung up in city centres.

The use of pastels, made fashionable by the portraits of Rosalba Carriera, was considered eminently suitable for amateurs: it was, declared the entry in the *Encyclopédie*, 'the easiest and the most convenient, in that it can be put down, taken up, retouched, and finished whenever one wants'.[7] A *Traité de la Peinture au Pastel* (1788) went further, advocating pastels as an aid to virtue since 'nothing is better suited to furnishing [young women] with resources against idleness, the source of so many indiscretions'.[8]

Another aid, used by both amateurs and professionals, was a *camera obscura*, which consisted of a darkened box with a convex lens or aperture for projecting the image of an external object on to a screen inside – a forerunner of the modern camera and a particularly useful tool for landscapes. A watercolour by Paul Sandby shows Lady Frances Scott standing over her *camera obscura* making

her own, mechanically assisted version of the scene before her – a bridge over the River Esk with Roslin Castle in the distance. Her friend Lady Elliot is seated patiently beside her; two servants hover in the background.

The vast increase in the number of amateur artists in the latter part of the century did not go unnoticed by the world of industry and commerce, which began to produce a range of drawing manuals with titles such as *The Art of Drawing in Perspective* and *The Complete Drawing Book*, both published in 1755.[9] By the early nineteenth century they were becoming more ambitious. With the help of a series of plates, the author of *The progress of a water-coloured drawing* (1812) guided the pupil from the initial drawing through to a finished watercolour. *The delights of flower-painting* (1756), which contained numerous seductive hand-coloured examples, was aimed – with wonderful condescension – at the 'fair-sex' who could thereby produce an 'image of their lovely selves', aided by a watercolour box designed especially with them in mind.[10]

Stationers and print-sellers were also quick to recognise a new breed of consumer, supplying prints that were specifically designed to be copied. Sayer & Bennett, Print-sellers of Fleet Street, sold a set of twelve engravings of fruits and flowers 'the most useful for Ladies delighting in embroidery, painting, japanning etc'; also sets of flower prints and even one of 'the most celebrated Beauties of the present time'.[11]

As women, amateur or professional, could not draw from the nude, Cipriani's *Rudiments of Drawing* (1786) with its engravings by Bartolozzi of various parts of the body, came to the rescue. The human body could also be studied in the round, if not in the flesh, by copying the many examples of classical sculpture on view in the Duke of Richmond's house in Whitehall, or of Charles Townley's superb collection in Westminster. In a watercolour of 1793 a young

45. A box of watercolours, made by Reeves & Woodyer, c. 1820

By mid-century many city centres in Britain could boast a shop selling artists' materials. Ackermann's in the Strand stocked everything from watercolour boxes to books, prints and drawing paper. The shop became famous as the meeting place for London's best society. It was the first shop in the city to be lit solely by gas.

woman is seated in Townley's dining room, surrounded by a bewildering array of Greek and Roman sculptures, both naked and clothed, her sketchbook on her knee and attended by a male companion who is probably her drawing master.

Established male artists who needed to supplement their incomes, like Paul Sandby and Thomas Girtin, also took advantage of the number of genteel ladies seeking tuition. By 1800 the number of drawing masters employed by the gentry was in the hundreds.[12] In the nineteenth century it was not uncommon for a young tutor to take up residence with his pupils. Marian Halcombe, the heroine of Wilkie Collins's *The Woman in White* (1859), explains to Mr Hartright the duties expected of him as the new Teacher of Drawing.

> After lunch Miss Fairlie and I shoulder our sketchbooks
> and go out to misrepresent Nature, under your direction.
> Drawing is her favourite whim, mind, not mine. Women
> can't draw — their minds are too flighty, and their eyes too
> inattentive. No matter — my sister likes it; so I waste paint
> and spoil paper, for her sake, as composedly as any woman
> in England.[13]

While they could not sell their work, amateurs could exhibit it at selected institutions, such as London's Royal Academy. Their non-professional status was indicated by the prefix 'Honorary' beside their names in the exhibition catalogue.[14] However, the Academy drew the line at 'needle-work, artificial flowers, cut paper, shell-work, or any such baubles' being admitted to their exhibitions, a rule introduced before the Academy's first show in 1770.[15]

Proof that women were increasingly taking up art as a pastime is borne out by the number of images by male artists of them at

46. Mary Delany, *Magnolia Grandiflora*, 1776
Although neither rich nor beautiful, Mrs Delany
became the centre of a brilliant circle of charming,
clever and industrious women. While she
turned her hand to every conceivable art, she is
remembered today for her astonishing production
of some one thousand examples of flower
portraits, painstakingly assembled from cut paper.

work, such as Sandby's charming watercolour of a young girl painting with great concentration at her easel, the little oyster shells in which she mixes her colours on the table beside her. Lady Diana Beauclerk made clear her wish to be seen as an artist by electing to be painted by Reynolds dressed in a loosely-draped working gown, holding a pencil in one hand and a large portfolio in the other. Jean-Claude Boilly painted several women artists at work: one shows a young woman seated in an improbably luxurious interior for a studio; she is wearing a large fashionable hat and a silly smile, and looks far too frivolous to be a professional.

Various forms of needlework were the female accomplishment most acceptable to polite society. Not only was it the least 'bold' but was considered a sign of virtue. Reynolds, in his well-known painting *The Ladies Waldegrave*, shows the three sisters clad in virginal white, busily stitching and winding silk. Their deportment and quiet industry signal their unimpeachable modesty and purity. Lady Bute is conveying the same message when she counsels her daughter 'not to neglect the less genteel employment of *good house-wifery*', for '*sensible* men are more likely to have serious thoughts of young ladies whom they observe to be neatly dressed, unaffected in behaviour, with good humour, and *attentive to economy*, than of indolent and accomplished beauties!'[16]

The indomitable Mary Delany embroidered everything she could lay her hands on, from clothing to covers to hangings; she decorated playing cards, created designs for shell-work, lustres, candelabra and furniture. She painted too, producing portraits of her family and female friends in oil – a medium seldom essayed by amateurs. She was also a witty correspondent, and wrote and illustrated a novel. Her extraordinary output can perhaps be partly explained by the fact that she was twice widowed and childless. Her greatest achievements were her 'paper mosaics', a name given to

them by Horace Walpole who congratulated her on founding 'a new branch' of art. Beginning in her early seventies, over the next ten years she created nearly a thousand botanical specimens by meticulously cutting them out of coloured paper, sometimes with a piece of the actual plant incorporated, and pasting them on to black backgrounds. The plants she used as models were provided by the Chelsea Physic Garden or came from the gardens of her many friends, such as Bulstrode, home of her great friend, the Duchess of Portland.

To house all the paraphernalia she needed for her work, Mrs Delany had a special closet built for it, but admitted to her sister that she felt guilty about its construction when she compared her 'performances', as she called them, to her sister's philanthropic activities:

> Mine fits only an idle mind that wants amusement; yours serves either to supply your hospitable table, or gives cordial and healing medicines to the poor and sick. Your mind is ever turned to help, relieve, and bless ... whilst mine is too much filled with amusements of no real estimation; and when people commend any of my performances I feel a consciousness that my time might have been better employed.[17]

In all, she produced ten volumes of these *Flora Delanica*, which eventually ended up in the British Museum. It would surely astonish her to know that some 200 years after her death the Museum devoted an entire exhibition to her wonderful productions, which then crossed the Atlantic to be exhibited at the Yale Center for British Art in New Haven, Connecticut in 2009.

Flowers were the most popular subject for amateurs. The author

of *The Art of Painting in Miniature,* published in 1752, had sound reasons for recommending them: 'You maim and bungle a face, if you make one eye higher or lower than another ... But the fears of these disproportions constrain not the mind at all in flower painting; for unless they be very remarkable, they spoil nothing. For this reason most persons of quality who divert themselves with painting, keep to flowers.'[18] A century later the attitude of male writers to aspiring women artists remained patronising: 'Let women occupy themselves with those kinds of art they have always preferred ... the paintings of flowers, those prodigies of grace and freshness which alone can compete with the grace and freshness of women themselves.'[19]

Flowers and other imitations of nature made up the majority of women's exhibits at the Royal Academy and elsewhere. Between 1762 and 1800 more than seventy amateur female artists sent landscapes to London exhibitions.[20]

Yet by painting landscapes these women were rejecting Rousseau's view that while needlework was an entirely 'natural' pastime for the female sex, 'at no cost would I want them to learn landscape, even less the human figure'.[21]

One amateur seemingly unaffected by Rousseau's strictures not only drew the human figure but did it superbly. Marie-Anne Paulze (1758–1836), who married the chemist Antoine Lavoisier, attended Jacques-Louis David's classes for female pupils in the Louvre. One of her drawings of a male nude is annotated by David and dated 1786. Given the strict taboo against women drawing from life, and the tight control of its premises exercised by the Louvre authorities, she must have copied it from a classical sculpture; the result, however, is wonderfully robust and alive. Her drawing skills, allied to her work alongside her husband in his laboratory, enabled her to produce scientifically accurate drawings

of his experiments. Thirteen of these drawings were reproduced in his *Traité élémentaire de chimie* in 1789, which ultimately helped many of his contemporaries to understand his methods and results.

Lady Diana Beauclerk (née Spencer, 1734–1808), who broke many of polite society's rules during her lifetime, also turned her artistic talent to practical use by earning money from it when she fell on hard times. Initially, however, as the privileged daughter of the 2nd Duke of Marlborough, she could afford to paint and draw for the sheer love of it. Growing up at Blenheim Palace, surrounded by magnificent art, she made pastel studies of children from the Duke's paintings by Rubens and Van Dyck. Marriage to the serially unfaithful Viscount Bolingbroke ended in divorce (by an Act of Parliament), but not before she had embarked on a clandestine affair with Topham Beauclerk, for which she was damned by both society and Dr Johnson, who declared 'The woman's a whore and there's an end on't.'[22]

Lady Di is best known for her cavorting cupids, infant bacchantes and charming images of young children at play, the latter demonstrating the influence of Rousseau's teachings that children should be allowed to grow up in a freer, more natural environment, not treated – and dressed – like stunted adults. Lady Di supplied Wedgwood with about four designs of her cupids and bacchantes, which appeared on wares as varied as wine coolers, teapots and marble clocks. These designs, and others – such as her pastel of her two daughters – were engraved in stipple by Bartolozzi, ensuring them wide distribution.[23] On receipt of the engraving of Lady Di's daughters, Sir William Hamilton wrote ecstatically from Naples that he defied 'any artist in England to compose two figures with more grace and elegant simplicity than these two delightful little girls'.[24] This fulsome praise may have been prompted in part by the fact that he had courted Lady Di in his youth.

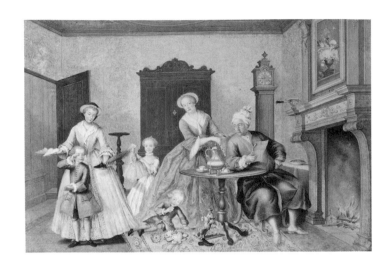

47. Archduchess Maria Christina of Austria, *Christmas in the Royal Household of Empress Maria Theresa*, 1763
This charming scene shows the Empress of Austria with her husband Francis I, surrounded by four of their children. Maria Christina stands on the left, Marie Antoinette (later Queen of France) holds up her doll. Clever, beautiful and talented, Maria Christina is a good example of an aristocratic amateur who produced work to an extremely high standard.

Her notoriety and the support and egregious praise of Horace Walpole also helped to publicise her work, which stood her in good stead when Beauclerk died in 1780 — no longer the charmer she had so recklessly married but 'grown morose and savage' — leaving her and her family in dire financial straits. Quite how she earned what she described as 'that nasty thing, money' from her work is unclear, but the engraving of her designs by Bartolozzi and his team 'would suggest that she received a fee in return for her skills and name'.[25] The same must apply to the use of her designs by Wedgwood and others.

Despite her reputation as an adulteress, George III was reported by Fanny Burney to have said that Lady Di 'draws very finely', and he and the Queen were known to possess a portrait of her in chalk by Bartolozzi and a copy of one of her most successful prints, a portrait of Georgiana, Duchess of Devonshire.[26]

The royal couple and two of their daughters, Princesses Charlotte and Elizabeth, were keen botanists as well as amateur artists. Elizabeth was the most prolific, working in several media, but particularly in cut-paper work, a skill she learnt from Mrs Delany. She was also heavily involved in the decoration of the rooms at Frogmore House in Windsor Great Park, bought by the King for the Queen as a country retreat. Frogmore provided the Queen with a refuge where she and her two daughters could indulge in their favourite pastimes: painting, drawing, needlework, japanning, reading and 'botanising'.

One pastime missing from Queen Charlotte's list was shell-work. A prime example of this minor art is the elaborate shell cottage in the grounds of Goodwood House, designed in the 1740s by the 2nd Duchess of Richmond and her two daughters, Emily and Caroline. There was no shortage of shells as the Duke was an avid collector of all things natural, and was frequently supplied by

enterprising sea captains with marvels that they thought might take his fancy. (His menagerie, which included two tigers, two leopards, three bears and five wolves, was the first of its kind in Britain. They were housed in heated catacombs under the park at Goodwood.[27]) The Duchess and her girls designed the intricate patterns but the actual work of sticking the shells to the walls and ceiling of the grotto was probably done by workers on the estate. The result is a riot of shells of all sizes arranged in whorls, twisted into ropes, spilling out of cornucopias, woven into ribbons and bows, shaped into medallions — a crazy rococo fantasy.

If creating patterns out of shells can be considered an art — of sorts — then it is possible to include Emma Hart's famous 'Attitudes' with which she entertained Sir William Hamilton's guests at Palazzo Sessa in Naples. Emma was still his mistress (they married in 1791) when together they developed this unlikely new art form. By skillful use of immensely long, floating scarves, Emma struck the graceful poses of the women of antiquity. These *tableaux vivants*, performed in a darkened room, mirrored the attitudes of statuary, paintings and Greek vases. Goethe, passing through Naples in 1787, attended one of Emma's performances and described her as 'very handsome and of a beautiful figure'. Wearing garments modelled on those of the women in the recently discovered wall paintings at Pompeii and Herculaneum, and letting her hair hang loose, 'she exhibits every possible variety of posture, expression and look, so that at the last the spectator almost fancies it a dream'.[28] For 'the old knight' as Goethe called Sir William, Emma's creation of this 'Gallery of Statues' had brought to life his great passion: his study and collection of antique vases.

Another visitor to Palazzo Sessa was Anne Seymour Damer (née Conway), Britain's first woman sculptor. Hamilton had known her for years, and it was said that she was one of the young ladies

48. Elisabeth Vigée Le Brun,
Lady Hamilton as a 'Bacchante', 1790–91
Both Reynolds and Romney painted portraits
of Emma Hart as a bacchante (a follower or priestess
of Bacchus). Here, Vigée Le Brun has depicted her
in one of her famous 'attitudes', the pose based on
the frieze of dancers at Herculaneum. The volcano
Vesuvius can be seen smoking in the background.

he contemplated marrying to alleviate his loneliness after the death of his first wife in 1782. Anne's marriage to John Damer (known as the 'man of the hundred waistcoats') had ended in 1776 when he shot himself in the Bedford Arms in Covent Garden, having accumulated enormous debts that his father refused to pay. Hamilton was among her greatest admirers as a sculptor, and when she presented him with a bust of Ceres, he declared to his friend Horace Walpole that 'there is not an artist now in Italy that could have done it with so much of the true sublime, and which none but the first artists of Greece seem to have understood.'[29] This is clearly Sir William speaking more with his heart than his head since her work, though some pieces are extremely competent, could not be called remarkable if compared to the great classical Greek sculptors. What *is* remarkable, however, is that she sculpted at all. As John Gould said of her in his *Biographical Dictionary of Artists* (1839): 'Her birth entitled her to a life of ease and luxury; her beauty exposed her to the assiduity of suitors and the temptations of courts; but it was her pleasure to forget all such advantages and dedicate the golden hours of her youth to the task of raising a name by working in wet clay, plaster of Paris, stubborn marble, and still more intractable bronze.'[30]

Horace Walpole, who was devoted to her (she was the only child of his much loved cousin Henry Seymour Conway) was equally enthralled by her work, asserting that she modelled 'like Bernini [and] has excelled the moderns in the similitudes of her busts...'[31] Fanny Burney was less impressed: '... her performances in sculpture were of no great merit, but were prodigiously admired by Horace Walpole, who has a notorious weakness for the works of a person of quality.'[32]

Unlike Lady Diana Beauclerk, whose straitened circumstances in later life obliged her to sell some of her designs, there is no

49. Anne Seymour Damer, *Sir Joseph Banks*, 1812–13
Damer had a taste for portraying contemporary heroes.
She sculpted busts of Admiral Nelson, the chemist Sir
Humphrey Davy, Charles James Fox – which she gave
as a personal gift to Napoleon – and this bronze of
the great explorer and plant collector. Banks is
wearing the insignia of the Order of the Bath.

evidence that Anne Damer was ever paid for her sculptures. But there is no doubt that she took her art seriously, producing some eighty works during her lifetime. Many of her portrait busts, modelled in bronze, terracotta and marble, reflect the high society in which she moved, including socialising with members of the royal family. Her sculptures of dogs, in particular, reveal great charm and technical skill. Thirty-one of her works were exhibited at the Royal Academy. And she did not just 'dedicate the golden hours of her youth' to her sculpting, but completed a bronze of Lord Nelson the year she died, aged eighty.

'Tinkling' at their pianos and 'smearing' at their easels – lady-like occupations so disparaged by George Eliot – continued to be a resource for genteel and aristocratic ladies until well into the nineteenth century. Acquiring accomplishments was increasingly seen by the growing wealthy middle classes as one more way of demonstrating their fitness to be counted as polite society. By the 1850s training in an art school had become available to anyone who could afford to pay for it. The line between amateur and professional had ceased to exist.

10

Looking ahead

I honour every woman who has strength enough to step out of the beaten path when she feels that her walk lies in another, strength enough to stand up and be laughed at, if necessary... But in a few years it will not be thought strange that women should be preachers and sculptors, and every one who comes after us will have to bear fewer and fewer blows.

HARRIET HOSMER[1]

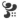

This defiant yet optimistic view, expressed by America's leading nineteenth-century female sculptor, shows that women artists were still subject to ridicule and prejudice despite the undoubted progress they had made during her lifetime, especially from the 1850s onwards.

But it had been a bumpy ride. The Revolution in France (the country of origin for the majority of eighteenth-century women artists), with its talk of liberty, equality and fraternity, had seemed to offer new hope to women. Yet when the dust began to settle, women artists found that while some doors had opened to them, others had slammed shut with distressing firmness. One important institution to do so was the Académie Royale which was suppressed in 1793, and when it reopened two years later, women were excluded

from membership altogether. Vigée Le Brun, safely in exile during all these upheavals, wrote with nostalgia of the glory days when she had been a member of the Académie, Marie Antoinette's favourite portraitist and a familiar face about the French court: 'It is difficult to convey an idea today of the urbanity, the graceful ease, in a word, the affability of manner which made the charm of Parisian society forty years ago. Women reigned then: the Revolution dethroned them.'[2]

However, the opening of the Salon in 1791 to all artists, not just to the work of academicians, was a welcome breakthrough for women who had been unable to exhibit there before, and no fewer than twenty-two leapt at the chance to make their work known. But for Labille-Guiard, who had fought so hard for the inclusion of unlimited numbers of women to the Académie, this influx of women to the Salon was a major setback: she no longer stood out from the crowd.[3]

By 1886, when Émile Zola published *The Masterpiece,* he estimated the number of visitors to the Salon on free days to be a 'truly staggering figure of fifty thousand'.[4] There were fewer public entertainments at that time, and the Salon's exhibitions attracted not only high society but people from all classes. 'They come as they would to a pantomime or a circus', wrote the French critic Hippolyte Taine. 'They want melodrama or military scenes, undressed women and *trompe d'oeil;* and they get it: battles and *auto-da-fé,* scenes of slaughter in Roman arenas, Andromeda on the rocks, stories about Napoleon and about the Republic, illusionistic jugs and dishes.'[5] The multitude raised such a cloud of dust that it was difficult to see the pictures.

Although their subjects seldom fulfilled Taine's criteria, several of the women artists who had begun their careers in the eighteenth century were still exhibiting at the Salon in the early years of the

nineteenth: Vigée Le Brun until 1824 and Vallayer-Coster until
1817, the year before she died. In 1800 Marie-Guillemine Benoist
exhibited her stunning *Portrait of a Negress*. In its boldness and
simplicity this extraordinary image seems almost modern, a far
cry from the lush opulence of the standard eighteenth-century
portrait. A few years later Benoist was commissioned by Napoleon
to paint portraits of himself and his family. The one of his favou-
rite sister, the sexually voracious Pauline Borghese, shows the
princess seated in a huge gilded chair, dwarfed by mounds of scarlet
velvet, a look of beguiling innocence on her face. The two portraits
could not be more different, and it has been suggested that the
Negress was not commissioned, but painted by Benoist for herself.
This suggestion rings true since prior to 1800 she had produced
small paintings depicting families blissfully living out the Rous-
seauian ideal, the genre then in such demand with the wealthy
middle classes.

Despite the increasing number of women exhibiting their work
in the Salon – in 1808, a fifth of the exhibitors were female – the
majority had done so without the benefit of any formal training at
art school. There were no free art schools for women, and the
official state art school, the École des Beaux-Arts, did not accept
them. However, to those who could afford it, tuition was available
at the independent Paris studios and academies. These fulfilled a
vital role for aspiring artists, especially for women as several accepted
them as students, though they were taught in separate studios to
the men. One of the earliest to accept women was opened by the
ex-boxer Alexandre Abel de Pujol. In 1822 Adrienne Grand-
pierre-Deverzy – Pujol's wife and also one of his pupils – made
her debut at the Salon with *The Studio of Abel Pujol*, which shows a
crowded class of female students, all busily engaged in various
painterly tasks. What makes the scene so unusual is that instead of

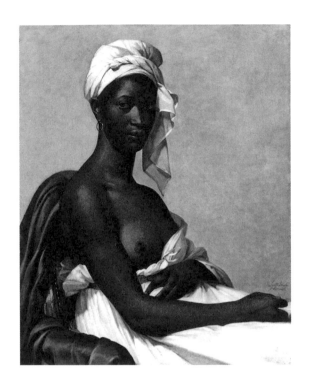

50. Marie-Guillemine Benoist,
Portrait of a Negress, 1800

This remarkable image may have been inspired by
a temporary decree in 1794 abolishing slavery.
The painting is unusual in that it deviates from
standard representations of blacks in eighteenth-
century European art, which typically show them as
servants, grooms or attendants. Here Benoist has
depicted a proud and independent woman who
regards the viewer with cool detachment.

studying classical sculpture, the students are working from a live female model. Admittedly, she is fully-clothed, but a living, breathing human being nonetheless. The studio's collection of plaster casts has been relegated to a high shelf.

One of the most important private academies was the Académie Julian, founded in 1868 by Rodolphe Julian. One of his pupils, the Ukrainian-born Marie Bashkirtseff (1858–84), described her joy at being in a place where 'one is no longer the daughter of one's mother, one is one's self — an individual — and one has before one art and nothing else. One feels so happy, so free, so proud.'[6] Aware that a representation of his women's studio would be good publicity, Julian convinced Bashkirtseff that it would make an ideal subject for her 1881 Salon entry. Her painting, *Life Class in the Woman's Studio at the Académie Julian,* shows female students grouped around a live model. But, unlike the fully-clothed woman in Grandpierre-Deverzy's picture, they are studying a rather limp youth who is naked except for a length of cloth bunched discreetly about his waist.

The society portrait painter Charles Chaplin also opened an atelier for women. In 1867 Louise Jopling (1843–93), a young English girl living in Paris, attended Chaplin's classes: 'His was the only atelier at that time where all the students were women, so that careful mothers could send their daughters there without any complications arising between the sexes.'[7] The 'careful mothers' were possibly unaware that Chaplin, whose particular talent lay in his depiction of young girls in everyday situations, had had one of his paintings, *Aurora*, banned by the Salon judges in 1859 for being 'too erotically suggestive'. One of the earliest known depictions of women studying a completely nude model, albeit a woman, was *The Female Life Class* painted in 1879 by the American artist Alice Barber Stevens (1858–1932).

From mid-nineteenth century onwards an increasing number

of American and European women decided that Paris was the only place to study. It had the finest galleries, best schools and a rapidly developing art market. The city itself was undergoing momentous change: one of Napoleon III's first acts on becoming Emperor of the Second Empire was to appoint Baron Haussmann as Prefect of the Seine, and together they began the transformation of Paris from a warren of stinking medieval alleyways to a city of broad, tree-lined boulevards, leafy public parks and squares.

William Makepeace Thackeray's short-lived ambition to become a painter took him to Paris in 1834. 'There are a dozen excellent schools in which a lad may enter here,' he wrote. 'In England there is no school except the Academy, unless the student can afford to pay a very large sum...'[8] He estimated that there were some 3,000 artists in the city, and described his life as an art student as 'the easiest, merriest, dirtiest existence possible',[9] a view later echoed by the French novelist and poet Henri Murger in his *Scènes de la Vie de Bohème* (1845), which described in authentic detail the life of poverty-stricken art students living with their *grisettes* in chilly attics in the city's Latin Quarter. (A *grisette* was a girl who would willingly share the lot of an artist or student.)

Although their lives were probably less Bohemian than Thackeray's — and very far from poverty-stricken since they came from wealthy backgrounds — the young women who converged on Paris lived lives of unimaginable freedom. The American painter May Alcott Nieriker (1840–79), immortalised as 'Amy' by her sister Louisa May Alcott in *Little Women*, wrote a delightful little booklet entitled *Studying art abroad and how to do it cheaply* in which she described Paris as 'one vast studio ... particularly between seven and eight o'clock [in the morning], when students, bearing paint-box and toile, swarm in all directions, hurrying to their cours; or still more when artistic excitement reaches its height, during the days

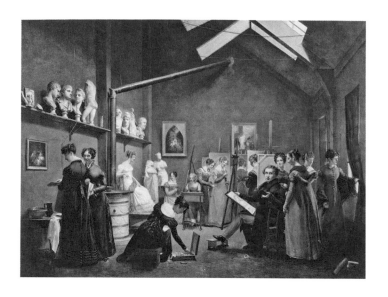

51. Adrienne Grandpierre-Deverzy,
Interior of Pujol's Studio in 1822, c. 1822

The artist shows her husband presiding over a class of women
students – a rare subject this early in the century – who are
studying a female model. As a measure of the significance
of what the painting depicts, it was used on the cover of the
catalogue of the ground-breaking exhibition, *Women Artists:
1550–1950*, held in Los Angeles in 1976.

appointed for sending works to be examined by the jury of the Salon. Then pictures literally darken the air, borne on men's shoulders and backs, packed in immense vans, or under an arm of the painter himself, all going to the same destination, — the Palais de l'Industrie on the Champs Elysées.[10]

In England, women continued to struggle to obtain adequate training. Although the Royal Academy had elected Angelica Kauffman and Mary Moser as founder members, the rules did not allow them to attend the Academy Schools. Despite its admission that training in its Schools was an important stepping-stone to success, the Academy continued to exclude women until 1860 when they accepted one by mistake. A student, Laura Herford, had submitted a piece of work signed with her initials only and the examiners, assuming that no woman would dare to apply, accepted her. However, as a woman, she was still not permitted to study a male nude. It was not until 1893 that this ban was lifted: as stated in their Annual Report, a male model was allowed so long as his 'drapery' consisted of 'ordinary bathing drawers and a cloth of light material 9 feet long by 3 feet wide, which shall be wound round the loins over the drawers, passed between the legs and tucked in over the waist-band, and finally a thin leather strap shall be fastened round the loins in order to insure that the cloth keeps its place'— a belt and braces approach to save maidenly blushes.[11] The Slade School of Art, reacting against the conservative teaching of the Academy Schools, was opened in London in 1871 and rapidly gained a reputation for the excellence of its teaching. It was the first co-educational art school in Britain and would later count among its students Gwen John, Paula Rego and Rachel Whiteread.

Although the number of art schools might be increasing, women were still hampered by society's expectations of them as women, their lack of education and adequate training to tackle subjects

other than small-scale genre scenes and still life. 'Since it is not necessary to have had a long training in draughtsmanship in order to paint a copper pot, a candlestick, and a bunch of radishes', remarked the art critic Paul Mantz in 1865, 'women succeed quite well in this type of domestic painting.'[12]

However, there were two artists who refused to restrict themselves to 'domestic painting': Rosa Bonheur and Elizabeth Southerden Thompson (later Lady Butler). Both artists became internationally famous due, in each case, to the runaway success of one particular painting.

Born in Bordeaux, Bonheur (1822–99) was trained principally by her father. She was already well established as an animal painter when her masterpiece, *The Horse Fair*, caused a sensation at the Salon in 1853. This enormous painting shows a great phalanx of Percheron draft horses, their necks arched and nostrils flaring, surging across the canvas, their bareback riders fighting to keep them under control. One anonymous writer described it as 'a wonderful work for any painter; but as the production of a female it is marvellous in conception and execution',[13] a comment that underlines the art establishment's constant amazement that a woman should attempt such a 'masculine' subject. The fact that Bonheur dressed like a man also contributed to her fame, although she initially adopted this attire in order to gain permission to attend horse fairs and cattle markets so that she could study her subjects from life. May Alcott relates a story told to her by an art tutor who had taken his students to Barbizon in the Forest of Fontainebleau to teach them to paint *en plein air*. En route to and from their hotel 'they often met a slender, solitary youth, who with easel and colours seemed from early until late intent only on work'. They later discovered that the youth was Bonheur who, 'for greater independence, had donned male attire to paint unknown at Barbizon'.[14] By her thirties,

Bonheur was wealthy enough to buy a chateau near Fontainebleau where she lived and painted, surrounded by a menagerie of exotic animals, including a pet lion. She was the first female artist to receive the Légion d'Honneur, which was delivered to her in person at the chateau by the Empress Eugénie.

The painting that made the reputation of Lady Butler (1846–1933), *Calling the Roll after an Engagement, Crimea*, was exhibited at the Royal Academy in 1874: a sombre huddle of Guardsmen, their busbies outlined against the snow-laden sky, lean on their upturned rifles, battle-weary and silent. The picture also paid a visit to Queen Victoria, who promptly bought it. Other paintings depicting heroic and patriotic military engagements followed, among them the headlong charge of the Scots Greys in *Scotland for Ever!* Famous for her forensic attention to detail, Lady Butler recorded her preparations for painting the scene: 'I twice saw a charge of the Greys ... and I stood in front to see them coming on. One cannot, of course, stop too long to see them too close.'[15] Her painting *The 28th Regiment at Quatre Bras* (1875), which showed red-coated infantrymen facing a blistering attack during the Waterloo campaign, was praised by John Ruskin for its 'gradations of colour and shade of which I have not seen the like since Turner's death'.[16] Despite her continued success, Butler failed by two votes to be elected to the Royal Academy.

It would be hard to imagine an artist who produced works more at odds with Lady Butler's epic battles than the small sentimental genre scenes painted by Emily Mary Osborn (1828–1925). Such scenes, which emphasised the blameless domestic lives led by middle-class women — the so-called 'Angel in the House' — were immensely popular with the Victorians who sought to emulate the bourgeois family life of the Queen and Prince Albert.

Osborn's best-known work, *Nameless and Friendless* (1857), shows a beautiful young woman, accompanied by her young son, attempting

52. Elizabeth Southerden Thompson (Lady
Butler), *Scotland for Ever!* 1881 (detail)

Lady Butler went to great lengths to ensure that
every detail of her paintings was correct: soldiers
were hired and dressed in the appropriate uniforms;
a field of rye was trampled to simulate an historic
action; canons were fired to gauge the effects of the
smoke. She also prided herself on being one of the first
artists to accurately represent the movement of
a horse's legs – as this painting demonstrates.

53. Emily Mary Osborn, *Nameless and Friendless*, 1857
Many Victorian genre artists focused on the plight
of unmarried middle-class women who struggled to
make a living. Osborn's image of a young female artist
anxiously awaiting a dealer's verdict is depicted with
great compassion. When the painting was exhibited, she
highlighted its message by adding a line from Proverbs to
the title: 'The rich man's wealth is his strong city, etc.'

to sell a painting to an art dealer. Her timidity and dejection as she awaits his verdict is being slyly observed by two top-hatted connoisseurs in the background. The plight of women was one of Osborn's principal themes, but to show a professional female artist in distress was highly unusual.

The figure of the art dealer in Osborn's picture is significant: although art dealers had existed in the previous century, selling pictures had been little more than a sideline to their main function of selling stationery and artists' materials. But by the nineteenth century it was no longer the connoisseur who was the principal buyer of works of art but members of the wealthy middle classes. Bewildered by the choice offered by the art galleries springing up in towns and cities, they sought the advice of a dealer. This suited the artists, as it relieved them from having to waste time and effort trying to find buyers themselves.

A clever dealer could prove the making of an artist: Rosa Bonheur's English dealer, Ernst Gambart, spread her fame by exhibiting *The Horse Fair* in London and arranging for it to be seen – and rapturously applauded – by Queen Victoria at Buckingham Palace. And, had it not been for dealer Paul Durand-Ruel's faith in the potential of artists like Monet, Manet and Renoir, they might never have become the household names they are today. Known as 'The man who sold a thousand Monets' – literally – it was Monet who said of Durand-Ruel, 'Without him we wouldn't have survived.'

Durand-Ruel also handled the work of the French artist, Berthe Morisot (1841–95). She and her sister Edma had been determined to become professional artists, despite such an ambition being unusual for girls of their high class. Nor had they received much encouragement from their first art teacher, Joseph-Benoît Guichard, who warned their mother: 'Considering the character of

your daughters, my teaching will not endow them with minor drawing-room accomplishments, they will become painters. Do you realise what this means? In the upper class milieu to which you belong, this will be revolutionary, I might almost say catastrophic.'[17]

Berthe Morisot was already exhibiting successfully at the Salon when she married Édouard Manet's brother, Eugène. Under the influence of her famous brother-in-law she concentrated on portraits and scenes of everyday life, still the period's most popular subjects, both with artists and the public. In the view of the Irish novelist George Moore, 'she has created a style, and has done so by investing her art with all her femininity; her art is no dull parody of ours: it is all womanhood.'[18] Her painting, *The Cradle,* shows her sister Edma seated in quiet contemplation of her sleeping child. The sense of peace and stillness within the room is palpable. The same feeling pervades her well-known painting, *Reading* of 1873. A woman – Edma again – wearing a sparkling white dress and a jaunty little hat, sits alone in a lush green meadow reading a book. Self-contained and absorbed in her task, she has the air of someone who is doing exactly what she wants to do.

Morisot was the first woman to join the small group of artists who had rebelled against the Salon's dictates and were exhibiting independently. When reviewing the second exhibition of these Indépendants (or Impressionists as they became known) the art critic Albert Wolff described them as 'five or six lunatics – among them a woman'.[19]

Manet also influenced the career of Eva Gonzalès (1849–83). His large portrait of her seated at her easel painting a bowl of flowers (now in London's National Gallery) is possibly better known today than her own pictures. However, in her short life (she died aged just thirty-four) she produced a substantial body of work,

54. Berthe Morisot, *Reading*, 1873

This was one of the paintings that Morisot showed at the
first Impressionist exhibition in 1874 where it was savaged
by the critics. In the opinion of her first art teacher, Guichard,
she should have apologised to Correggio for trying to do
something in oil that could only be done in watercolours.
It has since become one of her best-known works.

55. Mary Cassatt, *The Child's Bath*, 1893
The image of the 'modern madonna' – a woman
and her child in a pose reminiscent of the Virgin
Mary and the infant Jesus – was a popular
theme in nineteenth-century France. Here, the
cropped forms, the bold stripes of the mother's
dress and the flattened perspective of this
intimate scene display the influence of Cassatt's
study of Japanese woodblock prints.

specialising in fashionable women at the theatre and intimate scenes of daily life, her models drawn from her close family circle.

While Morisot and Eva Gonzalès owed much of their success to their connection with Manet, it was Edgar Degas' friendship and guidance that benefitted the career of Mary Cassatt (1844–1926). Born in America, Cassatt studied for four years at the Pennsylvania Academy of Fine Arts. But, growing weary of 'drawing from dull lifeless casts',[20] she went to Paris and enrolled with Charles Chaplin. After further studies in Europe, she settled in Paris and began to exhibit at the Salon. Disillusioned by the Salon's jury system, she was quick to accept Degas' invitation to exhibit at the fourth Impressionist exhibition in 1879. Today, Cassatt is best known for her delightful images of mothers and children. One of her finest paintings, *The Child's Bath* (sold for her by Durand-Ruel), shows a mother washing her daughter's feet. It demonstrates Cassatt's ability to infuse such scenes with great tenderness and love. She was also a brilliant printmaker, some of her subjects inspired by the Japanese woodblock prints which became so popular in the West in the latter half of the century.

Paris was not the only European capital to attract aspiring women artists. Harriet Hosmer, whose defiant quote begins this chapter, was one of several sculptors who left America for Rome in search of expert tuition, fine materials and a way of life unhindered by the conventions of American society. Hosmer had studied sculpture and human anatomy in America but completed her training with John Gibson, a leading English sculptor resident in Rome. She made her reputation with life-sized figures in marble of famous doomed heroines in history, but her most successful work, a small statue of a chubby *Puck on a Toadstool* of 1856, was bought by the Prince of Wales and proved so popular that Hosmer sold thirty copies of it.

By the 1890s the Salon and the Académie des Beaux-Arts (originally the Académie Royale but it had, for obvious reasons, dropped the 'Royale') had lost their former authority; artists now sold their work through private galleries, dealers or organised their own shows.[21] The Union des Femmes Peintres et Sculpteurs (dubbed 'Sisters of the Brush' by Rosa Bonheur), under the leadership of the artist Mme Léon Bertaux, campaigned through the '80s and '90s for the École des Beaux-Arts to open its doors to women; in 1897 it finally capitulated.[22]

Yet despite the progress made by female artists during the nineteenth century, when Renoir was asked his opinion of feminism, his reply demonstrates that he was not free of prejudice against women who neglected their 'natural' roles as wives and mothers in order to pursue a career: 'I consider that women are monsters who are authors, lawyers and politicians, like George Sand ... and other bores who are nothing more than 5-legged beasts. The woman who is an artist is merely ridiculous, but I feel that it is acceptable for a woman to be a singer or dancer.'[23] This view, while not so blatantly or so brutally expressed, persisted among art historians until the 1970s, although they expressed it more subtly – by simply leaving women artists out of the art historical record.

Today women artists have been recognised in a number of tangible, irrefutable ways: the first museum dedicated to the work of a female painter, the Paula Modersohn-Becker Museum, was opened in 1927 in Bremen, Germany; and since 1987 America has had a National Museum of Women in the Arts in Washington, DC, the only major museum in the world solely dedicated to celebrating women's achievements in the visual, performing and literary arts. In 2015 a painting by the twentieth-century artist Georgia O'Keeffe, *Jimson Weed/White Flower No.1*, was sold for £28 million,

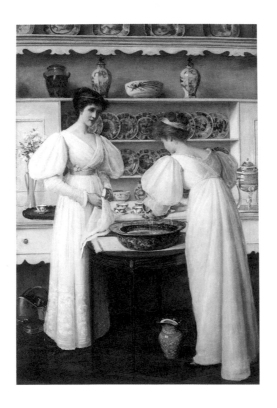

56. Louise Jopling, *Blue and White*, 1896
Jopling was one of the first English artists to study
in Paris, enrolling at the studio of Charles Chaplin
from 1867–68. She is best known for her portraits
of aristocrats, wealthy financiers and actresses like
Ellen Terry. She championed the right of female art
students to work directly from live models, and in
1887 opened an art school for women.

smashing the record for a price at auction by a female artist. This may sound impressive, but when compared with the £116 million commanded by Picasso's *Femme d'Algers* in the same year, it is clear that women artists, both dead and alive, are woefully undervalued.

How has posterity treated those eighteenth-century artists who had faced greater obstacles than their nineteenth-century counterparts and yet still contrived to forge successful careers? Some sank without trace, some became shadowy figures until resurrected by an exhibition entitled *Old Mistresses* at the Walters Art Museum in Baltimore in 1972. This was followed three years later by the crucial exhibition *Women Artists: 1550–1950* in Los Angeles. In 2002 Anne Vallayer-Coster was the subject of a major exhibition in America. A retrospective of Angelica Kauffman's work was held at Munich, Dusseldorf and Chur in Switzerland (her birthplace) in 1998. In 2013 her portrait of Lord Byron's Venetian landlady was sold at Christie's for £433,875 – almost twice its estimate.

However, it is the work of Elisabeth Vigée Le Brun that has undergone the most spectacular revival: in late 2015 the first ever major retrospective of her work to be shown in her native country was held at the Grand Palais in Paris. From there, an abridged version travelled to the Metropolitan Museum in New York. Vigée Le Brun was hailed as one of the finest eighteenth-century French painters and among the most important of all women artists.

Perhaps it is only right that Vigée Le Brun has weathered the passage of time and the whims of fashion better than all her contemporaries. To become a professional artist in the eighteenth century required not only talent but enormous resilience – both physical and mental – courage, fierce ambition and a dash of audacity. Vigée Le Brun possessed all these attributes in abundance. She was also blessed with charm and beauty, although these could – and often did – prove dangerous assets in a scandal-seeking society. Looking

back on her long life, Vigée Le Brun noted in her *Memoirs*: 'I know I have often said ... how untypical my life was for a young woman; for my talent, feeble though it might have been compared with the great masters, made me welcome, nay sought after, at all the salons. Sometimes I became the recipient of ... public acclaim; I must admit, this was a source of great satisfaction to me.'[24] The retrospective of her work would have given her even greater satisfaction, especially if she knew that one of the editors of the catalogue considered that 'When her genius was fully in play, Vigée Le Brun ranked equally with the great masters of her time.'[25] So why did it take so long for the country of her birth to pay tribute not only to a superb artist but to one who left an invaluable record of a vivid period in its history?

There are so many answers to that question, the principal being that she was a woman operating in a world governed by men. They made the rules, set the standards, dictated taste, controlled every art institution. Female art critics were an unknown species. It was a world that intimidated artists less obsessive, confident and determined than Vigée Le Brun.

Intimidated they may have been, but not deterred. Although they did not achieve the celebrity status of Kauffman, Carriera and Vigée Le Brun, many women artists stubbornly resisted society's opprobrium and the male establishment's indifference, and continued to produce work of high quality. Their paintings hold up a mirror to an age of elegance and ease, albeit enjoyed by a tiny minority. Their perseverance against all the odds blazed a trail for succeeding generations to follow. As the pages of this book demonstrate, together they left a body of work that is a testament to their resilience, talent and dedication.

Notes

Introduction

1. Fine, p. 36
2. Harris & Nochlin, p. 41
3. Brewer, p. 77
4. de Goncourt, pp. 243–4
5. Hyde & Milam, p. 1
6. Ibid., p. 6.
7. *Grove*, vol. 33, p. 307
8. Harris & Nochlin, p. 11
9. Museum of Modern Art, New York
10. *Grove*, vol. 33, p. 307
11. Borzello, *A World of Our Own*, p. 123
12. Boswell, *Journal*, 23 September 1773

A woman's place

1. Chadwick, p. 40
2. Shawe-Taylor, p. 99
3. Sheridan, p. 17
4. Hill, p. 56
5. Smollett, *Humphry Clinker*, p. 11
6. de Goncourt, p. 5
7. Fine, p. 67
8. Shawe-Taylor, p. 112
9. Parker & Pollock, p. 61
10. Eliot, p. 65
11. Chadwick, p. 40
12. Fine, p. 63
13. Harris & Nochlin, p. 45
14. Fine, p. 62
15. Hill, p. 44
16. Austen, *Northanger Abbey*, p. 86
17. Boswell, *Life*, vol. I, no. 15
18. Rousseau, p. 6
19. Ibid., p. 445

20. Hill, p. 55
21. Piper, p. 154
22. Robertson, p. 199
23. Diderot, *Correspondance*, vol. 5, pp. 100–5
24. Hicks, p.199
25. Goodden, *Kauffman*, p. 71
26. Parker & Pollock, p. 93
27. Chadwick, p. 165
28. Goodden, *Vigée Le Brun*, p. 54
29. Higonnet, p. 29
30. www.metmuseum.org
31. Borzello, *A World of Our Own*, p. 114
32. Robertson, p. 199
33. Chadwick, p. 41

Training

1. Manners, p. 380
2. Nochlin, *Art News*, pp. 22–39
3. Fenton, p. 77
4. Munro, p. 27
5. Whitley, vol. 1. p. 348
6. Bignamini & Postle, p. 20
7. Whitley, vol. 1, p. 350
8. Smith, vol. 1, p. 65
9. Goodden, *Kauffman*, p. 6
10. Auricchio, p. 14
11. Harris & Nochlin, p. 36
12. Kahng & Michel, p. 86
13. Northcote, p. 53
14. *Oxford Dictionary of National Biography*
15. Manners, p. 380
16. Vigée Le Brun, p. 16

17. Ibid., p. 11
18. Ibid., p. 16
19. Whitley, vol. 2, p. 164
20. Borzello, *A World of Our Own*, pp. 88–9
21. Vigée Le Brun, p. 27
22. Kahng & Michel, p. 19
23. Harris & Nochlin, p. 180
24. Ibid., p. 213
25. Goodden, *Kauffman*, pp. 176–7

The artist's studio

1. Borzello, *A World of Our Own*, p. 105
2. Walker, p. 322
3. Brewer, p. 306
4. Waterfield, *Foreword*
5. Brewer, p. 311
6. Page, pp. 75–6
7. Borzello, *A World of Our Own*, p. 108
8. Rosenthal, pp. 88–9
9. Whitley, pp. 84–5
10. Wendorf, p. 251
12. Ayres, p. 45
13. Cosway's chair is in the V & A Museum, London
14. Vigée Le Brun, p. 355
15. Mannings, p. 280
16. Whitley, vol. 1, pp. 103–4
17. Borzello, *A World of Our Own*, p. 108
18. Ibid., p. 108
19. Pasquin, p. 115
20. Pointon, *Art History*, p.196
21. Ibid., pp. 200–1
22. Ibid., p. 197

23. Whitley, vol. 1, p. 331
24. Ayres, p. 87
25. Ibid., p. 94
26. Webb, p. 84
27. Borzello, *A World of Our Own*, p. 109
28. Yarrington, *Sculpture Journal*, p. 34
29. Borzello, *World of Our Own*, p. 105
30. Vigée Le Brun, p. 28
31. Ibid., p. 355
32. Manners, *The Connoisseur*, p. 385
33. Brewer, p. 224
34. Penny, p. 60
35. Wendorf, p. 164

Portraiture

1. Piper, p. 89. Is Cromwell addressing Sir Peter Lely, who painted Cromwell in c. 1653? Piper suggests that Lely's portrait is so like a miniature by Samuel Cooper of 1650 'that one must depend on the other...'
2. Ribeiro, p. 7
3. Ibid., p. 1
4. Pointon, *Art History*, p.187
5. R-M. & R. Hagen, p. 517
6. Pointon, *Art History*, p. 202
7. Shawe-Taylor p. 99
8. Ribeiro, p. 6
9. Borzello/*A World of Our Own*, p. 72
10. Pointon/*Art History*, p. 189
11. Crow, p. 21
12. Shawe-Taylor, p. 7

13. Ibid., p. 7
14. Ibid., p. 9
15. Ibid., p. 10
16. Goodden, *Kauffman*, p. 328
17. Rosenthal, p. 46
18. Vigée Le Brun, p. 18
19. Shawe-Taylor, p. 3
20. Rosenthal, p. 213
21. Bremer-David, p. 65
22. Borzello, *A World of Our Own*, p. 101
23. Vigée Le Brun, p. 88
24. Shawe-Taylor, p. 113
25. Vigée Le Brun, p. 354
26. Shawe-Taylor, p. 16
27. Heller, p. 60
28. Bermingham & Brewer, p. 131
29. R-M. & R. Hagen, p. 156
30. Penny, p. 59
31. Vigée Le Brun, p. 36
32. de Goncourt, p. 144
34. Ribeiro, p. 72
35. Bremer-David, p. 64
36. Smollett, *Travels*, p. 55
37. Harris & Nochlin, p. 105
39. Chadwick, p. 143
40. Goodden, *Kauffman*, p. 195
41. Ribeiro, p. 14
42. Brewer, p. 310
43. Borzello, *A World of Our Own*, p. 95
44. Goodden, *Kauffman*, p. 303
45. Vigée Le Brun, p. 355
46. Rosenthal, p. 44
47. Mowl, pp. 65–6
48. Rosenthal, p. 115

49. Borzello, *Seeing Ourselves*, p. 32
50. Beyer, p. 245
51. Pointon, *Hanging*, p. 80
52. Brewer, p. 311
53. Ribeiro, p. 6

The genres

1. Hicks, p. 127
2. Crow, p. 20
3. Harvey, p. 21
4. Bremer-David, p. 79
5. Cosmetti, p. 17
6. Hyde & Milam, p. 188
7. Roworth, p. 86
8. Goodden, *Kauffman*, p. 11
9. Roworth, p. 135
10. Goodden, *Kauffman*, p. 7
11. Ibid., p. 173
12. Harris & Nochlin, pp. 48–9
13. Borzello, *A World of Our Own*, p. 102
14. R-M. & R. Hagen, vol. 2, p. 438
15. Ibid., p. 447
16. Harris & Nochlin, p. 180
17. 'Apples, Pears and Paint: How to make a Still-Life Painting', BBC4, 5 January 2014
18. Smith, p. 321
19. Heller, p. 84
20. Rosenthal, p. 2
21. Borzello, *A World of Our Own*, p. 40
22. Harris & Nochlin, p. 195

23. R-M. & R. Hagen,
p. 472
24. Auricchio, p. 63
25. Heller, p. 53

The marketplace
1. Cosmetti, p. 16
2. Goodden, *Vigée Le Brun*, p. 239
3. Goodden, *Kauffman*, p. 112
4. Austen, *Pride and Prejudice*, p. 266
5. Foreman, p. 28
6. Whitley, vol. 1, p.160
7. Brewer, p. 204
8. Whitley, vol. 1, p. 160
9. Heller, pp. 11–12
10. Brewer, pp. 202–3
11. Ibid., p. 212
12. Taylor, p. 10
13. Rosenthal, p. 31
14. Goodden, *Kauffman* p. 119
15. Taylor, p. 4
16. Shawe-Taylor, p. 25
17. Hutchison, p. 48
18. Fenton, p. 119
19. *The World, Fashionable Advertiser*, 8 May 1787
20. Fenton, p. 119
21. Ibid., p. 121
22. Lewis, Walpole to Mann, 6 May 1770, vol. 23
23. Crow, p. 4
24. Ibid., p. 20
25. Kahng & Michel, p. 87
26. Schama, p. 216
27. Ibid., pp. 216–7
28. Goodden, *Vigée Le Brun*, p. 52

29. Borzello, *A World of Our Own*, p. 93
30. Harris & Nochlin, p. 169
31. Kahng & Michel, p. 55, n5
32. Goodden, *Kauffman*, p. 1
33. Fine, p. 48
34. Tillyard, p. 203
35. Goodden, *Kauffman*, p. 333
36. Ibid., p. 141
37. Vigée Le Brun, p. 38
38. Kahng & Michel p. 30
39. Walker, p.320
40. Brewer, p. 453
41. Johnson, E. D. H., p. 83

The patrons
1. Boswell, *Life*, vol. 1, p. 261
2. Wendorf, p. 160
3. de Goncourt, p. 265
4. Goodden, *Vigée Le Brun*, p. 43
5. Auricchio, p. 35
6. Ibid., p. 37
7. Brewer, p. 207
8. Goodden, *Kauffman*, p. 218
9. Rosenthal, p. 163
10. Goodden, *Kauffman*, p. 325
11. Roworth, p. 44
12. Ibid., p. 44
13. Ibid., p. 72
14. Constantine, p. 170
15. Ibid., p. 328
16. Baillio, Baetjer & Lang, p. 145 17. Auricchio, pp. 56–7

18. Borzello, *A World of Our Own*, p. 75
19. Ribeiro, pp. 227–8
20. Vigée Le Brun, pp. 32–3
21. Chadwick, p. 169
22. Fraser, p. 256
23. Goodden, *Vigée Le Brun*, p. 159
24. Vigée Le Brun, p. 33
25. Auricchio, p. 73
26. Kahng & Michel, p. 41
27. Goodden, *Kauffman*, p. 16
28. Constantine, p. 46
29. Goodden, *Kauffman*, p. 224
30. Ibid., p. 222

Private lives
1. Borzello, *A World of Our Own*, pp. 110–1
2. Borzello, *A Graphic Guide*, p. 15
3. Heller, p. 29
4. Vigée Le Brun, p. 26
5. Goodden, *Vigée Le Brun*, p. 14
6. Ibid., p. 32
7. *The Spectator*, December 2014, p. 86
8. Goodden, *Vigée Le Brun*, p. 97
9. Fine, p. 67
10. Rosenthal, p. 97
112. Goodden, *Kauffman*, p. 110
12. Rosenthal, p. 232
13. Goodden, *Kauffman*, p. 235
14. Ibid., p. 237
15. Ibid., p. 230

16. Goodden, *Vigée Le Brun*, p. 51
17. Baillio, Baetjer & Lang, p. 30
18. Goodden, *Vigée Le Brun*, p. 50
19. Goodden, *Kauffman*, p. 278
20. Rosenthal, p. 9
21. Goodden, *Vigée Le Brun*, p. 318
22. Baillio, Baetjer & Lang, p. 9
23. Walker, . 320

A polite recreation

1. Borzello, *Seeing Ourselves*, p. 95
2. Austen, *Pride and Prejudice*, p. 84
3. Borzello, *Seeing Ourselves*, p. 95
4. Sloan. p. 294
5. Hicks, p. 53
 Ibid., 134
7. Auricchio, p. 19
8. Ibid., p. 19
9. Hicks, p. 58
10. Goff, Goldfinch, Limper-Herz & Peden, pp. 52–3
11. Hicks, pp. 135–6
12. Greer, p. 287
13. Collins, p. 27
14. Borzello, *Seeing Ourselves*, p. 95
15. McIntyre, p. 209
16. Shawe-Taylor, pp. 115–6
17. Sloan, p. 46
18. Borzello, *Seeing Ourselves*, p. 94
19. Parker & Pollock, p. 54
20. Greer, p. 287
21. Chadwick, p. 148
22. Hicks, p. 3
23. Sloan, p. 238
24. Hicks, p. 267
25. Ibid., p. 320
26. Ibid., p. 294
27. Tillyard, p. 15
28. Ribeiro, p. 218
29. Webb, p. 69
30. Gould, p. 132
31. Webb., p. 68
32. Noble, p. 76

Looking ahead

1. Heller, p. 73
2. Fine, p. 41
3. Auricchio, p. 99
4. Lethève, p. 119
5. Ibid., p. 120
6. Mancoff, p. 13
7. Borzello, *A World of Our Own*, p. 133
8. Chapman, p. 59
9. Thackeray, p. 56
10. Nieriker, p. 43
11. Borzello, *Graphic Guide*, p. 39
12. Garb, p. 6
13. Metropolitan Museum of Art, New York
14. Nieriker, p. 52
15. Sunderland, p. 220
16. Ibid., p. 220
17. Garb, p. 8
18. Ibid., p. 15
19. Mancoff, p. 31
20. Fine, p. 130
21. Mainardi, p. 1
22. Borzello, *A World of Our Own*, p. 142
23. Borzello, *Graphic Guide*, p. 26
24. Vigée Le Brun, p. 24
25. Baillio, Baetjer & Lang, p. 21

🎗 Bibliography

I would like to select a few sources for special mention for the simple reason that I could not have written this book without them. Two of Frances Borzello's books have been invaluable: *A World of Our Own: Women as Artists* and *Seeing Ourselves: Women's Self-Portraits*, both superbly illustrated. I also relied heavily on Angelica Goodden's meticulously researched biographies of the two principal artists: *Miss Angel: The Art and World of Angelica Kauffman* and *The Sweetness of Life: A Biography of Elisabeth Louise Vigée Le Brun*. And, lastly, I could not have survived without the catalogue for *Women Artists: 1550–1950*, the major exhibition held at the Los Angeles County Museum of Arts in 1976. The authors, Ann Sutherland Harris and Linda Nochlin, with the help of specialist contributors, delved deep and brought to light many women artists who had been either ignored or forgotten.

Auricchio, Laura, *Adélaïde Labille-Guiard: Artist in the Age of Revolution*, Los Angeles, 2009

Austen, Jane, *Northanger Abbey* (1816), Oxford, 1991

––, *Pride and Prejudice* (1813), London, 1977

Ayres, James, *The Artist's Craft: A History of Tools, Techniques and Materials*, Oxford, 1985

Baillio, J., K. Baetjer and P. Lang (eds), *Vigée Le Brun*, exhibition catalogue, Metropolitan Museum of Art, New York, 2016

Bermingham, Ann and John Brewer, *The Consumption of Culture 1600–1800*, London, 1995

Beyer, Andreas, *Portraits: A History*, New York, 2003

Bignamini, Ilaria and Martin Postle (eds), *The Artist's Model: Its Role in British Art from Lely to Etty*, Nottingham, 1991

Borzello, Frances, *Seeing Ourselves: Women's Self-Portraits*, London, 1998

(revised and expanded 2016)

––, *Women Artists: A Graphic Guide*, London, 1986

––, *A World of Our Own: Women as Artists*, London, 2000

Boswell, James, *The Journal of a Tour to the Hebrides*, 23 September 1773

––, *Life of Samuel Johnson* (1790), London, 1946

Bremer-David, Charissa (ed.), *Paris: Life and Luxury in the Eighteenth Century*, Los Angeles, 2011

Brewer, John, *The Pleasures of the Imagination: English Culture in the Eighteenth Century*, London, 1997

Chadwick, Whitney, *Women, Art and Society*, London, 1990

Chapman, Caroline, *Elizabeth and Georgiana: The Duke of Devonshire and His Two Duchesses*, London, 2002

Constantine, David, *Fields of Fire: A Life of Sir William Hamilton*, London, 2002

Cosmetti, *The Polite Arts, Dedicated to the Ladies*, 1767

Crow, Thomas E., *Painters and Public Life in Eighteenth-Century Paris*, New Haven and London, 1985

Diderot, D., *Correspondance*, Paris, 1955–70

––, *Diderot on Art*, (ed. and trans.) J. Goodman, vol. 2, New Haven, 1995

Fenton, J., *School of Genius*, London, 2006

Fine, Elsa Honig, *Women and Art*, Montclair, New Jersey, 1978

Fraser, Antonia, *Marie Antoinette: The Journey*, London, 2001

Garb, Tamar, *Women Impressionists*, Oxford, 1986

Goff, M., J. Goldfinch, K. Limper-Herz and H. Peden (eds), *Georgians Revealed: Life, Style and the Making of Modern Britain*, exhibition catalogue, The British Library, London, 2013

Goncourt, J. and E. de, *The Woman of the Eighteenth Century*, Paris, 1928

Goodden, A., *Miss Angel: The Art and World of Angelica Kauffman*, London, 2005

––, *The Sweetness of Life: A Biography of Elisabeth Louise Vigée Le Brun*, London, 1997

Gould, John, *Biographical Dictionary of Artists*, London, 1839

Greer, Germaine, *The Obstacle Race: The Fortunes of Women Painters and Their Work*, London, 1979

Grove Dictionary of Art, (ed.), Jane Turner, vol. 33, London, 1996

Hagen, Rose-Marie and Rainer, *What Great Paintings Say*, vol. 2, Hohenzollernring, Germany, 2005

Harris, Ann Sutherland and Linda Nochlin (eds), *Women Artists: 1550–1950*, exhibition catalogue, Los Angeles County Museum of Art, 1976

Heller, Nancy G., *Women Artists: An Illustrated History*, London, 1987

Hicks, C., *Improper Pursuits: The Scandalous Life of Lady Di Beauclerk*, London, 2002

Higonnet, Anne, *A Museum of One's Own: Private Collecting, Private Gift*, Pittsburgh and New York, 2009

Hill, Bridget, *Eighteenth-Century Women: An Anthology*, London, 1984

Hyde, Melissa and Jennifer Milam, *Women, Art and the Politics of Identity in Eighteenth-Century Europe*, London, 2003

Johnson, E.D.H., *Painters of the British Social Scene from Hogarth to Sickert*, New York, 1986

Johnson, Dr. S., *The Letters of Samuel Johnson*, (ed.), R.W. Chapman, London, 1952

Kahng, Eik and Marianne Roland Michel, *Anne Vallayer-Coster: Painter to the Court of Marie-Antoinette*, New Haven and London, 2002

Lethève, Jacques, *Daily Life of French Artists in the Nineteenth Century*, (trans.) Hilary E. Paddon, London, 1972

Lewis, Wilmarth S. (ed.), *The Yale Edition of Horace Walpole's Correspondence*, Newhaven and London, 1937–83

McIntyre, Ian, *Joshua Reynolds: The Life and Times of the First President of the Royal Academy*, London, 2003

Mainardi, P., *The End of the Salon: Art and the State in the Early Third Republic*, Cambridge, 1993

Mancoff, D.N., *Danger! Women Artists at Work*, London and New York, 2012

Manners, Lady Victoria, 'Catherine Read: The English Rosalba', *Connoisseur*, vol. 88, London, 1931

Mannings, David, 'At the Portrait Painter's: How the painters of the eighteenth century conducted their studios and sittings', *History Today*, vol. 27, 1977

Munro, Jane, *Silent Partners: Artist and Mannequin from Function to Fetish*, Cambridge, 2014

Nieriker, May Alcott, *Studying art Abroad and How to do it cheaply*, Boston, Mass., 1879

Noble, Percy, *Anne Seymour Damer: A Woman of Art and Fashion 1748–1828*, London, 1908

Nochlin, Linda, 'Why Have There Been No Great Women Artists?' *Art News*, January 1971

––, *Women Artists: The Linda Nochlin Reader*, (ed.) Maura Reilly, London, 2015

Page, T., *The Art of Painting*, Norwich, 1720

Parker, Rozsika and Griselda Pollock, *Old Mistresses: Women, Art and Ideology*, London, 1981

Piper, D., The English Face, London, 1992

Pointon, Marcia, *Hanging the Head: Portraiture and Social Formation in Eighteenth-Century England*, New Haven and London, 1993

––, 'Portrait-Painting as a Business Enterprise in London in the 1780s', *Art History*, vol. 7, No. 2, June 1984

Reynolds, J., *Discourses on Art* (ed.) R.R. Wark, New Haven and London, 1997

Ribeiro, Aileen, *The Art of Dress: Fashion in England and France 1750–1820*, London, 1995

Robertson, Fiona (ed.), *Women's Writing 1778–1838*, Oxford, 2001

Rosenthal, Angela, *Angelica Kauffman: Art and Sensibility*, New Haven and London, 2006

Rousseau, Jean-Jacques, *Émile*, (trans.) B. Foxley, London, 1998

Roworth, Wendy Wassyng (ed.), *Angelica Kauffman: A Continental Artist in Georgian England*, London, 1992

Schama, Simon, *Citizens: A Chronicle of the French Revolution*, London, 1989

Shawe-Taylor, Desmond, *The Georgians: Eighteenth-Century Portraiture and Society*, London, 1990

Sheridan, R.B., *Sheridan's Plays: The Rivals* (1775), London, 1963

Sloan, Kim, *A Noble Art: Amateur Artists and Drawing Masters c.1600–1800*, London, 2000

Smith, J.T., *Nollekens and his Times*, 2 vols, London, 1895

Smollett, Tobias, *Humphry Clinker* (1771), London, 1945

––, *Travels Through France and Italy* (1766), London, 1970

Stone, Lawrence, *The Family, Sex and Marriage in England 1500–1800*, London, 1984

Sunderland, John, *Painting in Britain 1525 to 1975*, Oxford, 1976,

Talley, M. K., Jr, 'All Good Pictures Crack: Sir Joshua Reynolds's Practice and Studio', *Reynolds*, exhibition catalogue (ed.) N. Penny, Royal Academy, 1986

Taylor, Brandon, *Art for the Nation: Exhibitions and the London Public 1747–2001*, Manchester, 1999

Tillyard, Stella, *Aristocrats*, London, 1995

Vigée Le Brun, Elisabeth, *The Memoirs of Elisabeth Vigée Le Brun*, (ed. and trans.) S. Evans, London, 1989

Walker, John, 'Maria Cosway: An Undervalued Artist', *Apollo*, May 1986

Waterfield, Giles (ed.), *The Artist's Studio*, exhibition catalogue, Compton Verney, Warwicks., 2009

Webb, R., *Mrs. D: The Life of Anne Damer*, Studley, Warwickshire, 2013

Wendorf, Richard, *Sir Joshua Reynolds: the Painter in Society*, London, 1986

Whitley, William T., *Artists and Their Friends in England 1700–1799*, 2 vols, London, 1928

Yarrington, A., 'The Female Pygmalion: Anne Seymour Damer, Allan Cunnningham and the writing of a woman sculptor's life', *The Sculpture Journal*, vol. 1, 1997

☙ List of illustrations

Front Cover: Marie-Geneviève Bouliar, *Adélaïde Binart*, 1796. Oil on canvas, 82 x 62 cm. Musée Carnavalet, Paris

Title Page: Elisabeth Vigée Le Brun, *Self-portrait in a Straw Hat*, 1782. Oil on wood, 95 x 68.5 cm. The National Gallery, London

Back Cover: Anne Vallayer-Coster, *The Attributes of Painting, Sculpture and Architecture*, 1769. Oil on canvas, 90 x 121 cm. Musée du Louvre, Paris

1. Sofonisba Anguissola, *The Chess Game*, 1555. Oil on canvas, 72 x 97 cm. National Museum, Poznán, Poland.

2. Artemisia Gentileschi, *Judith and her Servant*, c.1618–19. Oil on canvas, 114 x 93.5 cm. Pitti Palace, Rome

3. Jean-François de Troy, *The Reading from Molière*, c. 1730. Oil on canvas, 73.9 x 93 cm. Private Collection

4. Angelica Kauffman, *Morning Amusement*, 1773. Oil on canvas, 74 x 63 cm. The Pushkin State Museum of Fine Arts, Moscow/akg-images

5. Rose Adélaïde Ducreux, *Self-portrait with a Harp*, c. 1791. Oil on canvas, 193 x 128.9 cm. Metropolitan Museum of Art, New York, Bequest of Susan Dwight Bliss, 1967

6. Marguerite Gérard, *The Piano Lesson*, 1785–87. Oil on canvas, 45.7 × 38.1 cm. H. Shickman Gallery, New York

7. Marie-Denise Villers, *Portrait of a Young Woman called Charlotte du Val d'Ognes*, 1801. Oil on canvas, 161.3 x 128.6 cm. Metropolitan Museum of Art, New York. Mr and Mrs Isaac D. Fletcher Collection, Bequest of Isaac D. Fletcher, 1917

8. Marie-Anne Collot, *Catherine the Great*, 1771. Marble, height 48 cm. State Hermitage Museum, St Petersburg/Bridgeman Images

9. Rolinda Sharples, *Self-portrait with her Mother*, c. 1820. Oil on panel, 36.8 x 29.2 cm. City of Bristol Museum and Art Gallery

10. Johann Zoffany, *The Academicians of the Royal Academy*, 1771–72. Oil on canvas, 100.7 x 147.3 cm. The Royal Collection

11. Adélaïde Labille-Guiard, *Self-portrait with Two Pupils*, 1785. Oil on canvas, 210.8 x 151.1 cm. Metropolitan Museum of Art, New York

12. Constance Mayer, *The Sleep of Venus and Cupid*, 1806. Oil on canvas, 96.5 x 144.5. The Wallace Collection, London

13. Marguerite Gérard and Jean-Honoré Fragonard, *The Reader*, 1806. Oil on canvas, 64.8 x 53.8 cm. Fitzwilliam Museum, University of Cambridge/Bridgeman Images

14. Marie Gabrielle Capet, *Studio Interior*, 1808. Oil on canvas, 69 x 83.5 cm. Neue Pinakothek, Munich

15. Marguerite Gérard, *Artist Painting a Portrait of a Musician*, 1803. Oil on canvas, 61 x 52 cm. Hermitage Museum, St Petersburg

16. Rosalba Carriera, *Self-portrait Holding a Portrait of her Sister*, 1715. Pastel on paper, 71 x 57 cm. Galleria degli Uffizi, Florence

17. Marie-Geneviève Bouliar, *Adélaïde Binart*, 1796. Oil on canvas, 82 x 62 cm. Musée Carnavalet, Paris

18. Elisabeth Vigée Le Brun, *Hubert Robert*, 1788. Oil on wood, 105 x 84 cm. Musée du Louvre, Paris

19. Elisabeth Vigée Le Brun, *Charles Alexandre de Calonne*, 1784. Oil on canvas, 155.5 x 130.3 cm. The Royal Collection, London

20. Angelica Kauffman, *Portrait of Lady Elizabeth Foster*, 1785–86. Oil on canvas, 127 x 101.5 cm. Ickworth, Suffolk/National Trust Photographic Library/Angelo Hornak/Bridgeman Images

21. Angelica Kauffman, *Lord Althorp and His Sisters*, 1774. Oil on canvas, 125.5 x 101 cm. From the Collection at Althorp, Northants

22. Elisabeth Vigée Le Brun, *Marie Antoinette 'à la rose'*, 1783. Oil on canvas, 116.8 x 88.9 cm. Musée Nationale du Château de Versailles

23. Rosalba Carriera, *Louis XV as a Boy*, 1720–21. Pastel on paper, 50.5 x 38.5. cm Staatliche Kunstsammlungen, Dresden

24. Angelica Kauffman, *Cleopatra Decorating the Tomb of Mark Antony*, 1770. Oil on canvas, 125 x 107 cm. Burghley House Collection, Stamford. Photo Akg Agency

25. Maria Cosway, *The Death of Miss Gardiner*, 1789. Oil on canvas, 101 x 127 cm. Musée de la Révolution Française, Vizille

26. Françoise Duparc, *A Woman Knitting*, n.d. Oil on canvas, 78 x 64 cm. Musée des Beaux-Arts, Marseilles, France

27. Anne Vallayer-Coster, *Still life with Seashells and Corals*, 1769. Oil on canvas, 130 x 97 cm. Musée du Louvre, Paris

28. Rachel Ruysch, *Spray of Roses with Beetle and Bee*, 1741. Oil on canvas, dimensions unknown. Kunstmuseum, Basel

29. Thomas Rowlandson, *The Exhibition Stare Case*, c. 1800. Coloured etching, 44.5 x 28.6 cm. Private Collection/ Bridgeman Images

30. Elisabeth Vigée Le Brun, *Peace Bringing Back Abundance*, 1780. Oil on canvas, 103 x 133 cm. Musée du Louvre, Paris/akg-images/Erich Lessing

31. Adélaïde Labille-Guiard, *Augustin Pajou*, 1782. Pastel, 71 x 58 cm. Musée du Louvre, Paris

32. Anne Vallayer-Coster, *The Attributes of Painting, Sculpture and Architecture*, 1769. Oil on canvas, 90 x 121 cm. Musée du Louvre, Paris

33. Angelica Kauffman, *Maria*, 1777. Oil on copper, 31 x 22.9. Burghley House Collection, Stamford/akg-images

34. Rosalba Carriera, *Portrait of Gustavus Hamilton, 2nd Viscount Boyne*, 1730–31. Pastel on paper, laid on canvas, 56.5 x 42.9 cm. Metropolitan Museum of Art, New York

35. Angelica Kauffman, *Self-portrait in the Character of Painting Embraced by Poetry*, 1782. Oil on canvas, 61 cm, tondo. Iveagh Bequest, Kenwood House, London

36. Anne Vallayer-Coster, *Bouquet of Flowers in a Terracotta Vase, with Peaches and Grapes*, 1776. Oil on canvas, 121 x 113.3 cm. Dallas Museum of Art, Dallas, Texas; Dallas Museum of Art Foundation for the Arts Collection, Mrs John O'Hara Fund and gift of Michael L. Rosenberg, 1998.51

37. Marie-Guillemine Benoist, *Portrait of Pauline Bonaparte, Princess Borghese*, 1808. Oil on canvas, 200 x 142 cm. Musée National du Château de Versailles

38. Adélaïde Labille-Guiard, *Madame Adélaïde*, 1787. Oil on canvas, 271 x 195 cm. Musée Nationale du Château de Versailles

39. Elisabeth Vigée Le Brun, *Marie Antoinette and Her Children*, 1787. Oil on canvas, 275 x 216.5 cm. Musée Nationale du Château de Versailles

40. Elisabeth Vigée Le Brun, *Self-portrait with Her Daughter Julie*, 1786. Oil on wood, 105 x 84 cm. Musée du Louvre, Paris

41. Angelica Kauffman, *Self-portrait*, c. 1770–75. Oil on canvas, 73.7 x 61 cm. National Portrait Gallery, London

42. Rosalba Carriera, *Self-portrait*, 1746. Pastel on paper, 31 x 25 cm. Galleria dell' Accademia, Venice

43. Anna Dorothea Therbusch, *Self-portrait*, 1776–77. Oil on canvas, 151 x 115 cm. Staatliche Museen, Berlin

44. Print by Valentine Green after a painting by Maria Cosway, *Self-portrait with Arms Folded*, 1787. Coloured engraving, dimensions unknown. Trustees of the British Museum, London

45. A box of watercolours, made by Reeves & Woodyer, c. 1820. Victoria & Albert Museum, London

46. Mary Delany, *Magnolia Grandiflora*, 1776. Collage of coloured papers, with bodycolour and watercolour. Trustees of the British Museum, London

47. Archduchess Maria Christina of Austria, *Christmas in the Royal Household of Empress Maria Theresa of Austria*, 1763. Gouache on paper, 30 x 45 cm. Kunsthistorisches Museum, Vienna/Bridgeman Images

48. Elisabeth Vigée Le Brun, *Lady Hamilton as a 'Bacchante'*, 1790–91. Oil on canvas, 132.5 x 105.5 cm. National Museums, Liverpool

49. Anne Seymour Damer, *Sir Joseph Banks*, 1812–13. Bronze, height 71 cm. Trustees of the British Museum, London

50. Marie-Guillemine Benoist, *Portrait of a Negress*, 1800. Oil on canvas, 81 x 65 cm. Musée du Louvre, Paris

51. Adrienne Grandpierre-Deverzy, *Interior of Pujol's Studio in 1822*, c. 1822. Oil on canvas, 96 x 129 cm. Musée Marmottan, Paris

52. Elizabeth Southerden Thompson (Lady Butler), *Scotland for Ever!*, 1881 (detail). Oil on canvas, 101.6 x 194.3 cm. Leeds Museum and Galleries

53. Emily Mary Osborn, *Nameless and Friendless*, 1857. Oil on canvas, 82.5 x 103.8 cm. Tate Britain, London

54. Berthe Morisot, *Reading*, 1873. Oil on canvas, 46 x 71.8 cm. Cleveland Museum of Art, Ohio

55. Mary Cassatt, *The Child's Bath*, 1893. Oil on canvas, 100.3 x 66 cm. The Art Institute of Chicago, Chicago, Illinois

56. Louise Jopling, *Blue and White*, 1896. Oil on canvas, 123.5 x 86 cm. Lady Lever Art Gallery, Port Sunlight

Index

Locators in *italics* denote illustrations. Those in **bold** relate to the entries with the most significant information.

Académie de Saint-Luc, Paris 118, 119
Académie de Toulouse 48
Académie des Beaux-Arts, Paris 206
Académie Julian, Paris 193
Académie Royale de Peinture et de Sculpture, Paris 37, 42, 47, 49, 77, 102, 115, **118**, 122, 123, 133, 154, 162, 189–90, 206
 women's membership of 47, 119, 120
Accademia di San Luca, Rome 42, 117–8
Ackermann, Rudolph 126, 175
Aelst, William van 106
Althorp, Lord *85*
amateur painting 172–8
anatomy, lack of study of 45, 94, 174
Angiviller, Comte d' 47, 120
Angiviller, Comtesse d' 133
Anguissola, Sofonisba 16
 The Chess Game 15
art dealers 111, 201
art schools **42–4**, 63
 admittance of women to 47–8, 191–3
assistants, in studios 67–8, 70
attribution, of artists' work 36–7
auctions 111
Auricchio, Laura 47
Austen, Jane 75
 Northanger Abbey 30
 Pride and Prejudice 32, 110, 171
Auzou, Pauline **7**, 45, 97, 100–2

Bachaumont, Louis-Petit de: *Mémoires Secrets* 119–20, 166
Basseporte, Madeleine 50
Batoni, Pompeo 132, 136, 160
Bartolozzi, Francesco 125, 181, 183
Bashkirtseff, Marie 193
Beale, Mary 70, 76

Beauclerk, Lady Diana *7*, 178, **181–3**, 186
Benoist, Marie-Guillemine *7*, 151
 Portrait of a Negress 191, 192
 Portrait of Pauline Bonaparte, Princess Borghese 139, 191
Bessborough, Harriet (née Spencer) 84, *85*
Bluestocking Circle 81, 131–3
Bonaparte, Pauline, Princess Borghese *139*, 191
Bonheur, Rosa **197–8**, 201, 206
Boswell, James 75, 79
Bouliar, Marie-Geneviève *7*, 69, 71
 Adélaïde Binart 69, 71
Bowles, George 40, 97, 134, 138, 140, 150
Boydell, John 128, 130
Bristol, Frederick Augustus Hervey, Earl of 135–6
Burney, Fanny 26, 29, 34, 183, 186
 on Catherine Read 70, 86–7
Butler, Lady Elizabeth Southerden (née Thompson) 197, 198
 Scotland for Ever! 199

Calonne, Charles-Alexandre de 36, *78*
camera obscura 173–4
Canova, Antonio 136, 161
Capet, Marie-Gabrielle *8*, 55, 107
 Studio Interior 61, 72
Carreaux de Rosemond, Marie 55
Carriera, Rosalba *8*, 36, 47–8, 70, **167–9**, 209
 patronage of 87, 130, 144
 self-portraits 66, 70, 163, 167
 style of paintings 86, 107, 173
 Louis XV as a Boy 87, 91
 Portrait of Gustavus Hamilton, 2nd Viscount Boyne 132
 Self-portrait 163, 167
 Self-portrait Holding a Portrait of Her Sister 66, 70
Cassatt, Mary 205
 The Child's Bath 204
Catherine 'the Great' II, Empress of the Russias 38, *39*, 142, 150, 167
Ceracci, Giuseppe 51

Cerroti, Violante 53
Chaplin, Charles 193, 205
Chardin, Jean Siméon 102, 104, 122
Charlotte, Queen of England 27, 105, 116, 149, 183
Charpentier, Constance Marie 37
Chatsworth House, Derbyshire 110, 136
Chesterfield, Philip Dormer Stanhope, 4th Earl 30, 129
child rearing, role of mothers in 32–3
children, of women artists 152
Christie, James 110
Cipriani, Giambattista: *Rudiments of Drawing* 174
clothing, painting of 64–5
collections, private 109–10
Collot, Marie-Anne *8*, 105, 167
 Catherine the Great, 38, 39
colours, of paints 68
Condorcet, Marquis de 30
Conolly, Louisa 125
convent education 25–6, 50
Conway, Anne Seymour see Damer, Anne Seymour
Cosmetti: *The Polite Arts, Dedicated to the Ladies* 93, 109
Cosway, Maria (née Hadfield) *9*, 53–4, 60, **169–70**
 history painting of 97, 98
 other forms of art by 107
 studios of 111
 use of print trade 126
 The Death of Miss Gardiner 98
 Self-portrait with Arms Folded 168, 169
Cosway, Richard 53, 64, 110, **169–70**
Crozat, Pierre 130
Cruikshank, Dr. William 51

Damer, Anne Seymour *9*, 51, **184–8**
 studios of 70, 71
 use of assistants 70
 Sir Joseph Banks 187
Damer, John 186
Dance, Nathaniel 34, 53, 158
Daubigny, Charles-François 107
David, Jacques-Louis 28, 35, 37, 54, 55, 146, 153, 180

Deare, John 135
Delany, Mary 81, 114–6, *177,*
178–9
Degas, Edgar 205
Devonshire, William Cavendish,
5th Duke of 80, 82, 85, 136
Devonshire, Georgiana
Cavendish, Duchess of 82, **84,**
85, 110, 183
Diderot, Denis **33–4,** 36, 47,
99, 122
Encyclopédie 33, 90, 173, 174
divorce 32
drapery painters 65, 67
dress, of artists 70–1
Ducreux, Rose Adélaïde:
Self-portrait with a Harp 28
Dunlap, William 44
Duparc, Françoise **9,** 100
A Woman Knitting 101
Durand-Ruel, Paul 201, 205
Dürer, Albrecht 14, 16, 136

Earl-Bishop see Bristol, Frederick
Augustus Hervey, Earl of
École des Beaux-Arts, Paris 118,
191, 206
education
see also art schools
Classical 92, 93, 94
of women 24–5, 30–2
Eliot, George: *Middlemarch* 29,
188
engravings 125, 126–8
equipment, art 63–4, 65
exhibitions 113–14, 116–17,
120, 176
see also Salon (Paris)

Falconet, Étienne-Maurice 38,
39, 167
family, women's role in 32–3,
33, 152
fashions 70–1, 84, 86, 99
Ferdinand IV, King of Naples 149
flowers, in still life 104, 174, *177,*
179–80
Fontana, Lavinia 16
Foote, Samuel: *Taste* 89
Forbes, Anne **10,** 51, 63, 65, 71,
80, 129
Ford, Anne 29, 81
Foster, Lady Elizabeth **80,** 82,
108, 136

Fragonard, Jean-Honoré 56,
153, 166
The Reader 57
Free Society of Arts 122
French Revolution **147–8,** 162,
189
Fuseli, Henry 54, 97, 128

Gainsborough, Thomas 51, 63,
77, 81, 93
galleries 60, 77, 109, 135, 201
see also Louvre, Musée du
Gambart, Ernst 201
Garrick, David 122, 158
'genre' painting 92, **100–7**
Gentileschi, Artemisia 16
Judith and her Servant 19
Geoffrin, Mme 131, 133
George III, King of England 144,
149, 183
Gérard, Marguerite **10,** 56, 67,
100, 102, 166
Artist Painting a Portrait of a
Musician 62
The Piano Lesson 31
The Reader 56, 57
Goethe, Johann Wolfgang von
75, 90, **160–1,** 184
Goncourt, Jules and Edmond 25,
84, 130
Woman of the Eighteenth
Century 18
Gonzalès, Eva 202–05
Goodden, Angelica 136, 153,
159, 161
Gould, John: *Biographical*
Dictionary of Artists 186
Grandpierre-Deverzy, Adrienne
191
Interior of Pujol's Studio 191-3,
195
Grant, Abbé 48, 130
Greuze, Jean-Baptiste 55, 100,
125, 131
Guichard, Joseph-Benoît 201,
203

Hadfield, Charles 53
hairstyles, fashion of 84
Hamilton, Emma, Lady see Hart,
Emma
Hamilton, Gavin 53
Hamilton, Sir William **140–2,**
181, 184–6

Harris, Ann Sutherland 21
Hart, Emma **142,** 184, *185*
Hayley, William: *The Triumphs of*
Temper 24
Herford, Laura 196
hierarchy of art genres 77, 102
history painting 42, 77, 92–9
Hogarth, William 113, 125
Hone, Nathaniel 158
Horenboult, Susanna 14, 15
Horn, Frederick de 158–9
Hosmer, Harriet 152, 189, 205
Hughes, Robert 21
Hume, David 114
Hunter, Dr. William 44

Italy, as cultural centre 53, 133–5,
205

Jameson, Anna 39–40
Jefferson, Thomas 124, 169
Jerningham, Lady 90
Johnson, Dr. Samuel 22, 32, 75–6,
79, 90, 92, 116–7, 129, 181
Jopling, Louise 193
Blue and White 207
Joséphine, Empress of the French
52. 97
Julian, Rodolphe 193

Kauffman, Angelica 10, 83, 86,
89, 90, 93, 104, 120, **156–9,**
161, 196
character and appearance 34,
122, 164
comparisons with Vigée Le Brun
164–6
exhibitions of 113, 114, 122,
140, 208
genres of art 105–7
history painting of 94, 95, 96–7,
99, 138–40, 150
patronage of 53, 129, 133,
136–140, 138–43, 149, 150
print trade 125, 128
relationships of 34, 54, 156–8,
160–1
reviews of work 56, 67, 79, 96
self-portraits 124, *134,* 140, *157,*
159–60
studios of 59, 60, 71, 87,
110–11
training of 41, 45, 46, 48, 50,
53

Cleopatra Decorating the tomb of Mark Antony 94–6, *95*
Lord Althorp and His Sisters 84, *85*
Maria 125, *127*
Morning Amusement 27, *29*
Portrait of Lady Elizabeth Foster 80, *82*, 108
Self-portrait 157
Self-portrait in the Character of Painting Embraced by Poetry 134, 140
Knight, Cornelia 83
Knight, Dame Laura 120
Kotzebue, August von 79

La Font de Saint-Yenne, Étienne 93
La Tour, Maurice Quentin de 48, 50
Labille-Guiard, Adélaïde 11, 61, 70, 73, 83, 108, 121, 161
accusations of plagiarism against 36
as a miniaturist 107
as a tutor to other women 49, 54–5
career during French Revolution 147–8, 162
exhibitions of 119, 190
patronage of 130, 133, 143, 144, 162
rivalry with Vigée Le Brun 162–4
training of 47, 50–1
Augustin Pajou 119, *121*
Madame Adélaïde 141, 143, 162
Self-portrait with Two Pupils 49, 54–5, 70, 122–4, 161
Lama, Giulia 45
landscape painting 107–8, 180
Lawrence, Thomas 75, 77, 142
Le Brun, Jean-Baptiste-Pierre 153
Le Brun, Julie 154, *155*
Lely, Sir Peter 75
Levey, Michael 76
lighting, in studios 60–3
Linley, Elizabeth 29
London, as artistic centre 59, 76, 126
Louis XV, King of France 17, 87, 91, 148

Louis XVI, King of France 108, 120, 141, 143
Louvre, Musée du 54, 55, 118, 180
see also Salon (Paris)

make-up, fashion of 86
Manet, Édouard 201, 202, 205
mannequins, use of 65–7
Mantz, Paul 197
manuals, for amateur artists 174
Maria Carolina, Queen of Naples 149–50
Marie Antoinette, Queen of France 55, 86, 88, 119, 131, 137, **144–7**, *146*, 148, 150, 151, 153, 156, 166, 190
Maria Christina of Austria, Archduchess: *Christmas in the Royal Household of Empress Maria Theresa of Austria* 182
Marie Louise, Empress of France 97
Maria Theresa, Empress of Austria 86, 182
marriage, role of women in 30–2, 33, 152
Mayer, Constance 11, 55–6, 102, 166–7
The Sleep of Venus and Cupid 52, 56
media, role in artist's popularity 114–16
meeting places, studios as 73–4
Ménageot, François-Guillaume 37, 156
Mercier, Louis-Sébastien 76-7
Tableaux de Paris 92, 118
Merian, Maria Sibylla 17
Metropolitan Museum of Art 37–9, 124, 208
Meyer, Friedrich Johann 164
mezzotints 124, 125
miniature painting 107
Montagu, Elizabeth 133
Montagu, Lady Mary Wortley 26, 30, 89, 172
More, Hannah 30, 33
Morisot, Berthe 201–2, 205
Reading 203
Moser, Mary 11, 46, 48, 104–5, 120, 149, 196
Murat, Caroline, Queen of Naples 87

Museum of Modern Art, New York 21
music, as pastime 29

Napoleon I, Emperor of the French 55, 97, 139, 190, 187, 191
Napoleon III, Emperor of the French 194
National Gallery, London 21, 70, 202
needlework 26–9, 176, 178
Nelson, Vice Admiral Horatio Nelson, Viscount 142
Nieriker, May Alcott 194, 197
Nochlin, Linda 21, 42
nudes 97–9, 180, 196
as study for women 42, 45, 193
women as 44–5

O'Keeffe, Georgia 206–08
'Old Masters', collections of 110, 113
Old Mistresses (exhibition) 208
Osborn, Emily Mary 198–201
Nameless and Friendless 200

paints 68
Pajou, Augustin 71, 118, 121
Parker, John 97, 138–40, 150
Pasquin, Anthony 67, 96
pastels 86, 173
Paston, George: *Little Memoirs of the Eighteenth Century* 29
Paulze, Marie-Anne 180
Piles, Roger de: *The Principles of Painting* 79, 81
Pine, Robert Edge 44
plagiarism, accusations of 36–7
plaster casts 64
Pliny the Elder 16
Historia Naturalis 14
'polite society' 114
Pollock, Griselda 21
poses, of sitters 79–81, 89
Poussin, Nicolas 93, 110
Prince of Wales (*later* George IV) 107, 111, 116, 205
print trade 124–8, 174
Prud'hon, Pierre-Paul 52, **55–6**, 102, 167
Pujol, Alexandre Abel de 191, *195*

Read, Catherine 11, 29, 41,
72, 74
criticism of 70, 86–7
patronage of 149
training of 48–50
use of chaperone 130
Rembrandt, Harmensz van Rijn
37, 104, 110
Reni, Guido 93, 95
Renoir, Pierre-Auguste 201,
206
Reynolds, Sir Joshua 33, 44, 54,
99, 116, 128, 140, 142, 178,
180, 185
on patronage 130
portrait of, by Kauffman 89
relationship with Kauffman 59,
158
studios of 60, 63, 64, 65, 68,
74
style of paintings 83–4
7th Discourse on Art
Richardson, Jonathan: An Essay on
the Theory of Painting 90
Richardson, Samuel 24, 25
rivalry between artists 34, 162
Robert, Hubert 50, 71, 73, 153
Rome see Italy, as cultural centre
Romney, George 60, 75, 142,
185
Rosenthal, Angela 80
Rossi, Properzia de' 16, 105
Rouquet, André 118
L'État des Arts en Angleterre
111
Rousseau, Jean-Jacques 18, 100,
122, 154, 180, 181, 191
Émile 32–3
Rowlandson, Thomas 117, 151
The Exhibition Stare Case
112
Royal Academy of Arts, London
44, 45, 46, 94, 97, 107, 112,
113–4, 149, 161, 168, 169,
174, 188, 196
exhibitions at 76, 116–7, 140
women as members of 48,
104, 120
Royal Academy Schools 44
royal patronage 143–50
Royal Society of Arts see Society
for the Encouragement of Arts,
Manufactures and Commerce
Ruysch, Rachel 12, 17, 104, 152

Spray of Roses with Beetle
and Bee 106
Ryland, William 125
Salon (Paris) 77, 88, 92, 99, 118,
120, 124, 126, 162, 190-1,
193, 202, 205, 206
Salon de la Correspondance,
Paris 120
sculpture 105, 186, 187, 205
see also Collot, Marie-Anne;
Damer, Anne Seymour; Hosmer,
Harriet
sexual morality 34–6
Sharples, Rolinda 42
Self-portrait with her Mother
43
shell-work 183–4
Sheridan, Richard Brinsley 25, 29
sitter's books 67–8
Skavronskaya, Countess 142–3
Slade School of Art, London 196
Smith, J.T.: Life of Nollekens 34
Smollett, Tobias 25, 86
Society for the Encouragement
of Arts, Manufactures and
Commerce 113
Society of Artists 113
Somerset House, London 112, 116
status, portraits for 76–7
Sterling, Charles 102
Sterne, Laurence: A Sentimental
Journey 96, 127
Tristram Shandy 96
Stevens, Alice Barber 193
still-life painting 102–5
Sturz, Helfrich Peter 56
symbols, within portraits 83, 84

Taine, Hippolyte 191
Thackeray, William Makepeace
194
Therbusch, Anna Dorothea 12,
36
history painting of 97–9
patronage of 144
reviews of work 122
use of nude models 45–7
Self-portrait 165
'toilette' portraits 80
Townley, Charles 50, 174
Troy, Jean-François de 17
Reading from Molière 20
Turkish influence, on art and
fashion 29, 84

tutors 176
see also art schools
penalised for teaching women
53, 54
women as 53, 54–5

Uffizi Gallery, Florence 53,
124, 156
Union des Femmes Peintres et
Sculpteurs 206

Vallayer-Coster, Anne 12, 102-4,
119, 148, 166, 190
legacy of 208
patronage of 55
reviews of work 122
training of 41, 50–1, 55
use of print trade 126
The Attributes of Painting,
Sculpture and Architecture 119,
123
Bouquet of Flowers in a
Terracotta Vase with Peaches
and Grapes 137
Still life with Seashells and
Corals 103, 148
Van Mander, Carel: Advice to
Painters, Art Lovers, and Poets,
and For People of All Ranks
152
Vasari, Georgio 105
Lives of the Most Eminent
Painters, Sculptors and
Architects 16
Vaudreuil, Comte de 131
Vigée Le Brun, Elisabeth 13, 32,
49, 70, 84, 109, 143, 152-3,
161, 208-9
accusations of plagiarism
against 36–7
as teacher 54
business sense of 122
character and appearance
164–6
comparisons with other female
artists 162–4, 164–6
exhibitions of 119–20, 190
exile during French Revolution
147, 153–4, 190
history painting of 97
Memoirs of 71, 79, 81, 89,
126, 131, 143, 145, 162, 209
patronage of 53, 130, 131,
135, 140-3, 144-7, 150

reviews of work 145, 150
rumours of affairs 34, 36, 79
self-portraits of 70–1, 131,
154, 155, 156, 160
studios of 60, 64, 71, 72,
80-1, 87–9
training of 42, 50, 51–2
Charles Alexandre de Calonne
78
Hubert Robert 71, 73
Lady Hamilton as a 'Bacchante'
143, 185
Marie Antoinette 'à la rose' 86,
88
Marie Antoinette and Her
Children 145–7, 146, 162
Peace Bringing Back
Abundance 115, 119

Self-portrait in a Straw Hat 3,
131, 154
Self-portrait with Her Daughter
Julie 122, 154, 155
Villers, Marie Denise **13**
Portrait of a Young Woman
called Charlotte du Val
d'Ognes 35, 37, 39
Vincent, François-André 161,
162
Vincent, François-Élie 36, 50,
161

Wakefield, Priscilla 33, 39
Wallace Collection, London
37, 56
Walpole, Horace 76, 89, 117,
133, 179, 183, 186

watercolours 173, 174, *175*
Wedgwood 105, 183
Wentworth, Bridget, Lady
136–8
West, Benjamin 34, 53, 60, 99,
114, 128, 142
Wilmot, Catherine 164
Winckelman, Johann 53, 94
Women Artists: 1550-1950
(exhibition) 18, 195, 208

Zoffany, Johann 53
The Academicians of the Royal
Academy 46, 48
Zucchi, Antonio 134, 159, 160,
161

❦ Acknowledgements

In a preamble to the Bibliography I have paid tribute to certain authors whose books on women artists guided me through mine. But my book would never have come to pass had it not been for my agent, Laura Morris, whose patience, encouragement and wonderful good humour kept me going until Unicorn accepted it for publication. That they did so is entirely due to the faith of their Chairman, Ian Strathcarron, in the project, and to their Editorial Director, Lucy Duckworth, who could not have been more flexible and supportive.

The two people who actually transformed my words into this handsome book were my editor, Liz Wyse, and designer Nicola Liddiard: Liz with her skill and precision, and Nicki with her marvellous taste. Both were endlessly forgiving of my computer illiteracy and changes of mind. I am also indebted to Sandra Pollard whose lecture on two of the principal artists sowed the seed of inspiration for the book and who then checked the manuscript with great care. And I am grateful to Ramona Lamport for her remarkable proofreading. She could, I believe, find a needle in a haystack. I would also like to thank my brother John for his generosity, my husband Roger for his years of forbearance as I thrashed away at my computer, my daughter Catherine for her perceptive comments and wise counsel, and my daughter Jessy for her encouraging words.